Chinese Street Food

A Field Guide for the Adventurous Diner

FRANK KASELL

CHINESE STREET FOOD

ISBN 978-988-77927-2-7

Published by **Blacksmith Books**
Unit 26, 19/F, Block B, Wah Lok Industrial Centre,
37-41 Shan Mei Street, Fo Tan, Hong Kong
Tel: (+852) 2877 7899
www.blacksmithbooks.com

Edited by **Asta Lam**
Layout by **Vincent Vi**

First printing 2018

Parts of this book were previously published in altered
form under the title *Red In Tooth And Claw* in *The Cleaver Quarterly*.

To Tallulah and Wednesday

Some xiao chi for my xiao children

Contents

Acknowledgments

Introduction

Congratulations! You, dear reader, are holding in your hands the very first English-language guide to Chinese street food. Clearly you are a person of exceptional taste and wisdom, not to mention very likely good-looking. Probably the kind of person that calls your mother regularly, remembers every new acquaintance's name after hearing it the first time, and stops your car to carefully move turtles out of the road. Well done. So how did this book find itself in your hands?

Perhaps you're an adventurous eater looking for some new tastes to explore. Maybe you're preparing to visit China and a thoughtful relative sent it your way. It's possible you picked it up in a bookstore and are still deciding whether to buy it or not (go for it; you won't regret it!). Maybe you're my mom (Hi, Mom!). Perhaps you are staying at a backpacker's hostel somewhere in the world and found it on the leave-one-take-one bookshelf. However you came to discover this book, I'm glad you did. Whether you are a hitchhiking backpacker, a dark-suited business traveler, a grey-haired group tour participant, a food aficionado, an armchair traveler, or any other person, categorizable or not, this book is for you. Welcome.

Now that we've established who you are and how you ended up holding this book, the next obvious question is: why street food? Of all the myriad facets of Chinese culture to which one could devote an entire book, why would street food jump to the front of the queue? The short answer is that I believe it is one of the finest—and certainly tastiest—tools a person can use to truly access Chinese culture. In my experience, a first-time visitor to China can be overwhelmed by the surface-level, monolithic tourist culture of dragons, pagodas, Mao statues, Great Walls, and pandas, all of which certainly have a place in the country's history and future. And yet the country is considerably more diverse—ethnically, geographically, culturally,

and more—than this monolithic view of Chinese culture would have you believe. I maintain that most travelers today are eager to dig past this surface-level view of the country to see the finer details that make up the larger picture; they just don't have a clear way of doing it. If that sounds like you, let me say this: street food is the answer.

Most cities in China have street foods that are unique to that city's culture. A local street food is typically found only in its home city or region. By sampling street dishes throughout the country, you can experience the rich nuances that comprise Chinese culture at large. Street food tells you about the history, geography, values, and people of an area in a way nothing else can. When you eat street food, you are eating the food that local people have eaten in that city for hundreds or even thousands of years. Street food is quite literally the fuel for daily life in a city.

In this book, you will find information about representative local street foods in 53 Chinese cities, spanning 32 out of China's 33 provinces or province-level divisions (number 33 is Tibet, which was closed to all foreigners during my research trip). Some cities have only a single highlighted street food, while others have more than a dozen. Each food is accompanied by a paragraph or two describing the food to help you decide if it tickles your fancy, along with a photograph and the name of the food in both Chinese characters and pinyin to help you seek it out on the streets. I've also included some keywords on the entries, to provide a quick cue about what you're getting into. My hope is that with this guide in hand, you will have all the tools you need to try out some of the best local street food in China.

Before we go any further, it might be worthwhile to clarify how exactly I define street food. At first blush it might seem like street food is fairly self-defining: food that is prepared and sold by vendors operating out of sidewalk carts or stalls and eaten right there on the street. No restaurant necessary. Unfortunately, this basic definition doesn't always hold up in practice. For the purposes of this book, I have operated under a fairly loose definition of street food. In many cases, you really will find the food as described above. The entire transaction, including the consumption, takes place in the great outdoors. This is my favorite way

to experience street food, as the vibrancy of a street seems to enhance the experience in certain ineffable ways. In other cases, however, street foods are more likely found in small shops with a few stools or tables, technically out of the street, but not really full-fledged "restaurants." These sorts of shops are so close to the walks, they might as well be considered "on the street." In a handful of other situations, particularly when a famous street food is no longer in fashion as a daily repast and serves now as more of a fetishized historic novelty, I had to resort to legitimate restaurants to find the right dish. Since this book is really about exploring the culture of street food, I thought it made sense to err on the side of inclusivity rather than exclusivity. If there were any compelling reasons for me to consider a food a "street food," I felt comfortable including it.

I'd like to share a few quick caveats about this book. First, despite my claim of inclusivity, you may notice the absence of certain well-known street foods such as bāozi herein. Chances are that a food like that has been omitted because it is so ubiquitous that it fits more into that broad-stroke picture of Chinese culture and didn't entirely make sense in a book focusing on the hyperlocal. That being said, certain foods in this category (jiān bǐng, for example) *have* been included because, although found all over China, they do have deep roots in a particular city's culture. In other cases, foods like this have unique regional variations on a national standard that I felt merited inclusion.

Second, you should know that histories of street foods are not always cut and dry. In a number of cases, two or three cities lay claim to an individual food, and it wasn't always easy to suss out the truth. Likewise, I ate some foods that local folks assured me came from their city, but I was unable to substantiate that claim in my subsequent research. In all such uncertain scenarios, I relied on my own judgment and placed the food where it made the most sense. Surely some will dispute my decisions. If you have a particularly strong feeling about where any foods should be placed, I'm open to hearing about it.

Third, if you are looking for directions to specific restaurants or vendors, you have come to the wrong book. While it is true that there can be a bit of variation in quality from vendor to vendor and it can be easier to get the best food if you have clear recommendations, this book is focused on foods that belong to a city's culture, not a specific vendor's cart. If you want the best of the best, I encourage you to ask around on the ground. Local citizens will be able to point you in the direction of their favorite purveyors of a particular food.

Fourth, and perhaps most importantly, I make no claims to comprehensivity. In fact, I'm not sure anybody could. Despite the hundreds of street foods I have sampled, there are foods that I looked for but couldn't find. Foods that I didn't hear about until I had already left a city. Foods that are seasonal and were unavailable when I passed through. Foods I've still never heard of. Each section of this book covers some of the best street foods a city has to offer. Rarely, if ever, does it cover *all* of the street foods a city has to offer.

Before I let you go, we must briefly address the question of food safety. This is one of the most common things people ask when I talk about street food in China. Is it possible to eat street food and not get sick? Yes. I can confidently say that I did not get sick at all during the three months I spent in the country eating nothing but street food. But that's anecdotal. Are you guaranteed not to get sick? No. It's always possible to get a bad meal now and then, as anybody who has had that experience is happy to tell you. Sanitary conditions at street food stalls are rarely what one might expect in a nice restaurant. Furthermore, some unscrupulous vendors reuse cooking oil to cut costs, which can also cause some intestinal distress. Fortunately, there are some ways to mitigate your risk. The best tip I can offer is to follow the crowd. Locals know which vendors have a track record of making people ill and which ones don't. If you follow their lead, you are likely to avoid the worst culprits. Some other basic tips include 1) making sure that the food you are eating is freshly prepared (even better if you can watch it being prepared) rather than sitting out in the air for an indeterminate amount of time; 2) avoiding raw fruits and vegetables when possible; and 3) simply using common sense. If a particular street food vendor seems dodgy, there's no

harm in passing by to the next one. All that being said, my main advice is not to be nervous, and plunge right in. There's no harm in taking some basic precautions, but there's also no reason for fear of illness to keep you from eating some of the best food in the country.

So that's it. Once again, I thank and congratulate you for choosing this book. I sincerely hope it will lead you to some amazing experiences. Now I invite you to explore the book, explore China, and explore the culinary delights that await you out there on the streets. Happy eating!

Frank Kasell

LANGUAGE NOTE

Simplified Chinese characters and Mandarin pinyin are used to describe the foods in this book, except in the Hong Kong and Macau chapters which use traditional Chinese characters and Cantonese. In the Urumqi chapter, Uyghur names are added to the Chinese ones.

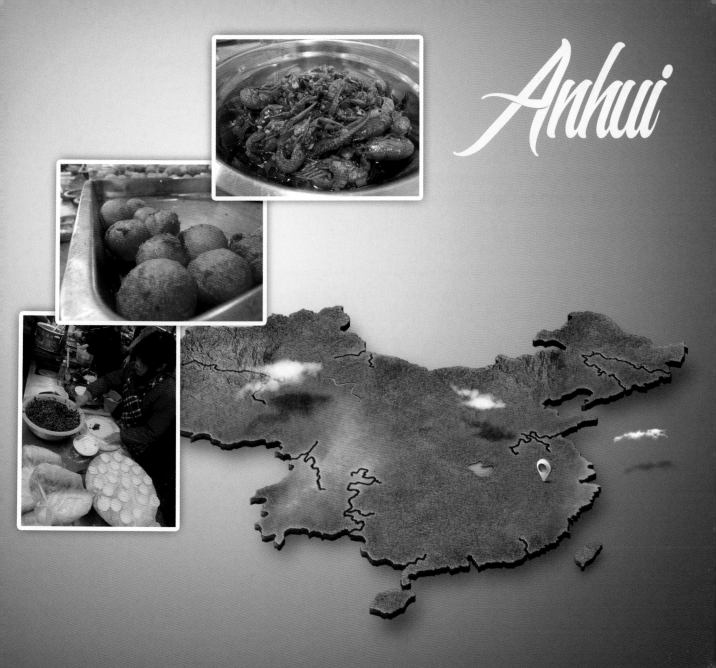

Anhui

Hefei

香辣小龙虾

Xiāng Là Xiǎo Lóng Xiā

COST: 30 RMB

Xiāng là xiǎo lóng xiā might be the most expensive street food I have included in this book. Generally, street food is known for its low prices, so this one is something of an anomaly. It might have been cheaper if the main ingredient—freshwater crayfish—had been in season when I passed through Hefei, but even so I think it would have been more expensive than the standard street food. The question, of course, is whether or not xiāng là xiǎo lóng xiā is worth the premium price. It all depends on how you feel about finger-licking spicy seafood. An order of xiāng là xiǎo lóng xiā includes a big bowl full of fire-red crayfish soaked in garlic and chili oil. They look like a cross between lobsters (with their hard, red shells, pinchers, and bulging black eyeballs) and shrimps (with their curved shape and size).

Alongside the crayfish are slices of green onions and powerfully spicy red peppers common in the region. This is not a food for finicky eaters, because the only way to attack it is with your fingers. One at a time, you'll need to pick up the crayfish, break them open with your hands, and unglamorously slurp out any meat you can find. By the time you've eaten your way through half of the bowl, your hands will be coated in enough grease to keep an oil lamp lit for eight days and nights. Xiāng là xiǎo lóng xiā is spicy, messy, greasy, and quite tasty. If that sounds to you like it's worth 30 RMB, then go for it. If not, maybe you can sneak a taste from a friend's order.

Key words: crayfish, greasy, messy, spicy, garlicky

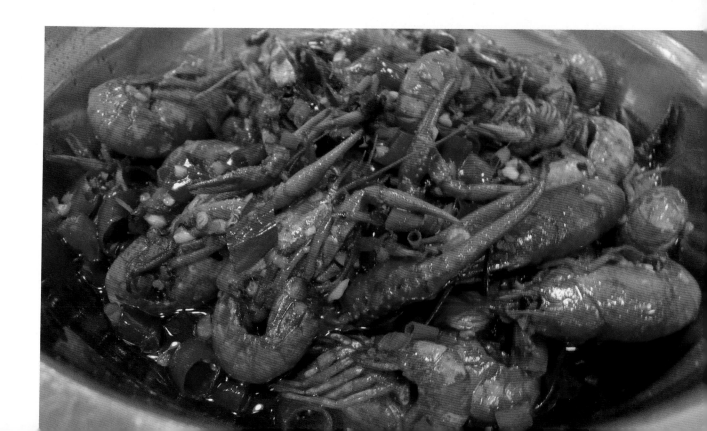

韭菜盒子

COST: 3 RMB

Jiǔ cài is one of my favorite vegetables in China. For some mysterious reason, it is rarely found in the Western world, which is a real shame. Different sources translate jiǔ cài as garlic chives, Chinese chives, or Chinese leeks. I prefer the "garlic chives" translation, because that comes closest to describing jiǔ cài's unique and addictive flavor. Imagine a vegetable with the look of a scallion but tastes less of onion and more of garlic. That food you're imagining is a glimmer of what jiǔ cài is like. Jiǔ cài hé zi is something like a greasy fried turnover or empanada stuffed to the gills with jiǔ cài. Some vendors include pork, eggs, or shrimps in the stuffing as well, but the jiǔ cài is always the dominant ingredient.

About the size of one's hand and shaped like a half moon, these enormous dumplings are literally bursting with both flavor and oil (jiŭ cài has a bad habit of soaking up and retaining oil when it is fried). Its heft and greasiness definitely puts it into the less healthy category of foods that you probably ought to eat sparingly. On those once-in-a-while occasions, though, your taste buds will rejoice.

Key words: jiŭ cài, fried, stuffed

山芋丸子

Shān Yù Wán Zi

COST: 1 RMB

Here we have fried sweet potato balls, a tasty (if somewhat insubstantial) little snack. The recipe is simple: steamed sweet potato is pounded into a paste, and milk and sugar are mixed into the paste; the paste is shaped into balls, which are then fried. That's all there is to it. They are crispy on the outside, chewy on the inside, and sweet all throughout. Buy a bagful—they will make a delightful snack for your wanderings around Hefei.

Key words: sweet potato, fried, ball, gummy

ALSO TRY:

庐阳汤包 (Lúyáng Tāng Bāo),
三河米饺 (Sānhé Mǐ Jiǎo),
白切 (Bái Qiē),
冬菇鸡饺 (Dōng Gū Jī Jiǎo)

12

Every city in China has street-side barbecue vendors, serving up tasty grilled meats and vegetables for all and sundry. There's not much variation between the offerings in different cities, so the whole category of generic nighttime barbecue is mostly absent from this book. The only time I considered including it at all was here in Hefei, where barbecue vendors seem to completely dominate the street food scene. Everywhere I looked at night it seemed there was a new billow of steam signaling the presence of another guy grilling whole fish, chicken necks, lotus root, tofu... really anything you might want. In a city without a ton of unique street foods but full of generic grills, it seems that the standard nighttime barbecue is worth at least a small mention.

Beijing

Beijing

板栗紫薯大麦粥

Bǎn Lì Zǐ Shǔ Dà Mài Zhōu

COST: 8 RMB

Porridge is a common breakfast snack in much of China, and Beijing is no different. One local variant is bǎn lì zǐ shǔ dà mài zhōu. Let's break that down: bǎn lì (chestnut); zǐ (purple); shǔ (yam); dà mài (barley); zhōu (porridge). It's handy when the full list of ingredients is right there in the name, yes? As I'm sure you can guess, this purple porridge is made from chestnuts, yam, and barley. It is wholesome and hearty with a mildly sweet taste. While not as thick as, say, oatmeal, it isn't as runny as a soup. Sort of mid-range density. Bits of all the ingredients are spread throughout. A full bowl of this stuff will fill up your belly and keep you going all day, so keep an eye out for it at breakfast time in Beijing.

Key words: porridge, purple, yam, chestnut, barley

南瓜发糕

Nán Guā Fā Gāo

COST: 3 RMB

Nán guā fā gāo is another charming breakfast snack in Beijing. It is a spongy steamed cake consisting of pumpkin, milk, flour, and dried fruit. To prepare these steamed cakes, the vendor must first scoop out the pumpkin flesh, chop it into cubes, cook it, and mash it. This pumpkin mash is mixed together with piping hot milk and self-rising flour to create a yellow-orange paste. The vendor then covers the paste and leaves it at room temperature for several hours, during which time it doubles in size all on its own. After that, all that's left to do is to put a dried raisin, date, or medlar on top of each bun and then steam it for about twenty minutes. That's all there is to it! The completed pumpkin cake is spongy, moist, soft, and puffy, with a pleasingly sweet pumpkin flavor. They are delightful little snacks and a fine way to start the day.

Key words: pumpkin, cake, steamed, sweet

香煎夹心豆皮

COST: 5 RMB

Here is a real treat for street food lovers with a soft spot for rich and greasy snacks. Xiāng jiān jiā xīn dòu pí is something like a paniniesque pressed sandwich, except instead of bread you've got tofu skin and instead of sandwich fillings you've got sticky rice and pork. If that sounds good to you, then you and I have similar tastes. In the category of greasy street foods, this thing is a marvel. Moving from the outside in, you start with the thin tofu skin, smooth and glossy where it wasn't touching the griddle and crispy gold where it was. Next you'll encounter a layer of fried sticky rice, spread evenly across the tofu skin, not quite a centimeter thick. After that you've got cubes of mild pork and, if you're lucky, some leafy vegetables or green and white onions. The vendors making these pockets of flavor wrap them up and then smoosh them on the griddle, making them more compact and sandwich-shaped than they might have been otherwise. There aren't any surprises or subtleties in the flavor here—it's savory and greasy, with a sticky oiliness that will coat your mouth for a while after eating it. Like I said, if you've got an inclination towards street foods in the rich and greasy category, you won't want to miss this one.

Key words: tofu skin, rice, pork, greasy, savory

豆汁

COST: 3 RMB

Walk around Beijing for a few short hours and you are guaranteed to see the characters "老北京" (lǎo Běijīng) emblazoned on a number of shop fronts. The phrase means "old Beijing," and it is ubiquitous in the city. In most cases it is meant as a signal to tourists that you can buy traditional Beijing foods or crafts or whatever at that establishment—an enticement of authenticity. Unfortunately, however, four times out of five it's little more than a cheap marketing ploy. It's the Beijing equivalent of U.S. manufacturers plastering the word "artisanal" on a wholesome looking package to attract the eyes of well-meaning consumers susceptible to sneaking advertising tactics. In a sea of pseudo-lǎo Běijīng products, it is always a pleasant surprise to come across something that truly deserves the title. One such example is dòu zhī, a food with a long history in the city, a large and devoted following among elderly Beijingers, supposed health benefits, and a notoriously hard-to-acquire taste. So what is it? A sour, fermented milk made of mung beans. More specifically, it is a by-product resulting from the preparation of cellophane noodles. Frankly speaking, dòu zhī does not come across as particularly appetizing. It looks like dirty, gray dishwater and smells like eggs and fetid gym socks. The taste is a combination of the two. It is thin and starchy, sour with a subtle beany aftertaste. Many locals say it must be eaten on at least three separate occasions before you can start to enjoy the flavor—after that, it is supposedly quite addictive. It is almost always served with two side dishes that help cut the taste a little bit: pickled vegetables and crispy rings of fried dough called jiāo quān. Dòu zhī absolutely lives up to its reputation as an acquired taste—it's not going to be for everyone. Nonetheless, dòu zhī is a must-try for street food aficionados passing through the city. It's an indelible part of the city's cultural heritage, providing cheap sustenance to

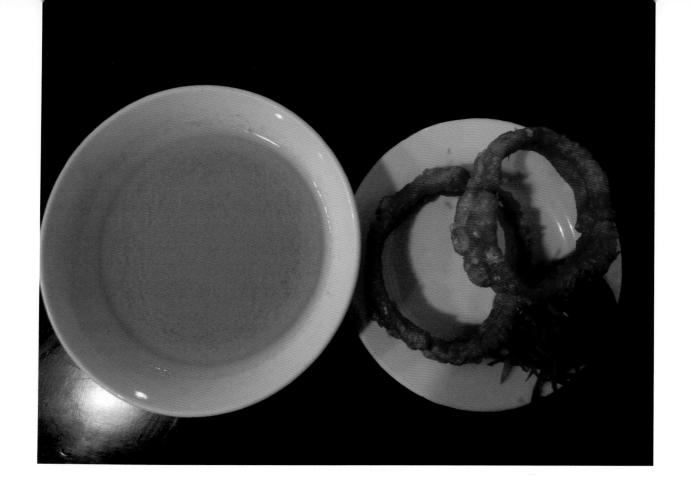

locals for hundreds of years. Perhaps the best endorsement comes from an old Chinese saying, which goes: "没有喝过豆汁儿，不算到过北京。" That roughly translates to "you haven't been to Beijing unless you have tasted dòu zhī." What more needs to be said?

Key words: mung bean milk, sour, smelly, acquired taste

褡裢火烧

Dā Lián Huǒ Shao

COST: 8 RMB

When you eat pan-fried dumpling, do you think to yourself, "these are good, but I wish they were longer"? If so, then have I got good news for you, friend: they exist and they are called dā lián huǒ shao. These long dumplings, a Beijing specialty, are wrapped in a thin wheat pancake and stuffed with savory filling (traditional fillings include pork and scallions, pork and fennel, lamb and green onions, or pork and leek; these days you can also get a vegetarian option from some vendors). The pancakes are stuffed to the brim, like a small burrito, and then pan-fried to a golden crisp. They are juicy, warm, and soft, just like all of the best dumplings. Dating back nearly 300 years, dā lián huǒ shao is a tasty part of Beijing's past, present, and (hopefully) future.

Key words: dumpling, long, pan-fried, pork, juicy

门钉肉饼

COST: 5 RMB

You know those immense, red, wooden doors you see on old Chinese buildings? The ones with intricately carved animal heads and tangerine-sized, golden studs decorating them? Keep those studs in mind when you are eating Beijing's mén dīng ròu bǐng, for these meaty dumplings are named after them (mén dīng ròu bǐng means "doornail meat cakes"). Can you see the resemblance? Legend has it that mén dīng ròu bǐng was invented during the reign of the Empress Dowager Cixi a little over 100 years ago. She asked her executive imperial chef to come up with an interesting new snack for her to eat. He came up with mén dīng ròu bǐng, he served them, she at them, and she loved them. When she asked him what to call the new snacks he noticed their resemblance to the doornails, and voila...a classic street food was born. Mén dīng ròu bǐng is basically a cross between a dumpling and a fried bun. The skin is wheaty, thicker than a dumpling wrapper and thinner than a bun. It has been pan-fried, giving it a lightly crispy texture on the flattened top and bottom and a softer, moister texture sides.Within this outer layer you will find some juicy ground beef, onions, ginger, and scallions. These little guys are just bursting with hot, fatty, beef grease, so be careful when you bite into them for the first time. They have a rich, tallowy beef flavor that keeps you coming back for more (which is too bad, as each one is gone in two or three bites). My verdict: mén dīng ròu bǐng is another tasty entry in the Beijing street food canon.

Key words: beef, dumpling, juicy, greasy, savory, pan-fried

炒肝

Chǎo Gān

COST: 5 RMB

As far as I'm concerned, liver is probably the most decadent and enjoyable of all organs. It's always a treat to bite into a dish and encounter the unmistakable flavor of liver. So it was with great pleasure that I came across chǎo gān on the streets of Beijing, a dish that really showcases the humble liver. Chǎo gān is essentially a soup with a thick, starchy, brown base. It has a glutinous consistency, closer to a paste than a broth. Suspended within this brown goop you will find the slices of pork liver. They are soft and spongy with that rich, nutritious iron taste that you either love or hate. Many vendors also throw in small pieces of other pork offal (mainly intestines) as well as some vinegar and heaps of garlic (the main flavor other than liver). Researchers claim that chǎo gān evolved directly from several Song Dynasty folksy organ dishes. Most suggest that it was invented by the chef at Beijing's famous Huixiangju restaurant during the Qing Dynasty in an effort to get around a common belief at that time that eating hearts and lungs together in one dish would make a person simple-minded. I've actually heard, but not been able to confirm, that the name "chǎo gān" is used as an insult in China, implying that your target lacks a heart. Tradition states that you should not use chopsticks or a spoon to eat chǎo gān, but rather drink it straight from the bowl, but you can certainly get away with using a spoon these days. If you like the taste of liver and garlic, chǎo gān is bound to be a highlight of your culinary experience in Beijing.

Key words: pork liver, garlic, thick, starchy

煎饼

COST: 3 RMB

Jiān bǐng is almost certainly in the top five most well-known (and well-liked) street foods in China. Any morning in any Chinese city you are likely to stumble across a street vendor on a corner mixing up some of these egg pancakes for hungry commuters. In Beijing—jiān bǐng's probable birthplace (some say they come from nearby Shandong Province; others claim they originated in Tianjin—see the Tianjin section for more)—you can find them all over the place. It's no surprise why the city's residents have such a love affair with jiān bǐng, because they are basically the perfect street food: greasy, filling, fast, and delicious. Jiān bǐng is a fairly simple dish. It begins with a batter made of wheat flour, soybean flour, and eggs that is thinly spread onto a wide, round griddle and then fried like a crepe. Shortly into the frying process, while it is still somewhat of a liquid, the vendor will usually crack a fresh egg on top, which blends in nicely but not completely with the pancake batter. When it is nearly ready to serve, the vendor will smear on a generous helping of spicy chili paste and sour fermented soybean paste, sprinkle it with scallions, and lay on a long, crispy cracker called báo cuì. All of these ingredients are optional, so be sure to tell the vendor which ones you want or don't want (I recommend getting them all). The final step is to roll up the pancake, fold it in half, and serve it. A completed jiān bǐng is eggy, spicy, salty, sour, heavy, rich, and oily—just what the doctor ordered. As any Beijing native can tell you, one jiān bǐng in the morning can keep you fueled for hours. Order one today and experience the joys of one of the country's most famous street foods.

Key words: crepe, eggy, rich, greasy, spicy, sour, heavy

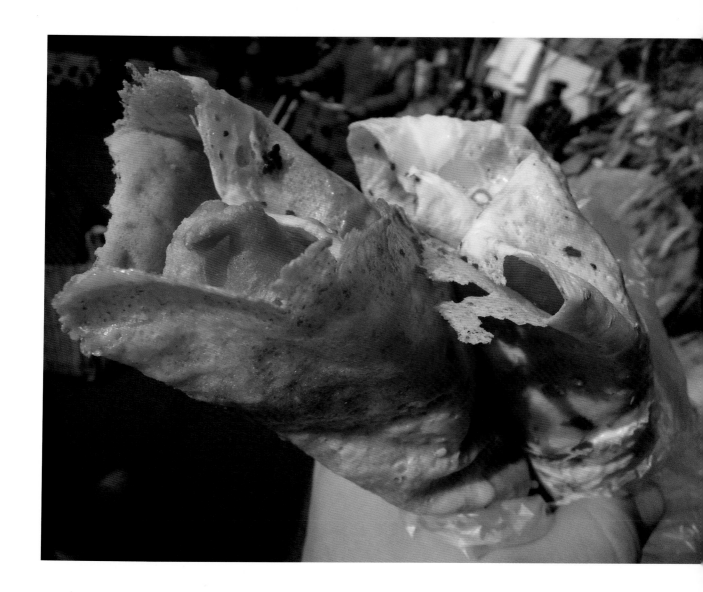

冰糖葫芦

COST: 2 RMB

Mention bīng táng hú lu to most Beijing natives and they are likely to be reminded of wintertime in their childhoods. Street vendors have reportedly been selling these glazed haws to children and nostalgic adults in every corner of the city since the Song Dynasty about 800 years ago. In fact, it's actually a little challenging to pin down the city where bīng táng hú lu originated (it is now available all over China). Normally that would disqualify it from inclusion in this book, but enough people still associate with Beijing culture that I've made an exception. The recipe is almost laughably simple: five to eight tart haws (closely related to crab apples), each about the size of a ping pong ball, are arranged on bamboo skewer then coated in a sweet sugar glaze that hardens as it cools. Legend has it that they were invented when one of the Emperor Guangzong's favorite concubines fell dreadfully ill. Imperial physicians tried everything they could think of, but her condition worsened day by day. Finally, one doctor from outside the imperial court examined her and suggested she cook some haws with sugar and water and then eat them with every meal. Amazingly, the concubine made a full recovery, and word rapidly spread about the miraculous food that cured her. Before long, bīng táng hú lu was a popular snack in the imperial court and among the masses alike. Amateur etymologists may be interested to know that bīng táng hú lu got its name (ice sugar bottle gourd) from an older way of preparing the snack that utilized only two haws—a larger one on the bottom and a smaller one on top. Arranged this way,

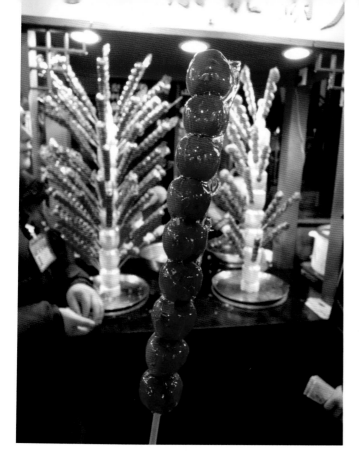

bīng táng hú lu had the same shape as the bottle gourd (hú lu), and thus a name was created. As every child in Beijing can attest, bīng táng hú lu make a fun and sweet/tart snack that really hits the spot on a cold day. Give it a try and feel like a kid again.

Key words: haw, sugar glaze, hard, tart, sweet

面茶

COST: 5 RMB

Miàn chá is an unusual looking food—there's no getting around that. But behind its striking dichromatic appearance, you will find a tasty and humble snack that's worth trying. As you might guess from the way it looks, miàn chá is composed of two distinct parts: millet gruel and sesame paste. The millet comes first in the recipe. Ground millet is mixed with cold water to make a very basic and goopy batter, which is then brought to an angry boil in a large wok. After a few minutes of high heat, the temperature is lowered to a simmer until the batter has adopted the right mushy consistency. Once you've got the millet gruel just where you want it, you will want to scoop it into a bowl and then drizzle a glossy, brown sesame paste all over the top. This paste has been prepared with sesame oil, crushed sesame seeds, salt, and pepper, so it has a really nice sesame flavor. That's the long and short of it. Many vendors will add some ginger into the millet while it is cooking for a little extra bite, but otherwise this just tastes like a grainy, faintly sweet, nutty porridge. The golden millet is thick and mushy and the sesame paste is about the same consistency and color as chocolate syrup, which is a nice visual and tactile contrast. Just like with the city's chǎo gān, tradition encourages you to drink miàn chá straight from the bowl without the aid of a spoon, but you needn't feel pressured to do so. Spoon or no spoon, it's a pleasant and hearty Beijing snack.

Key words: millet gruel, sesame paste, nutty, hearty

豌豆黄

COST: 2 RMB

Wān dòu huáng, a popular springtime snack in Beijing, yellow in color and mellow in flavor, is a perfectly pleasant little treat that was a favorite of Empress Dowager Cixi. To make wān dòu huáng, a vendor begins by peeling yellow peas, which he or she then soaks and washes three separate times before boiling them peas into a mush. Once they are good and mushy, the vendor will add a bit of sugar and then fry the whole mixture for about half an hour. This part requires some careful timing, for the window between too short (mushy, not-quite-solid wān dòu huáng) and too long (cracked and crumbling wān dòu huáng) is fairly narrow. An expert vendor will recognize the right time, take them off the heat, and then slice them into rectangles or rhombuses to be served. The completed wān dòu huáng tastes like mild and sweet yellow peas and boasts a soft, almost creamy texture. This one doesn't require much effort to eat as the structure is pretty delicate—exert some gentle pressure with your tongue and wān dòu huáng virtually melts in your mouth. It may not look like much, but taste is what counts in the street food game, and on that front wān dòu huáng gives a strong (albeit non-complex) performance. Count me as a fan.

Key words: yellow peas, mild, sweet, soft

艾窝窝

Ài Wō Wō

COST: 2 RMB

Supposedly ài wō wō was a big hit in the imperial court during China's Yuan (1271 – 1368) and Ming (1368 – 1644) Dynasties. Today, centuries later, they remain a favorite in the court of popular opinion. Ài wō wō is nothing more than a snowball of sweet glutinous rice with a small amount of sweet filling at its core. The rice is steamed and boiled before being pounded and rolled into a gummy dough. As with other Chinese treats of this nature (mooncakes, for example), there are a wide variety of fillings that can be encased within. Popular options include sesame paste, jujube paste, haw paste, red bean paste, walnut paste, and osmanthus paste—the common thread, you'll notice, is that they are all sweet pastes. Whichever paste the vendor is using that day will be pressed into a blob of rice dough, which is then wrapped around into a ball with the filling at the center. Finally, the vendor will dust the ball with rice flour, making it dry and dusty to the touch. And there you have a completed ài wō wō. Although the flavor of an individual ài wō wō depends on the filling inside, you can count on them being sweet, dense, and chewy. The long and short of it is that ài wō wō balls are delightful little trifles with no ambitions to be anything more. And that's just great.

Key words: glutinous rice, ball, sweet filling, chewy

窝头

Wō Tóu

COST: 2 RMB

Cornbread in the United States is often considered a Southern food. By contrast, in China it is more often found in the North, where rice doesn't grow as well. It is a simple snack that has a fairly interesting history. For many years, as it consists of cheap ingredients, it was considered a food to eat during times of poverty. During the Boxer Rebellion, the Empress Dowager Cixi was forced to flee her life of luxury in the Forbidden City. As the legend goes, she and her entire imperial court had to flee so suddenly that they didn't have time to pack any food for their journey to Xi'an. Along the way, hungry, tired, and not wanting to draw any attention to herself, she stopped at a humble roadside vendor and bought some cornbread cones to sustain herself for a little while. The Chinese have a saying: 饱了喝蜜蜜不甜，饿了吃糠甜如蜜. It means "when you eat and drink honey, honey isn't sweet; if you are hungry, bran is as sweet as honey." This pearl of wisdom held true for the Empress Dowager; in that moment of hunger, these simple treats were suddenly tastier than all of the fancy food she ever ate in Beijing. After the Boxer Rebellion and for the rest of her reign, she continued to ask her chefs to cook her some wō tóu, giving them an imperial association. So how do they taste to somebody not starving and afraid? Pretty good. They are not destined to be a lifetime favorite for me as they were for the Empress Dowager, but they were a nice little treat. Wō tóu are nothing more than cornbread made from cornmeal,

sugar, and osmanthus. The dough is shaped into a cone, steamed, and served. It has a grainy texture and tastes like sweet corn with a nearly imperceptible floral aftertaste from the osmanthus. Like I said, wō tóu probably won't become your favorite food anytime soon, but it's fun to eat for its connection to Chinese history.

Key words: cornbread, sweet, cone, steamed

炒疙瘩

Chǎo Gē Da

COST: 10 RMB

This hearty stew is based around the chunky, gnocchi-like pasta from which it gets its name ("gē da" means "lump"). The wheat-based pasta, making up the bulk of the dish, is dense, chewy, and cut into lumps about the size of two corn kernels. Mixed in with the pasta you will find fatty beef, tomatoes, green peppers, and green onions. All components are stir-fried together resulting in a savory pasta stew. Incidentally, this dish originated with the Muslim Hui minority in Beijing, so it is generally Halal. It is hearty, dense, and quite filling—a nice way to fill up on the cheap.

Key words: pasta, dense, stew

ALSO TRY:

糖耳朵 (Táng Ěr Duo), 灌肠 (Guàn Cháng), 爆肚 (Bào Dǔ), 卤煮火烧 (Lǔ Zhǔ Huǒ Shao)

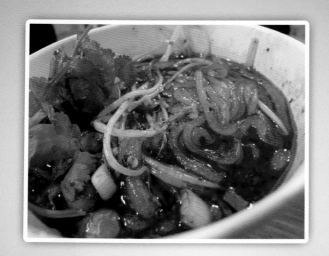

Chongqing

Chongqing

豌杂面

Wān Zá Miàn

COST: 6 RMB

This tasty Chongqing specialty, named after wān dòu (peas) and zá jiàng (ground pork stew), is at heart a fairly simple noodle dish. In an oily red broth which is moderately spicy (perhaps a 6 out of 10), you will find a mound of spaghetti-like noodles topped with ground pork, peas (chickpeas rather than green peas), scallions, and lettuce leaves. Although the soft noodles form the bulk of the dish, the key ingredients are the ground pork and peas. They are what distinguish this dish from any other noodle dishes throughout China. The pork adds a nice savory quality to the noodles while the peas provide a mellow, nutty kick. Vegetarians should take note that a meat-free version called 素豌杂面 (sù wān zá miàn) also exists. This hearty bowl of noodles—with or without pork—will satisfy your hunger, as well as any desires for spicy soup, in a trice.

Key words: spicy, noodles, ground pork, peas

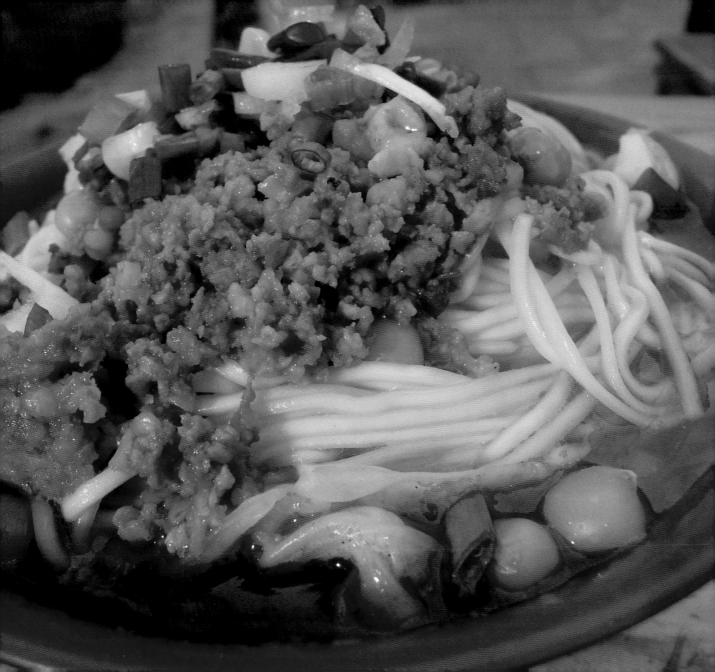

豆花

COST: 10 RMB

Dòu huā, or literally "bean flower," is one of the many variations of tofu that can be found in China. This particular variety is quite soft, similar in texture to ricotta cheese. When you order this dish, you will receive a generous portion of tofu plopped into a bowl along with some of the water it is stored in. The tofu itself is mostly flavorless, which is why it is served with a small bowl of salty or spicy dipping sauce made with chili oil, soy sauce, garlic, green onions, peanuts, and more (the exact recipe may vary from vendor to vendor). Eating this dish is a delight; the tofu and the sauce blend beautifully in one's mouth. Like some other similar foods, the tofu provides texture and structure while the sauce provides flavor.This kind of culinary teamwork is inspiring.

Key words: soft tofu, moderately spicy

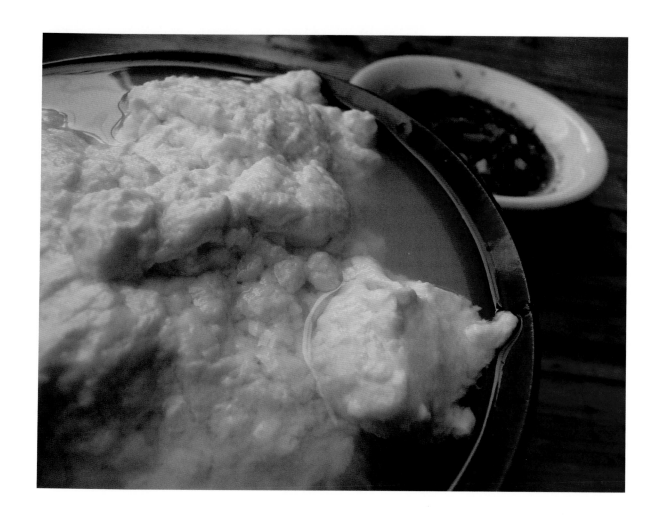

酸辣粉

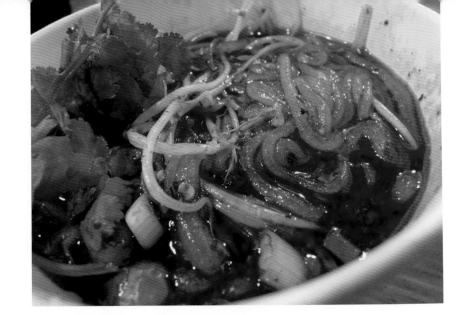

Suān Là Fěn

COST: 6 RMB

Suān là fěn roughly means "sour hot noodles," which happens to be a pretty accurate description of this Chongqing street food. The primary ingredient is the heap of noodles made not with egg, wheat, or rice, but with yam. If you are fortunate enough to see the vendors make them, you will notice that the starchy batter appears to be some sort of non-Newtonian fluid. This strange substance is pressed through a colander with many noodle-sized holes directly into boiling water. The cooked noodles look sort of glassy with a light taupe taint. They are firmer and chewier than rice noodles, to the point of being a bit rubbery. To create the final dish, the noodles are added to a broth of chili oil and vinegar, true to the name of the dish. Throw in a few bean sprouts, numbing Sichuanese peppercorns, peanuts, and scallions, and then top it with a sprig or two of cilantro and you've got your suān là fěn. Be prepared for some powerful flavors —the chili oil brings the broth up to about an 8 out of 10 on the spiciness scale, and the vinegar packs a puckering wallop.

Key words: yam noodles, spicy, sour, oily

涪陵油醪糟

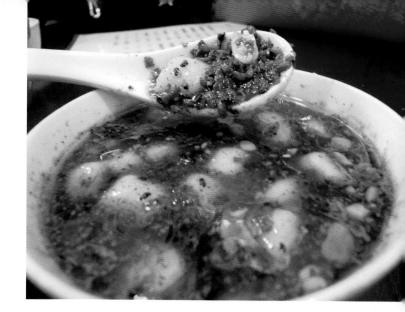

Fúlíng Yóu Láo Zāo

COST: 5 RMB

This sweet street food comes from the Fuling district of Chongqing, east of Chongqing city. Like similar dishes available in other parts of the country, the first things you see are the glutinous rice balls that fill the bowl. These soft and sticky globules are sitting in a sugary soup made with water, fermented rice, black sesame powder, sugar, peanuts, and occasionally walnuts. The soup is served piping hot, so watch your tongue. The black sesame and the ground walnuts make the soup a bit gritty, which is a nice contrast to the softness of the rice balls. The dish is quite sweet, although the sweetness is tempered a bit by the sesame flavor (which is also sweet, but in a different way) and the alcoholic kick from the fermented rice. I heard an unsubstantiated story claiming that this dish received a boost of popularity in the 1940s when Chairman Mao himself tried it, liked it, and recommended it. This may or may not be true, but any popularity it has is well-deserved. It is a delightful snack and should be near the top of your list of street foods to try in Chongqing.

Key words: sweet, glutinous rice, black sesame, rice wine

八鍋�

八鍋貼

Bā Guō Tiē

COST: 6 RMB FOR 4

Guō tiē, available throughout much of Central and Northern China, including here in Chongqing, are what people in the West might know as "pot stickers" or pan-fried dumplings, in other words (or, apparently, as "Peking ravioli" if you are in Boston). As opposed to steamed or boiled dumplings, guō tiē are fried on the bottom and then covered to steam. This gives them a pleasant textural contrast between the top and the bottom. Chongqing's unique version of these pot stickers is stuffed with pork, lotus root, celery, and—the secret ingredient—Sichuanese peppercorns. These ingredients combine winningly for a really pleasing flavor. The shell is crispy while the inside is savory. The peppercorns, of course, add their signature tingling sensation, as if your lips and tongue have fallen asleep. These peppercorns are the source of the "má" portion of the regional málà flavoring. Note that the "là" half of that equation, a spiciness usually given by the traditional chili spice, is not present in these dumplings. With all these flavors and sensations working together, Chongqing's bā guō tiē are a delicious local treat that is well worth trying if you're in the area.

Key words: pan-fried, dumpling, pork, tingling

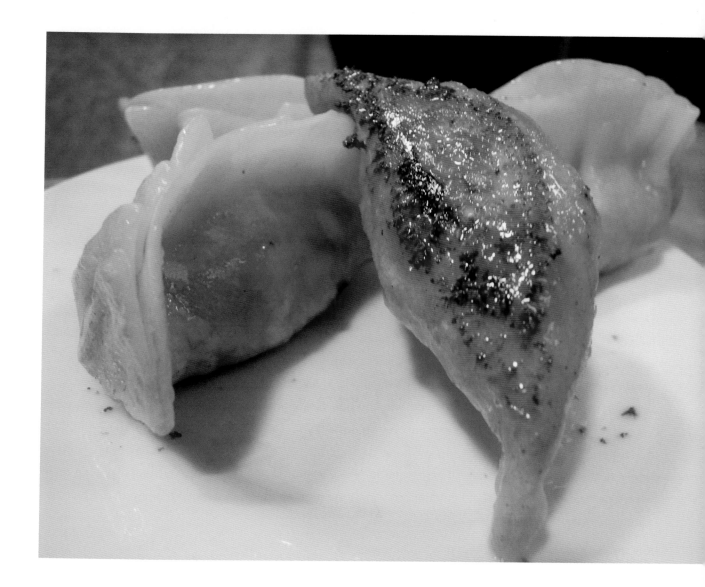

山城小汤圆

COST: 6 RMB

These glutinous rice balls can be thought of as the inverse of fúlíng yóu láo zāo. Instead of plain glutinous rice balls in a murky soup of black sesame and ground nuts, this dish features glutinous rice balls stuffed with black sesame and ground nuts in a plain, thin, and sweet syrup. The rice balls, smaller than the typical tāng yuán in other parts of China, are gummy and very soft, almost collapsing into shapeless blobs when removed from the safety of their soupy shelter. When you bite into one, it falls apart immediately, allowing the sweet and grainy black sesame paste inside to ooze into your mouth. If you like sweet and gooey foods, these glutinous rice balls are not to be missed. People in Chongqing typically eat them on the fifteenth day of the Chinese New Year to commemorate a Han Dynasty servant who allegedly saved a city from burning by giving these sweet rice treats to the fire god. Whether or not you eat them at the traditional time, these sweet rice balls are a fantastic little snack.

Key words: glutinous rice, black sesame, sweet, gooey

鬼城鸡

Guǐ Chéng Jī

COST: 5 RMB

Guǐ chéng jī literally means "Ghost City chicken," and it does indeed come from Ghost City, which you can find east of Chongqing proper in Fengdu County. Ghost City is essentially a tourist attraction dating back nearly two millennia. Its strange history began with two imperial officials from the Eastern Han Dynasty coming to the area to practice Taoism and gain immortality; they succeeded, as the story goes. If you combine their surnames, Yin and Wang, you get a word meaning "king of hell." Over time, this location became known as the place where dead souls undergo tests to enter the underworld; a number of temples, bridges, and other structures were built with ghosts, hell, and other such ideas in mind. Whether or not the local legends have anything to do with the provenance of this regional street food is unclear. What we do know is that this incredibly spicy chicken shares a name with the Ghost City. Guǐ chéng jī is nothing more than white chicken meat covered in chili and other spices. It is sliced very thin and shreds easily. The red chili powder and oil in the vendor's preparation area look ominous in their tongue-burning potential, and it turns out that that ominous look is no ruse—these seasonings are quite spicy. That's about all there is to it—if you can imagine dry chicken meat coated in spicy red chili oil then you can imagine the way this tastes.

Key words: chicken, spicy

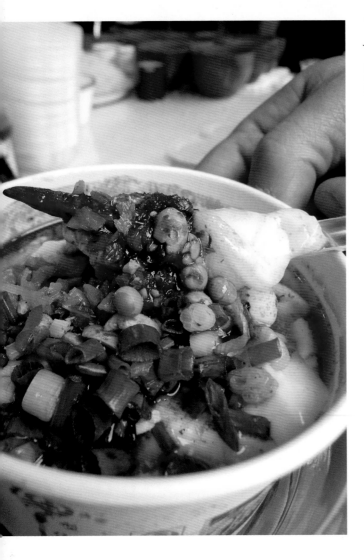

豆腐脑

Dòu Fǔ Nǎo

COST: 6 RMB

In some ways dòu fǔ nǎo is pretty similar to Chongqing's dòu huā, except much softer. It's nearly soft enough to be classified as a liquid. In fact, I might say it is more like congealed soy milk than traditional tofu. It even tastes more like soy milk than it does tofu. This nearly liquid dòu fǔ nǎo is mixed with sour vegetables, chili paste, peppers, scallions, and peanuts. There's a lot going on here, but it all works together nicely. It is gloopy, soupy, and delicious. The chili paste and peppers might scare some folks away, but you needn't be alarmed. The mild tofu flavor offsets the spiciness nicely, making this a nice gateway for people who want to experiment with the fiery flavor of traditional Chongqing food without scarring their taste buds.

Key words: very soft tofu, moderately spicy, peanuts

Fujian

Fuzhou

福鼎肉片

Fú Dǐng Ròu Piàn

COST: 4 RMB

Some foods you just don't want to see being made. Sausage is the classic example, but others abound (someone once told me that he toured a donut factory and never ate another donut in his life). There's just something about pulling back the veil of blissful ignorance and looking deep into the grotesqueries of food production that takes away some people's appetites. Readers sensitive to these kinds of things should consider ordering a bowl of fú dǐng ròu piàn without peeking behind the counter to see the unappetizing bin of pink, sludgy meat paste that becomes your meal. A vendor will scoop up a mound of meat paste, plop it down onto a flat sheet like a painter's palette, and then shave off small pieces into a large pot of boiling water. A few minutes later, the slices are scooped out into a bowl with some clear broth, shreds of seaweed, and green onions. Salty soup, chewy meat chunks, and oceany seaweed make for an excellent combination. Legend has it that fú dǐng ròu piàn was invented centuries ago when two men were courting the same woman. Unable to decide, she proposed a test reminiscent of modern reality cooking shows: each man would receive a pound of pork from which they would need to devise a satisfying meal for seven or eight people. The hero of the story decided to

chop the pork into very small pieces, mix it with starch, and shave it into boiling water, thus stretching one pound of meat into seven or eight pounds of meat paste. Needless to say, the recipe won the hearts of the dinner party and he won the heart of the girl. Today, fú dīng ròu piàn remains a tasty local street food, still capable of winning hearts after all these years.

Key words: pork paste, soup, seaweed, salty

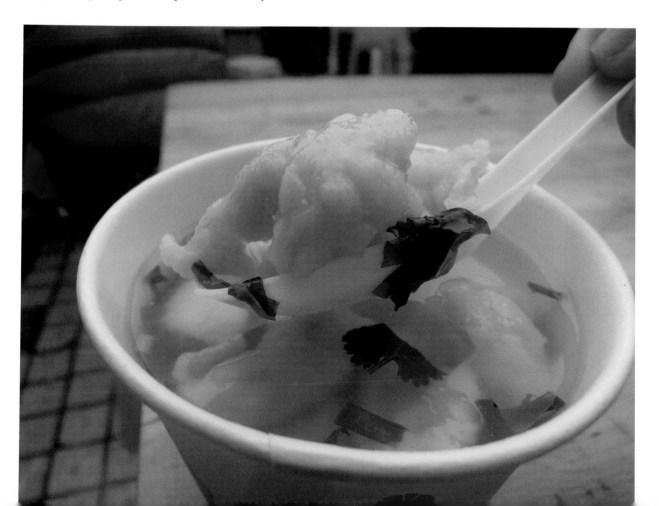

蛎饼

COST: 2 RMB

Given the city's coastal location, it's not really a surprise to find seafood making an appearance in Fuzhou's street food. In this case, we are looking at Fuzhou's famous oyster cakes. Lest it wasn't clear from their name, the seafood therein is oysters. Other than the obvious ingredient, lì bǐng also contains rice, soybeans, pork, celery, mushrooms, bamboo shoots, salt, and lots of oil. The recipe begins by soaking the rice and soybeans in water for a full day. After they have become nice and mushy, the water is drained to create a thick slurry. Into the slurry go the other ingredients, and then the batter is deep fried in a round mold. They emerge from the cooking oil looking like lumpy, golden flying saucers. With a crisp outside and a thick, battery, oyster-flavored interior, they make for a quick, delectable, and very greasy snack. (Note: On the streets of Fuzhou, you can also find a very similar snack made with shrimps instead of oysters.)

Key words: oysters, fried, rice, soybeans, greasy

ALSO TRY:

鼎边糊 (Dǐng Biān Hú), 光饼 (Guāng Bǐng), 鱼丸 (Yú Wán), 肉燕 (Ròu Yàn)

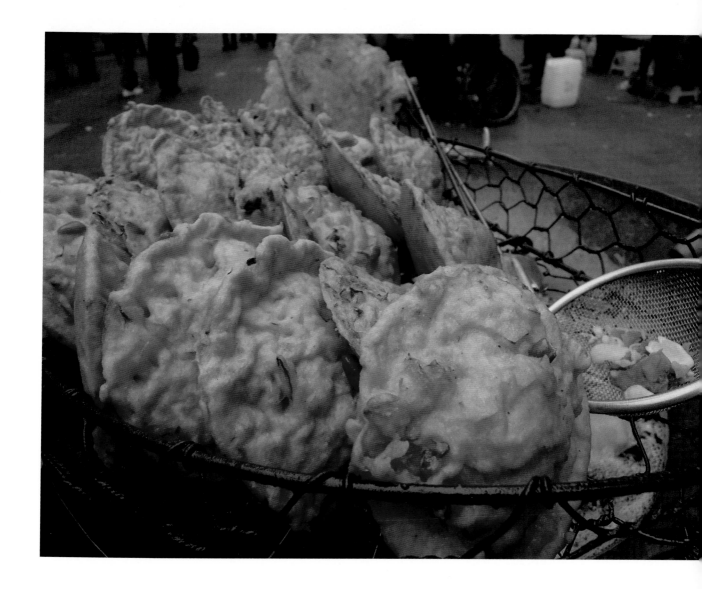

Xiamen

土笋冻

Tŭ Sŭn Dòng

COST: 5 RMB

Though it may sound unappetizing, tŭ sŭn dòng is usually translated as "sea worm jelly." Perhaps you think this is a colorful euphemism or a lost-in-translation moment, but in fact, sea worm jelly is *exactly* what this is. The primary ingredient is sipunculid worms harvested from shallow water and muddy beaches on the coast of Fujian. When they are boiled, these worms release a slimy collagen into the water that functions similarly to pectin. As the water cools, it is poured into small molds along with the worms to set like gelatin. A short while later, you've got some white sea worms suspended in small, firm, wiggly mounds of cloudy yellow-gray gelatin. They are usually covered with some chili sauce, mustard, wasabi, soy sauce, vinegar, and cilantro. The jelly itself tastes and feels like cool, smooth, unflavored (albeit mildly sour and briny) gelatin with some slightly chunkier textures within. The real flavor comes from the sauces on top, which give it a powerful, sinus-clearing kick. One of the joys of street food is finding truly novel things to eat, and a gelatin made from boiled sea worms should fit the description for most of you. For a uniquely local street food experience, you really can't go wrong with tŭ sŭn dòng.

Key words: sea worms, gelatin, spicy, mustard

厦门春卷

COST: 2 RMB

Take a moment to think of a typical spring roll: a small parcel of vegetables wrapped in a crispy golden shell. Take that image, blow it up to about eight times the size, and switch out the crispy fried shell for a softer crepe-like shell. The image you now have in your head is Xiamen's spring roll, or Xiàmén chūn juǎn (sometimes known as 厦门薄饼, Xiàmén bó bǐng). Plump and floppy, it looks more like a burrito than a spring roll. Within the thin and translucent pancake skin, you'll find shredded vegetables and sundry other items. Some combinations of carrots, cabbage, scallions, tea leaves, pea pods, celery, pork, tofu, a sweet red sauce, and (if you're lucky) some oysters pack this spring roll to the gills. It tastes fresh, healthy, and refreshing. Word on the street is that the best spring rolls in Xiamen can be found at 阿卿春卷 (ā qīng chūn juǎn), but most vendors make good ones—ask around and see what you can find.

Key words: thin pancake, roll, vegetables

花生汤

COST: 2 RMB

One of Xiamen's street food highlights is huā shēng tāng, or peanut soup. Different shops have their own recipes, but in general, you can expect exactly what the name suggests—a peanut soup. When I ordered my huā shēng tāng, the vendor cracked a raw egg into the bowl before ladling in the soup. Due to the heat of the soup, the egg was quickly cooked (mostly). The soup was full of different flavors and textures, from the soft peanuts (they basically melt in your mouth) to the viscous soup base and the silky, chewy drips of egg. It was slightly sweet, and really quite delicious. This is a must-try if you are in Xiamen.

Key words: peanut soup, eggs, sweet

沙茶面

Shā Chá Miàn

COST: 10 RMB

Possibly the most famous street food in all of Xiamen, shā chá miàn is a rich soup full of wheat noodles and your choice of other ingredients. The soup contains crushed peanuts, which give shā chá miàn its characteristic sandy gray sheen on top of an otherwise bright red soup. When you order a bowl of shā chá miàn, the first thing you have to do is determine which add-ins you want with your noodles (just like all those frozen yogurt shops that were trendy a few years ago). Choices typically include meat (chicken, pork, beef, entrails, etc.), seafood (squid, shrimps, oysters, etc.), and vegetables (mushrooms, cabbage, onions, etc.). Once you've chosen, the vendor will drop your choice ingredients and a handful of long, yellow-white noodles into the broth. The final product tastes nutty, creamy, gently spicy, and oily. It's nice to be able to customize shā chá miàn to suit your own personal tastes. That being said, you might as well go wild—everything is good in this soup.

Key words: soup, peanuts, oily, rich, creamy, meat, seafood

ALSO TRY:

海蛎煎 (Hǎi Lì Jiān), 金包银 (Jīn Bāo Yín), any seafood

60

Gansu

Lanzhou

牛奶醪糟

Niú Nǎi Láo Zāo

COST: 5 RMB

If you eat enough street food, it will soon become clear that neighboring towns usually share a lot of similar popular foods. They might claim to be different, but the differences are often small and indistinguishable to an outsider. While they all taste good, it's nice to come across something that is truly unique. Lanzhou's niú nǎi láo zāo is just such a dish. The ingredient list includes milk, eggs, fermented rice (basically like rice wine), black and brown sesame seeds, raisins, peanuts, and sugar. Individual vendors may alter the list here and there, but they should all include milk, eggs, and rice. The ingredients are combined and cooked in an iron pot over an open flame. You might consider it akin to a rich, milky soup. It's fairly thin, though the rice (very, very soft),

raisins, and peanuts add some extra texture. The sweet mixture tastes strongly of milk and egg, with a hint of wine present to add some tangy kick. I am not entirely sure whether this is considered a dessert or a meal; either way, it tastes great and offers some neat variety from the standard fare on Chinese streets. If you're in Lanzhou, you won't want to miss this one.

Key words: milk, eggs, soup, fermented rice, sweet, rich

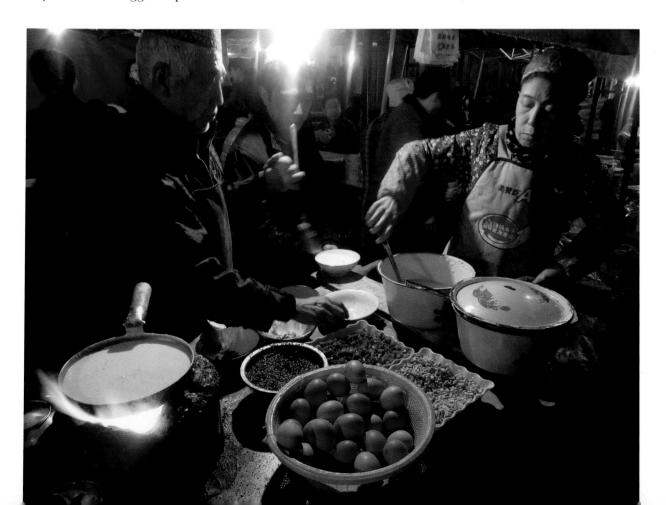

羊杂

Yáng Zá

COST: 6 RMB

Stop reading now if you don't have the stomach for sheep innards; this is not the dish for you. Yáng Zá, roughly translated as "sheep miscellany", contains nothing but sheep offal in a thin broth. Under a grimy, exposed incandescent light bulb, a vendor sits with a pile of offal, a large knife, and a cutting board. Order a bowl and he'll chop up some kidneys, livers, hearts, lungs, intestines, or stomachs and throw the whole organy mess into a shallow bowl with some spiced mutton broth and chopped garlic. The preparation is neither delicate nor refined. However, despite its simplicity, this dish is quite tasty. Each of the organs has a different taste and texture. I'm partial to the livers on taste and the kidneys on texture. The slightly spicy and sour broth and the garlic add some flavor, of course, but the organs themselves are the stars of the dish. If you aren't the type that finds offal awful, this may be just the dish to try in Lanzhou.

Key words: sheep organs, broth

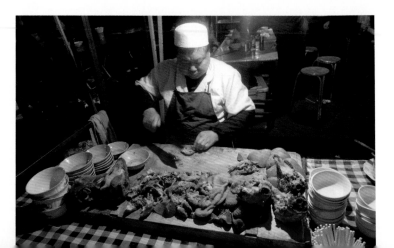

血腸

Xuè Cháng

COST: 10 RMB

Blood sausage could probably use an image consultant. It is available in wildly divergent cultures in all corners of the world, and yet how often do your friends suggest going out for a beer and some blood sausage? This is a clear case of a tasty food sabotaged by an unfortunate (albeit baldly descriptive) name. If you look past the name (or simply call it "black sausage", as some people do), blood sausage is a satisfying treat well worth some experimentation. China's version of this savory dish, xuè cháng, is more of a regional street food than a city-specific one. You can find it with minor variations in Gansu, Qinghai, Sichuan, and Tibet. In general, the sausage is made with sheep, but I've been told that you can occasionally find yak blood sausages in Tibet. Like most sausages, the intestinal casing is stuffed with the animal's meat. This blood sausage also includes some barley and the namesake blood in the filling. As a street food, blood sausages are usually cut into thick-sliced discs and stir-fried with some combination of potatoes, chives, regular sausages, chewy tubes of wheat, and barley dough. All of the ingredients are fried up in a giant pan, resulting in a fabulously savory, rich, aromatic, and greasy dish. The blood sausage is, naturally, the star of the dish, providing most of the best flavors and textures. It's a bit less salty and spicy than regular sausage, with more of a peppery flavor and a drier, grainier texture. If you are able to look past the name and give this blood sausage a shot, it offers a scrumptious reward.

Key words: blood sausage, potato, greasy

凉面

Liáng Miàn

COST: 6 RMB

The first stop for many street food aficionados in Lanzhou is a local hand-pulled noodle shop. Lanzhou's pulled noodles (lā miàn) are justifiably famous and widely available throughout China, but eating them elsewhere is not the same as getting them from their birthplace. Indeed, no trip to Lanzhou would be complete without a pilgrimage to one of the local noodle slingers. After a couple of days in the city, though, hard as it may be to believe, some travelers may start to get tired of the city's most famous dish and want a bit of variation. If you find yourself in that situation, perhaps you might consider sampling lā miàn's lesser-known cousin, liáng miàn. The name means "cold noodles," and that's exactly what you're looking at here. The noodles are the same hand-pulled ones you would find in the city's signature dish, except in this iteration they are served chilled and soupless. Cold noodles are always a surprisingly refreshing meal, and this is no exception. Different vendors put their own spin on the accompanying ingredients, so you might find some celery, cucumbers, spinach, chili oil, peppers, garlic, coriander, or other similar flavor enhancers mixed in with the noodles. The noodles are thin and slippery, like spaghetti, with the characteristic chewy consistency of hand-pulled noodles. For travelers looking for a novel spin on a well-known dish, this could be just the ticket.

Key words: noodles, cold, vegetables

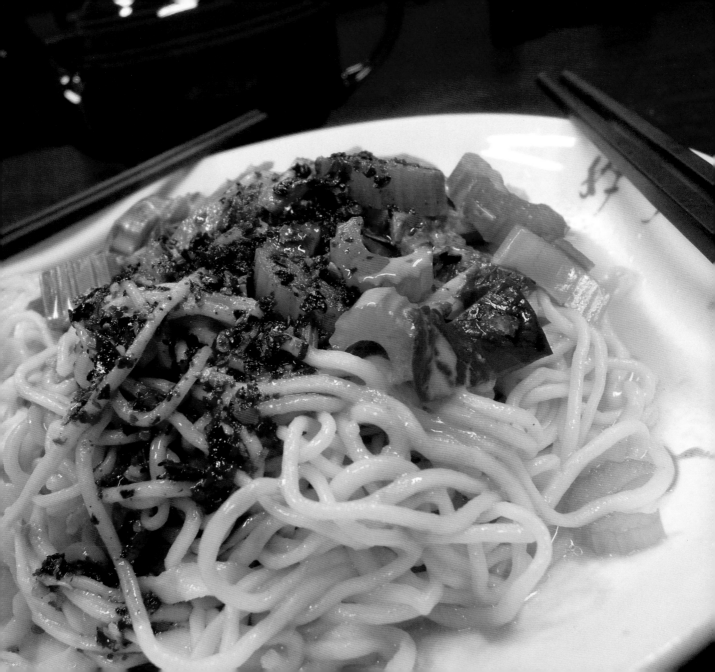

酸奶

Suān Nǎi

COST: 4 RMB

Unlike the sour Tibetan yogurt available in Qinghai and Tibet, the yogurt found in Lanzhou is a sweet and refreshing treat. This yogurt, served chilled, is bright white in color, smooth on the surface and throughout, and it boasts a firm yet soft consistency. If you like your yogurt a bit sweeter and a little less tart, then this will be right up your alley.

Key words: yogurt, smooth, cool, sweet

杏皮茶

Xìng Pí Chá

COST: 3 RMB

Although this sour, fruity tea may have originated in Dunhuang, Lanzhou's neighbor in the far northwest of Gansu province, it is not uncommon for it to be identified with Lanzhou. The simple production process involves soaking slices of peach peel in water (alternatively, some vendors use whole dried peaches and maybe some dates) and boiling it. The liquid is then filtered, sugared, and left to cool. It is served chilled, which makes it a particularly desirable beverage on a hot summer's day. This is not a traditional bitter tea—it has a pleasingly sweet and sour flavor (almost like a dried plum) with a lightly syrupy consistency. You have here a very nice way to quench your thirst in Gansu.

Key words: tea, sour, sweet, chilled

热冬果

COST: 5 RMB

Make no mistake: although it may not be as well-known as Lanzhou's famous pulled noodles, rè dōng guǒ is an important part of the city's cultural heritage. So important, in fact, that if you keep your eyes open, you might see a bronze sculpture by the artist Jin Le that depicts an old man serving rè dōng guǒ on a busy street corner. This straightforward yet delightful street food has a fun little origin story. Legend has it that rè dōng guǒ, or hot boiled pear, was invented approximately 1400 years ago by Wei Zheng, a Tang Dynasty politico. He was tending to his mother who had developed a terrible cough and stubbornly refused to take her bitter medicine. Foreseeing the wisdom of a Mary Poppins song more than 13 centuries in advance, Wei Zheng thought to create a hot sweet soup into which he could mix the medicine. His mother drank the soup and was cured of her cough. Thus was born an enduring street food that is still viewed as a cough suppressor today. The primary ingredient in rè dōng guǒ is a plump dongguo pear, native to Gansu province. The pear is boiled with some combination of red dates, tangerine peel, sugar, and ginger (recipes will, of course, vary slightly from vendor to vendor) until it is soft enough for the skin to be punctured with gentle pressure from a chopstick. A typical serving will include a whole boiled pear soaking in a bowl of the soup in which it was cooked. The pear is soft, warm, and grainy, while the soup is hot and fragrant, and they both offer a delicate sweetness that really hits

the spot. I can't speak to whether or not rè dòng guǒ actually cures a cough, but it certainly couldn't hurt. Cough or no cough, locals have been eating this for more than 1000 years. And who could blame them? It's a perfect snack to warm the body after a cold day in Lanzhou.

Key words: pear, warm, sweet, soup

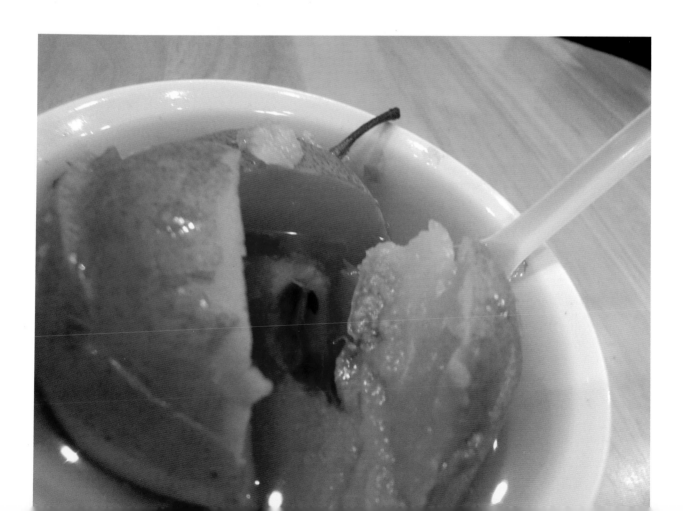

灰豆

Huī Dòu

COST: 4 RMB

Unless you're a connoisseur of world porridges (in which case we should be friends), this probably won't be the most memorable street food you try in Lanzhou. That being said, it's warm and hearty, so it ticks all the boxes for a good porridge. In most recipes, the ingredient list includes red dates (jujubes), lightly fermented peas, sugar, water, and a few spices. Mix those together and slow-cook them for about five hours, and you will have a reddish brown porridge to feast on. It's thick and chunky and very slightly sweet. Huī dòu can be served hot in the winter and cool in the summer, making it a pleasant snack throughout the year.

Key words: porridge, red dates, peas

甜醅子

COST: 3 RMB

I'll admit that this unassuming street food took me by surprise—it is much tastier than it looks! Part of the surprise for me was the unexpected (and welcome) kick of alcohol that you wouldn't know was hiding in there if you were approaching this dish for the first time. There are only three main ingredients: oats (or barley), water, and time. To prepare tián pēi zi, you must clean, soak, steam, and re-soak a bunch of oats. After that, cover them and leave them to soak and ferment for up to three weeks. In that time, the oats become soft and plump without losing their characteristic nutty flavor, while the water turns cloudy and develops a flavor not dissimilar to mild rice wine. What you receive from the vendor may look like soggy, unadorned oats sitting in a bowl of murky bathwater, so it's a lovely surprise when you take your first bite and remember that looks can be deceiving. If you're anything like me, your first spoonful will be far from your last. This tasty dish is cheap and won't fill you up too much—there's no harm in having two or three bowls in one go.

Key words: oats, fermented, alcohol, pleasant surprise

牛肉面

COST: 6 RMB

This is the ground zero of the culinary map of Lanzhou. All roads start from and lead to Lanzhou's justly famous hand-pulled beef noodles. One of the Hui minority's great contributions to Chinese culture, the noodles are available in virtually every city in the country, although they are arguably best here in Lanzhou. Watching a Lanzhou master noodle puller stretch, fold, bounce, and chop your noodles in a flurry of activity is half the fun of this dish. It's like magic—they start with a mound of dough and within minutes they have an armful of uniformly thin, round noodles. Those vendors make the process look so easy, and yet I have been assured it takes years of practice to master the technique. When you order a bowl of Lanzhou niú ròu miàn, a fresh batch of noodles are pulled just for you and flash-boiled in hot water. Using a sieve with a long handle, the cook will scoop out your cooked noodles and drop them into a bowl with some steaming beef broth, chili oil, scallions, garlic, and seasoned slices of beef. (Notice that the traditional recipe always uses beef and never pork—a good indicator that this dish was developed by Chinese Muslims.) The chewy noodles are long and slippery, resulting in a culturally acceptable slurp-fest. The broth is spicy without being overpowering—just enough to make the noodles bite back a little bit as you're eating them. Between the generous portion of noodles and the hot soup, this can be a very filling dish for less than 10 RMB. If you're exploring Lanzhou's street food, there's no excuse for missing out on the most famous food the city has to offer. Happy slurping!

Key words: pulled noodles, slippery, spicy

Zhangye

牛肉小饭

Niú Ròu Xiǎo Fàn

COST: 5 RMB

This hearty soup, typically eaten for breakfast, is a great way to warm up on cold mornings. The bulk of the dish is made up of small cubes of wheat noodles no more than an eighth of an inch on each edge. These noodle cubes are accompanied by scallions, thin slices of beef, long and wide translucent rice noodles, and a few small chunks of soft tofu. All ingredients are suspended in a salty beef broth. Every spoonful contains plenty of small wheat noodles and incredibly dense flavor. This is the kind of meal you can fill up on in the morning and go straight through to dinner.

Key words: noodles, beef, salty, filling

臊面

Sào Miàn

COST: 5 RMB

Nothing complicated here: a pile of long, flat noodles about half the width of fettucine floating in a thin brown soup. They are topped with scallions and wide slices of dry brown tofu. The noodles are slippery and soft enough to be broken with only your lips. The majority of the flavor comes from the salty broth. The tofu provides a good contrasting texture, but not too much extra flavor. It's a basic soup that tastes good and fills your belly with warmth. You can't go wrong with that.

Key words: noodles, tofu, salty

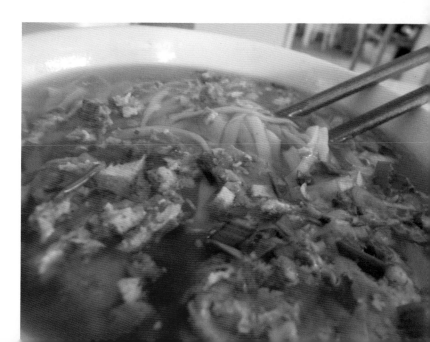

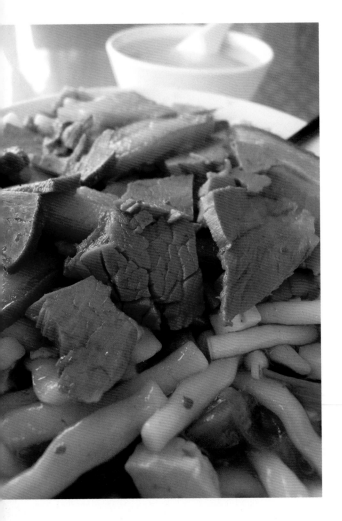

孙记炒炮卤肉

Sūn Jì Chǎo Bāo Lǔ Ròu

COST: 10 RMB

In my humble opinion, this is the best local street food Zhangye has to offer. Short, wavy, fried wheat noodles, reminiscent of German spätzle, form the base of the dish. They are coated generously in starchy, brown gravy. Mixed in with the noodles are hunks of soft tofu and a few green vegetables. The whole thing is topped off with dry, fatty slices of braised pork. This stuff tastes terrific. The pork has a rich flavor and chewy texture, which complements the gumminess of the soft noodles and savory sauce marvelously. I would have gladly had two or three bowls of this. Highly recommended.

Key words: noodles, pork, gravy

Guangdong

Guangzhou

萝卜牛杂

Luó Bo Niú Zá

COST: 5 RMB

If you make a Venn diagram with two circles, one for people who like radishes and the other for people who like cow organs, you might as well label the overlapping section "people who like luó bo niú zá." It's a stew made with beef hearts, livers, spleens, stomachs, intestines, and lungs, along with some large chunks of soft white radish. They are all boiled together in a large drum of water with a shelf near the top for organs that are finished cooking. As the various ingredients cook, the organ juices leech into the soup, which is in turn soaked up by the porous radish. When you order a bowl of luó bo niú zá, the vendor will scoop up some radish from the bottom of the barrel with a ladle, chop up some of the offal from the shelf, and dump both into a bowl with a small amount of broth. The dish you end up with is a real highlight of Southern Chinese cuisine. The organ meat can be chewy, soft, tough, sweet, salty, rich, or savory depending on which part it is. And the tender radishes have soaked up so much of the juices that they themselves are hot and juicy, retaining just enough of the piquant flavor that you look for in a fresh radish. Even the broth is tasty, having been flavored with a vendor's particular blend of spices. Put everything together and you get a wonderful combination that I absolutely recommend trying in Guangzhou—particularly if you belong to the overlapping part of the Venn diagram.

Key words: beef organs, white radish, broth

干蒸烧卖

COST: 5 RMB

Dim sum, with its vast arsenal of bite-sized snacks, is probably Guangzhou's biggest contribution to global cuisine. Most of the traditional dim sum items, although small and sometimes described as xiǎo chī, are challenging to find on the street. One exception is gān zhēng shāo mài. Although shāo mài originated in Hohhot (a city 2,500 km straight north from Guangzhou), the version that you're likely familiar with from your local dim sum restaurant is all Guangzhou. If you're not familiar with shāo mài, all you need to know is that they are wrinkly, open-topped steamed dumplings stuffed with savory fillings. Shāo mài stuffings do vary somewhat from vendor to vendor, but more often than not you'll encounter a dumpling stuffed with ground pork, chopped shrimps, flour, mushrooms, ginger, and eggs. Each one has a thin, glossy wrapper, dewy from the steaming, without much flavor of its own. Most of the flavor comes from the moist stuffing within, a rich and savory surf and turf blend. These scrumptious little treasure boxes are a delight to eat. As part of Guangzhou's dim sum tradition, gān zhēng shāo mài represent a major part of Cantonese culture. Travelers hoping to dig into that culture should not miss them.

Key words: dumpling, pork, shrimp, savory, steamed

布拉肠粉

Bù Lā Cháng Fěn

COST: 7 RMB

Moist and slippery, sweet and salty, bù lā cháng fěn is a delicious highlight of Guangzhou's street food scene. Some translators call it a steamed rice roll, which is a pretty fair description. The floppy wrapper for the roll is made from a rice, corn flour, and water slurry that is poured over a taut cloth. As the liquid seeps through the cloth, a layer of rice sludge is left on top, which is then steamed. The vendor now lays some mixture of shrimp, pork, beef, and vegetables atop the now-completed steamed rice wrapper, and then folds it over into a loose roll. A generous portion of soy sauce is dumped on top, and it is officially ready to serve. Bù lā cháng fěn tastes great and should be high on your list of foods to check out when you're passing through Guangzhou.

Key words: steamed, rice wrapper, shrimp, slippery, soy sauce

双皮奶

Shuāng Pí Nǎi

COST: 5 RMB

Remember on Seinfeld when George, noting that the skin was the best part of homemade chocolate pudding, invented "pudding skin singles"—individually wrapped skins that have been carefully extracted from the boiled pudding? Any readers out there who watched that episode and thought "yes...that is what I want," should keep an eye out for Guangzhou's shuāng pí nǎi. The name of this fantastic snack translates directly as "double skin milk". Production of shuāng pí nǎi takes several steps. First, you must bring whole milk to a boil and then let it cool, giving it a nice skin on top. Then, in a separate container, mix up some egg whites, sugar, and the boiled milk that is below the skin. Once mixed, pour that mixture back into the container holding the milk skin, which will float up to the top. Steam this mixture to create a simple, jiggly custard. As it steams, the custard will form a *second* skin around the first skin. The only thing left to do is chill the whole thing before serving. The finished shuāng pí nǎi is sweet, cool, and smooth—very refreshing. The skin provides some nice surface tension without being off-puttingly thick. Anybody who enjoys a chilled dessert would be wise to seek out Guangzhou's shuāng pí nǎi.

Key words: milk, custard, cool, sweet

ALSO TRY:

极地粥 (Jí Dì Zhōu), 云吞面 (Hún Tún Miàn), 沙河粉 (Shā Hé Fěn), 艇仔粥 (Tǐng Zǐ Zhōu),
姜撞奶 (Jiāng Zhuàng Nǎi)

Maoming

芋头丝饼 and 番薯丝饼

COST: 2 RMB

Yù tou sī bǐng and fǎn shǔ sī bǐng are basically crustless taro and sweet potato pies. If that sounds like a good thing to you, then you'd be right. Depending on your choice, one of the two types of root vegetables are chopped into slices the size of French fries, fried, and then mixed with a batter that makes them stick together in a giant clump. This clump is spread out onto a wide pan about the diameter of a large pizza and maybe two inches high. All that's left to do is to slice the pie into pieces and sprinkle some sugar on top. The final product is sweet, starchy, and full of taro or sweet potato flavor. It's like you're eating a pie made of sweet French fries. They are a unique treat and well worth trying if you happen to come across them.

Key words: sweet potato, taro, pie, sweet

化州牛杂

Huàzhōu Niú Zá

COST: 5 RMB

It may not be the most famous beef offal dish in Guangdong Province (that honor goes to Guangzhou's luó bo niú zá), but the huàzhōu niú zá found on the streets of Maoming gets my vote for the tastiest beef offal dish in Guangdong. Beef stomachs, livers, hearts, kidneys, intestines, and other miscellaneous insides are chopped into bite-sized pieces and boiled with a carefully selected blend of spices such as star anise and clove. When you order a bowl of huàzhōu niú zá, the vendor will scoop up a few pieces of cow offal along with a splash of the soup for flavor. You have the choice to add in some coriander, spicy red and orange peppers, or vinegar. Just like with pizza or hot dogs, I recommend ordering one with everything. In addition to the optional mixed-in ingredients, you can usually also get some scrumptious and complementary sides, such as similarly spiced radish, cabbage, or tofu. What makes huàzhōu niú zá so delicious is the freshness of the ingredients combined with the dynamic interplay of spicy and sour flavors. The different organs offer a rich array of textures—springy, spongy, chewy, tough, tender, and firm. Everything is so juicy and well-flavored that you've eaten the whole bowl before you know it. Folk recipes don't get much better than this local favorite.

Key words: beef offal

Guangxi

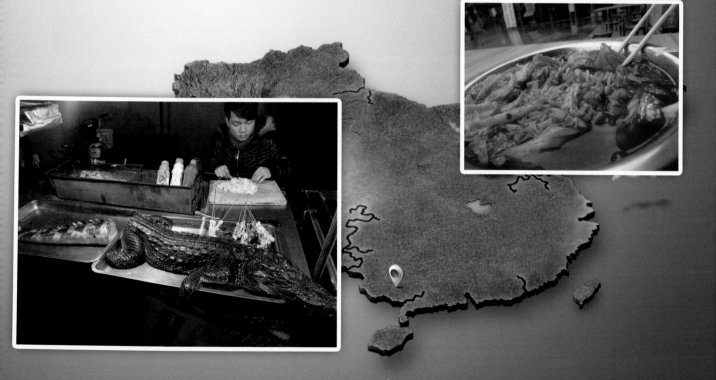

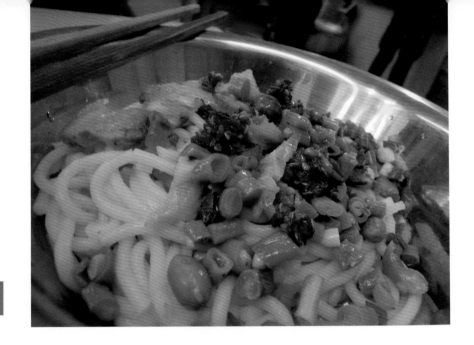

Guilin

桂林米粉

Guìlín Mǐ Fěn

COST: 8 RMB

Guilin rice noodles are one of the classic noodle dishes in China—supposedly they have a 2200 year history in the region! The bone-white noodles themselves are thick and round, like Japanese Udon. They can be served with soup or dry, each of which has its own strengths. I prefer them dry, but you may disagree. The add-in ingredients alongside the noodles vary from vendor to vendor (and from patron to patron, as you can usually choose your own add-ins). Traditional Guilin rice noodles include sour pickled vegetables, Guilin chili sauce (made with peppers, garlic, and fermented soy beans), peanuts, and horse meat (though you are just as likely to find pork or beef). Guilin rice noodles taste vinegary and spicy, with slippery, crunchy, and chewy textures mixed together. Locals often eat them for breakfast, but they are available throughout the day. This is by far the most famous street food in Guilin and is a must-try when you pass through the area.

Key words: noodles, spicy, sour, slippery

Guilin rice noodles have inspired chefs for generations. As it turns out, they have also inspired poets. A classic Chinese poem goes like this:

香喷喷，喷喷香，桂林米粉味道爽，

根根有头不见头，碗碗有汤不见汤，

不吃不是桂林人，吃了愿做桂林郎。

Loosely translated, it reads:

Appetizing fragrance travels through your nostrils,
Guilin rice noodles are scrumptious through all senses.

Each noodle has an end yet invisible;
each bowl has soup yet indiscernible.

You cannot claim to be Guilinese unless you have had this;
you would desire to become Guilinese once you try it.

So there you have it. Eat the Guilin rice noodles, and you'll wish you were Guilinese.

砂锅饭

Shā Guō Fàn

COST: 10 RMB

This traditional dish is something like a Guilin casserole. It is a mixture of rice, tofu, meat, and vegetables baked in a traditional clay pot (the "shā guō"). The specific ingredients may vary based on your own preferences. The meat can be frog, pork, beef, chicken, or horse (I recommend the frog), and the vegetables may include scallions, onions, radishes, peppers (sometimes stuffed with meat), or potatoes. Cooking in a clay pot seals in the moisture and prevents the dish from drying out. The rice in direct contact with the pot ends up crispier than the rice in the middle, adding a touch of crunchiness to the overall texture. This clay pot casserole is delicious and deserving of its place in the Guilin street food pantheon.

Key words: frog, tofu, rice, clay pot, succulent

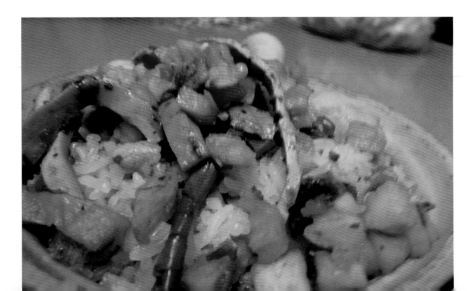

油茶

COST: 4 RMB

Yóu chá, or "oil tea," is a specialty of the Dong, Yao, and Miao people from Southwestern China, including the areas around Guilin. Though it is called a tea, it is probably fairly different than what you might have in mind. Instead of steeping tea leaves in boiling water like you normally would, the first step to make yóu chá is to stir fry some tea leaves with garlic, salt, ginger, and peanut oil. Usually, the cook also beats the tea leaves with a wooden stick to release their flavor. Once everything is good and fried, water is added and the whole mixture is boiled. The broth is then strained through a bamboo sieve to collect the greenish brown, opaque, extra-bitter base of the oil tea. Yóu chá is served in a bowl with a spoon, like a soup. Before eating, you will want to add a few garnishments. Traditionally they will include puffed rice, puffed corn, peanuts, and green onions. These airy grains will gradually soak up the liquid to become bloated and soggy. The whole thing seems to an American a bit like a bowl of cereal with bitter, oily tea instead of milk. And just like cereal, locals enjoy yóu chá in the morning. However, it is less of a meal and more of a caffeine jolt to start the day—the Guilin counterpart of the Western coffee. This unusual and distinctive street food is absolutely worth trying if you are comfortable with bitter flavors.

Key words: bitter, oily, tea, puffed rice

艾叶粑

Ài Yè Bā

COST: 3 RMB

Few edible items have a less enticing name than "Chinese mugwort." Actually, any kind of mugwort sounds pretty unappetizing. Nonetheless, what we have here is a fried Chinese mugwort patty. This CD-sized patty is made with glutinous rice flour and red bean paste and flavored with mugwort. The glutinous rice makes it chewy and sticky, the red bean paste makes it soft and gently sweet, the mugwort makes it green and bitter, and the frying process makes it greasy. It's a curious trifle of a street food with peculiar flavoring. I wouldn't go out of my way to find it, but I'd gladly eat it again if I stumbled across a vendor selling some.

Key words: chewy, bitter, sweet, glutinous rice, red bean paste

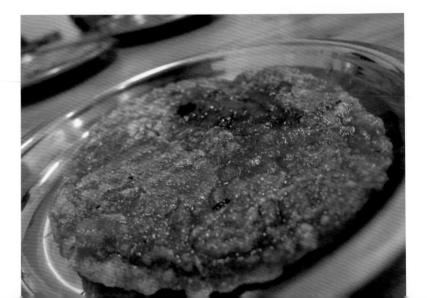

船上糕

Chuán Shàng Gāo

COST: 3 RMB

Chuán shàng gāo originated with the fisherman on Guilin's famously scenic Li River. It was designed as a lightweight and portable rice loaf that could effortlessly be stored on the boat for lunch. The base of this loaf is glutinous rice, which is mixed with leeks, lemon grass juice, cured pork, taro, and sometimes shrimp. This mixture—thick and sticky with a dark green color—is flattened, steamed, sliced, and then fried. What you, the buyer, receive is a rectangular green patty, glistening with oil. Scattered throughout are pieces of pork or taro, their flavors absorbed by the glutinous rice. There are no surprises in the taste sensations here: greasy rice, salty pork, starchy taro, and just a hint of lemongrass. I imagine that if I were a fisherman spending my days going up and down the river, this would be a very satisfactory meal. Give it a try and experience a local working man's tradition.

Key words: glutinous rice, fried, pork, lemongrass, taro

魔芋豆腐

Mó Yù Dòu Fu

COST: 5 RMB

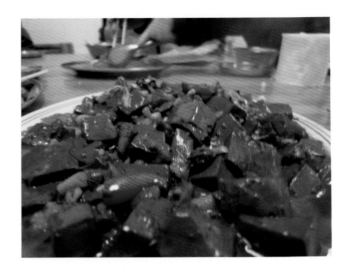

Mó yù is also known as "konjac", or more fancifully, "devil yam", "devil's tongue," "voodoo lily," or "elephant yam." It gets its colloquial name from the flower of a plant which looks like a red mouth with a red dagger of a tongue sticking straight up. The corm of this plant —its thick, underground stem—is the edible part, with a similar flavor and consistency to yam. Mó yù dòu fu (devil yam tofu) is not strictly a tofu, but a jellified block of mó yù. The process involves a lot of grinding, adding water, boiling, and steaming, but in the end, you have a quivering mass of brown devil tongue jelly. In this dish, the imitation tofu is sliced into thick squares and fried with chili peppers, garlic, green onions, and sometimes a few crumbles of pork. It's exactly as delicious as you might think. Not too spicy, not too garlicky, and extra greasy. The gummy consistency of mó yù tofu is not for everybody, so take heed if you are averse to unusual textures in your food. Give this a try if you are in Guilin—it's not every day you have the chance to eat tofu made with "voodoo lily".

Key words: devil yam, gummy, mildly spicy, greasy

96

白糍粑

Bái Cí Bā

COST: 5 RMB

Here we have a scrumptious little snack that is also widely available around the Chinese New Year. Around this time of year, many people in China eat tāngyuán (gumball-sized glutinous rice balls filled with sweet paste and soaking in soup), which shares some similarities with bái cí bā. This Guilin treat is like a larger, flatter, drier, and more fried version of that famous snack. To make bái cí bā, glutinous white rice is formed into a triangular pocket, stuffed with red bean paste or black sesame, and fried. It's crispy on the outside and chewy on the inside—a perfectly sweet and delicious way to welcome the new year.

Key words: glutinous rice, red bean paste, fried

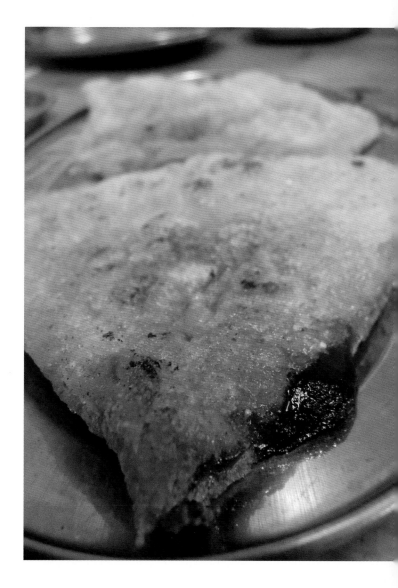

炒粉利

COST: 7 RMB

This fried noodle dish is popularly eaten around the Chinese New Year for good luck in the coming year (lì means "profit"). The thick, sticky noodles are made of rice flour dough sliced into strips. They are stir fried with garlic, cured pork strips, Chinese broccoli, and red chili peppers. Some recipes also include bamboo, celery, or carrots. Thanks to the heaping ladle of peanut oil used to fry it, the whole thing has the savory fried flavor of lo mein noodles in Chinese restaurants in the United States. The greasiness that sits in the back of your throat long after you've finished eating weighs down your stomach for hours. Outside of the flavor of oil, the cured pork adds the flavor of ham, and the chili peppers add a bit of kick. Even though chǎo fěn lì is not exceptionally tasty, I recommend eating it for tradition's sake.

Key words: greasy, rice noodles, sticky, pork

Liuzhou

螺蛳粉

Luó Sī Fěn

COST: 5 RMB

Thanks to some curious historical pigeonholing, Liuzhou is best known in China as a producer of coffins. This reputation even makes its way into a well-known Chinese saying about the key to a happy life that goes: 生在苏州，活在杭州，吃在广州，死在柳州. This translates to something like "be born in Suzhou (a city reputed to produce the most beautiful people), live in Hangzhou (a city renowned for its scenic location), eat in Guangzhou (the seat of world-famous Cantonese cuisine), and die in Liuzhou." Although the coffin industry casts a macabre pall over the city's history and culture, it is not the only game in town; Liuzhou is also renowned for its delicious snail soup, known to locals as luó sī fěn. Most people who hear about this snail soup expect at least a handful of the eponymous gastropods to lie in wait, lurking within the murky broth. This assumption is actually wrong, as snail meat is not a direct ingredient of luó sī fěn. In fact, the dish gets its name from its snail stock base. River snails and pork bones are stewed for hours with vendor-specific combinations of spices (generally including cardamom, fennel, star anise, cloves, pepper, and other similar spices) to create the distinctive broth. In addition to the snail broth, the recipe for luó sī fěn includes a thick tangle of skinny rice noodles, crispy fried tofu skin, peanuts, pickled vegetables (this is Guangxi, after all), fresh green vegetables,

and heaps of chili oil. This is usually a very spicy bowl of noodles with some intriguing contrasts of taste (spicy, sour, and faintly musty) and texture (slippery, crunchy, and soft). You can buy luó sī fěn in nearby cities like Nanning and Guilin, but if you want the finest bowl of snail soup money can buy, I'd recommend making a stop right in Liuzhou. If nothing else, it will give you something other than coffins to remember the city for.

Key words: snail broth, noodles, spicy

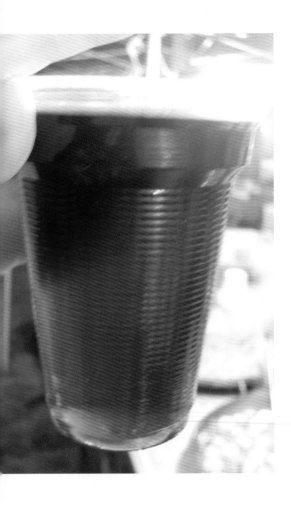

Nanning

王老吉

Wáng Lǎo Jí

COST: 3 RMB

Not so much a "street food" as a "street drink," this herbal tea, traditional in Nanning, has been mass-produced and sold throughout China in easily identifiable red cans in recent years. As it turns out, the popular canned drink now found in every corner of China shares little with the original version. Unlike the sugary canned version, the tea ladled out of large pots on the streets of Nanning is intensely, medicinally bitter. It gets its strong flavor from the tree roots and herbs with which it is brewed. Some vendors' individual brews are almost too bitter to drink, and yet that herbal bitterness makes you feel like you are consuming something that *must* be good for you. Nanning residents often drink wáng lǎo jí before a spicy meal, in order to

settle the stomach. Local wisdom suggests it is best to drink this tea straight down—no sipping allowed. If you can manage that on your first try, you have a more bitter-tolerant tongue than I.

Key words: tea, bitter

老友粉

Lăo Yŏu Fĕn

COST: 10 RMB

Lăo Yŏu Fĕn, meaning "Old Friend Noodles," is the signature street food of Nanning. It has a fun backstory and a great taste. The story goes like this: a long time ago, a man named Zhou owned a tea shop. Every day for many years an old man came to drink tea and soon became friends with Zhou. But one day, the old man didn't turn up, so Zhou went to the man's house and found him deathly ill. Wanting to do something for his ailing friend, Zhou went back to his tea house and whipped up a dish of rice noodles. With the bowl of noodles in hand, he ran back to the old man's house to feed him the new recipe. Miraculously, the noodles cured the man of his illness and he lived on for many more years. Zhou's dish became legendary in Nanning for its healing properties and is now a staple throughout the city. Old Friend Noodles typically contain the following ingredients: rice noodles, pickled bamboo shoots, garlic, fermented beans, chili, beef, and peppers. The rice noodles—long and slippery, like fettuccine—are soft when the dish is served and well-positioned for some good old-fashioned Chinese noodle-slurping. The soup base is oily and moderately spicy. To my mind, the bamboo is the most distinctive feature of this dish. The bamboo slices are a bit sour and add a firmer texture to the dish, in contrast to the noodles. Whether or not this dish has any salubrious properties, as posited by the locals, it is a tasty meal for a reasonable price.

Key words: noodles, bamboo, moderately spicy

烤鳄鱼

Kǎo È Yú

COST: 5 RMB PER SKEWER

There is no misidentifying this street food. Really, you can't miss it. Just look for the vendors with an entire alligator sitting on their cart. For 5 RMB, you are served a freshly grilled and seasoned skewer of either alligator meat or alligator skin. To be frank, the meat tastes like any other grilled skewer of meat in China. It has a greasy, charred flavor to it, is a bit stringy, and feels somewhat gritty on your tongue from the chili powder applied after grilling. It tastes good, but is nothing special. The real treat here is the alligator skin. The texture is soft and chewy, and it has a rich, fatty taste. The chili powder adds a tiny amount of saltiness and spiciness to it. It's not particularly filling, but it is a tasty treat. On an ethical note, several sources assured me that the alligators sold as food in Nanning come from alligator farms, where they are raised for meat and leather. Nonetheless, the species in the wild is not doing very well, so if you are nervous about accidentally eating an endangered wild animal, you might err on the side of caution and skip this one.

Key words: alligator, greasy, grilled

乌鸡汤

Wǔ Jī Tāng

COST: 8 RMB

Wū jī tāng literally means "black chicken soup," and that's exactly what you can expect if you order this. The chicken meat in this soup comes from Silkie chickens, known for their dark blue or black skin and meat. They are eaten regularly in Asia, but less so in the West. Though they look quite different, they taste virtually the same. In fact, they often taste a bit better than chickens in the United States because Silkie chickens—which fare poorly in cages—are almost always free-range. This soup is extremely simple: chicken broth with big chunks of black chicken, skin and bones included. The broth is oily and golden yellow: exactly like chicken soup in the U.S. The skin and meat fall right off the bone, succumbing to the gentlest bite. Wū jī tāng is often considered a "cold weather food," so look for it in the winter. It's a nice way to warm your body on a cold, rainy morning in Nanning.

Key words: black chicken, soup

螺蛳

Luó Sī

COST: 3 RMB

Luó sī, or river snails, are so small and labor intensive that it would take forever to fill up on them. This makes them impractical as a meal, but perfect as a snack while you sit around and shoot the breeze with your friends, which is exactly how they are eaten in Nanning. The snails are cooked in oil and chili and served still in the shell—you will need to use a toothpick to dig out the meat. The part you should eat is a ball of meat about the size of a pea (be careful not to eat the tail, as that contains the snail's digestive tract and any excrement that had not been expelled when the snail died). The small bite of meat has a gritty texture and seafoody taste, which is actually quite enjoyable. It's virtually impossible to eat them without getting your fingers greasy, so have napkins ready. This is neither a fast food nor a filling one. It does, however, exquisitely serve its purpose as a shared snack between conversational partners.

Key words: snails, greasy, messy

Guizhou

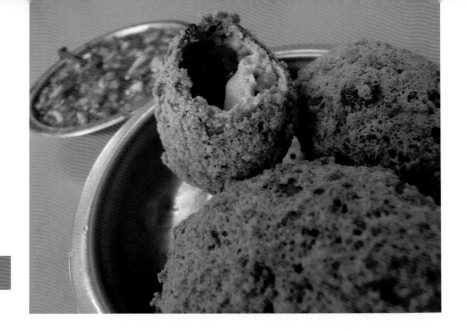

Guiyang

豆腐圆子

Dòu Fu Yuán Zi

COST: 5 RMB

Variations on tofu are a dime a dozen in China, from the stinky tofu of Changsha to the dòu fu nǎo of Northeastern China. This lesser known variation, native to Guiyang, is a worthy member of the Chinese tofu pantheon. A plate of dòu fu yuán zi looks a bit like a bunch of fried goose eggs. Their outside appearance gives little indication of their taste. When you bite through the delicate, crunchy exterior, you'll find that it is about 2/3 hollow. The other third of the inside is made up of a very soft grayish tofu, sour with the taste of fermentation, which layers nicely with the crispy shell. Dòu fu yuán zi is served with a dipping sauce that is spicy, oily, and full of the herbal bite of zhé ěr gēn (折耳根). The mix of flavors and textures is rather complex; readers are advised to savor the experience. This unusual dish is quite traditional locally and should be near the top of your to-eat list in Guiyang.

Key words: fermented, tofu

炸魔芋

COST: 3 RMB

Mó yù, or "devil yam" (see mó yù dòu fǔ entry in Guilin), gets its charming name from the dagger-tongued flower of the plant. In general, devil yam tastes fairly similar to the typical yam. As a street food, its value largely depends on the way an individual vendor cooks it. It is cut into cubes and fried, perhaps with some garlic or chili. Like other starchy foods, the flavor is somewhat bland on its own, so the other ingredients tend to dominate. Think of it as a blank canvas that provides structure and texture. The flavor comes from elsewhere. As it is served in discrete cubes, this is a nice dish to share with friends over a good conversation.

Key words: starchy, fried, devil's tongue

One ingredient that is almost unique to Guizhou Province is 折耳根 (zhé ěr gēn), the root of the plant houttuynia cordata. This plant grows throughout Southeast Asia, and most regions use the leaf for cooking purposes (it apparently has a fishy-minty taste). Choosing to buck the status quo, Guizhou nixes the leaves in favor of the root. The strong medicinal taste of this root is instantly identifiable in many native dishes of this region, including many of Guiyang's terrific street foods. Taste it once and you'll recognize it every time it shows up.

丝娃娃

Sī Wá Wa

COST: 10 RMB

Sī wá wa is perhaps the most characteristic street food in Guiyang. It is a staple in Guizhou-style restaurants all over the country. Naturally, though, it is best in the city where it was created. Sī wá wa can basically be thought of as a make-your-own spring roll. When you order sī wá wa you receive a tray filled with small dishes of ingredients and some thin pancakes. To eat, you must first assemble your food. Hold a single pancake in one hand and load it up with whatever ingredients you like. Some of the many possible options include rice noodles, pickled radishes, sour vegetables, cucumber strips, mushrooms, bean sprouts, cilantro, and the omnipresent (in Guizhou) zhé ěr gēn. Once the pancake is filled to your satisfaction, you simply roll the pancake up like a swaddled baby (the name literally means "silk baby") and eat. There are literally thousands of possible combinations, so you can come up with a new concoction with each separate pancake. Sī wá wa is a dish best shared—order up a big tray with a big pile of pancakes and snack to your heart's content.

Key words: rolls, variety, self-assembled

绿豆汤

COST: 3 RMB

This simple soup made with green beans (more like lentils or peas than Western-style green beans) makes a refreshing snack between meals. The thin and syrupy soup is served chilled. In addition to the green beans, you will find some scattered peanuts and sesame seeds floating on top. It's sweet and cool—just right for a summer evening.

Key words: sweet, syrupy, green beans, soup

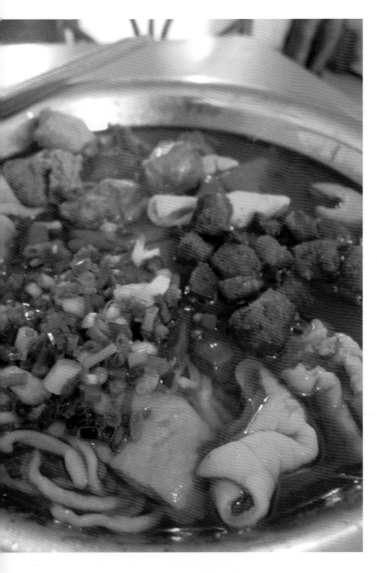

肠旺面

Cháng Wàng Miàn

COST: 8 RMB

This Guiyang specialty is quite tasty and definitely worth a try. The base is not particularly unusual in China—an oily, red soup with silky noodles and some meat (pork or chicken). The distinguishing feature here, though, is the generous portion of pig intestines mixed in. The intestines add both texture (thick and chewy) and taste to the dish, moving it from ordinary to—well, not extraordinary, but pretty darn tasty. The silky egg noodles closely resemble ramen noodles. Another odd feature is the handful of crouton-like bits on top that add an unexpected crunch to the bowl of noodles.You'll get slippery, chewy, soft, and crunchy textures all in one dish. These spicy noodles will fill you up handily, making them a very fine choice for a lunch or dinner in Guiyang.

Key words: intestines, ramen noodles, spicy, oily

炸洋芋

COST: 3 RMB

Take note, ye unadventurous eaters out there: zhá yáng yù is capable of pleasing even the most cautious of palates. The primary ingredient here is potato. Peeled and cubed, the potato chunks are fried like breakfast potatoes in the West. Just before it is served, you have the option to have the sticky potatoes rolled in a málà chili powder and zhé ěr gēn. People who don't like spicy food should, of course, forgo this step. As you might expect, it tastes like fried potatoes with spicy chili, numbing peppercorns, and herbal roots—which is to say it tastes great.

Key words: fried potatoes, málà, snack

黔西黄粑

Qiánxi Huáng Bā

COST: 5 RMB

These caramel-colored glutinous rice cakes are found in large loafs out of which the vendor can slice and weigh your serving. It is made with glutinous rice, sugar, and soybeans in a complicated procedure that involves steaming and fermenting. The texture is firm yet spongy. It is also sticky, but not so sticky that you would need a napkin to hold it. If you look closely, you can see individual glassy grains of rice speckled throughout the cake. It tastes slightly sweet with an interesting mix of spices. Inexplicably,

something in this item evoked a strong sensation of "Christmas" in my brain. Some of the spices were behind this nostalgia, I suspect—similar flavors to a Christmas pudding.

Key words: glutinous rice, slightly sweet, Christmas

恋爱豆腐果

Liàn Ài Dòu Fu Guǒ

COST: 5 RMB

The provenance of the name "lovers' tofu" is not immediately clear when you look at liàn ài dòu fu guǒ. One story says that it was invented in Guiyang during World War II. Air raid sirens were common; citizens frequently found themselves waiting for the all-clear. These long hours in close quarters were fertile ground for two things: love and hunger. Love has a way of taking care of itself. The hunger was staved off by the creation of this dish. As new romances flourished, the lovers ate this tofu, giving it its distinctive name. Whether or not this story is true, lovers' tofu remains a popular dish to this day in Guiyang. Other than the name, the distinguishing characteristic of this variation of tofu is that it is stuffed with other ingredients. The tofu itself is somewhat unremarkable: crispy, yellow exterior; very soft, white interior. This relative blandness is probably wise, as the stuffing packs a powerful punch. Each vendor's recipe for the stuffing is different, but most will include chili powder (typically of the málà variety), ginger, scallions, soy sauce, garlic, and a generous handful of zhé ěr gēn. Notice that each of those ingredients has a strong taste on its own. Put them all together in one concentrated melange and it is very strong indeed. In fact, some might say that it skirts the border of "too powerful to eat." If you are a fan of strong flavors, you enjoy experimenting with street food, or you want to take part in a lovers' tradition with your beloved, this may be just the dish to try in Guiyang.

Key words: tofu, powerful flavors, zhé ěr gēn

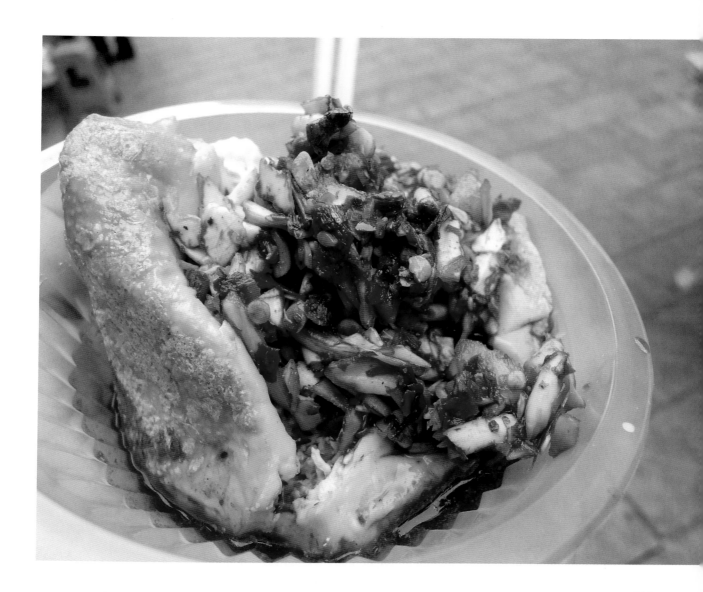

洋芋粑

COST: 3 RMB

Since Guiyang's qiánxī huáng bā reminded me of Christmas, it seems somehow fitting that another regional street food should remind me of another major December holiday. Latkes are indisputably a culinary highlight of Hanukkah. Does China have its own version? Yes—Guiyang's yáng yù bā, or "potato cake." It is not a complicated dish; it is made of mashed potatoes fried in a disc. Naturally it is served with a málà chili powder for dipping. Due to the greasy exterior of the potato patties, the powder attaches itself with little effort, giving the potatoes a nice kick (with a tiny bit of málà's distinctive numbing).

Key words: greasy, potatoes, málà

糕粑稀饭

COST: 5 RMB

This thick, viscous porridge is another in the line of "choose your own ingredients" street foods. As you watch, the vendor will mix hot water into a small mound of lotus root powder (or a powder of a similarly starchy food) until it takes on the characteristic texture of gāo bā xī fàn. At this point, you have the option of throwing in any mix-ins you like. Choices include red beans, peanuts, raisins, sesame seeds, sunflower seeds, candied fruits, sugar, and more. No matter which ingredients you choose, this is a warm and sweet concoction with the texture of rubber cement. It's a challenge to eat a whole bowl as it weighs heavily in your stomach. Nonetheless, it's a quick snack that can be delightfully tailored to your whims.

Key words: viscous, starchy, sweet, warm

Zunyi

鸭溪凉粉

Yāxī Liáng Fěn

COST: 5 RMB

This variation on liáng fěn—one of many in China—originates in a town about 50 km outside of Zunyi. Like all liáng fěn, the recipe for this dish begins with a starchy paste (here made of dried peas) that is left to congeal into a firm, jelly-like substance. All liáng fěn is also sliced to resemble noodles, though most don't do a great job at disguising themselves. Here in Zunyi we have an exception—if you didn't know this was liáng fěn, you would have no idea that it wasn't a bowl of rice noodles. The starchy bone-white pea paste is sliced into long, thin strips that wend their way hither and thither in your bowl. On top of the pseudo-noodles you will find fried soybeans, a sprinkling of green onion, and a mildly spicy chili-vinegar sauce. The "liáng" in liáng fěn means "cool," which is precisely how the noodles are served. The coolness is a lovely contrast with the heat emanating from the chili sauce, resulting in a refreshing dish appropriate for cold and hot weather alike. This unassuming little bowl of pea starch noodles is a great variation on a common Chinese street food and is worth seeking out when you're in Zunyi.

Key words: pea noodles, cool, chili sauce, soybeans

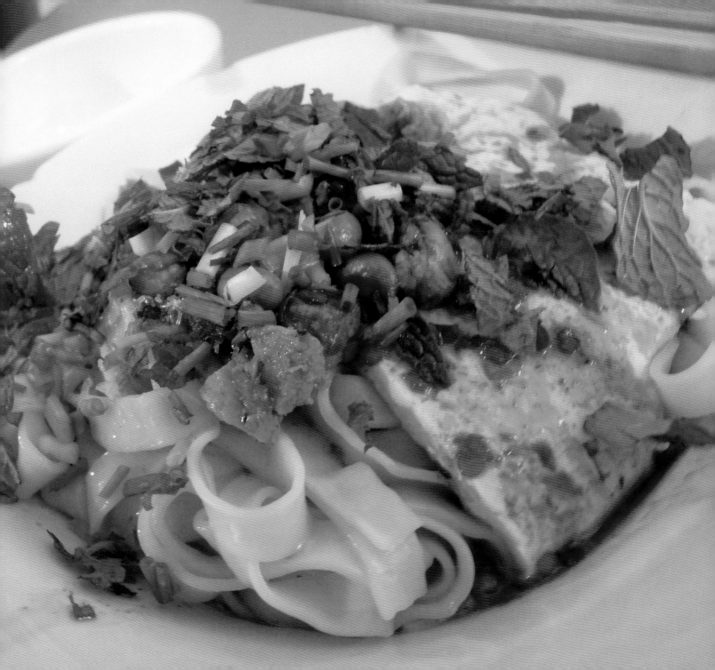

烙锅

COST: 15 - 30 RMB

If you know a few things about Chinese food, you are probably familiar with hot pot. Different regions in China have their own ways of preparing hot pot, but few stray from the basic idea of using a large pot of broth to cook raw vegetables or meat right at your table. Unlike nearby cities like Chongqing and Chengdu, Zunyi does not have its own take on hot pot—what it does have is lào guō. Lào guō is not directly related to hot pot, but it does share similar characteristics. You might think of it as the stir fried version of hot pot. Instead of a pot full of broth, you have a wide, flat pan with an indented inner core designed to come in direct contact with the little stove. Just like hot pot, the ingredients are served raw. They can be anything from lotus roots to carrots to beef to fish. The ingredients are deposited a few at a time into the inner core, where they are stir fried in vegetable oil seasoned with red pepper (the oil is often considered the most important part, so individual vendors take their recipes very seriously). When the ingredients are suitably cooked, they are pulled from the core and left on the side of the pan, from which anybody at the table is welcome to help themselves. This is, of course, a communal dish, one well-suited to long meals full of conversations with old friends. While you eat, there is always more food hissing and popping in the pan, allowing meals to go on for as long as you like. Great street food with great friends—we should all be so lucky.

Key words: fried, special pan, spicy, meat, vegetables

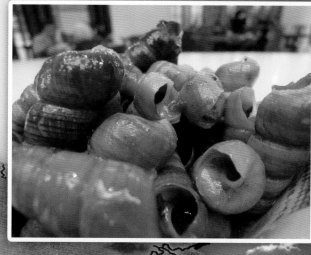
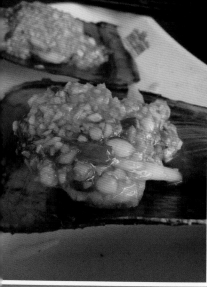

Hainan

Haikou

丁螺

Dīng Luó

COST: 5 RMB

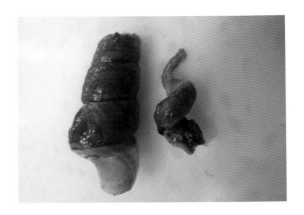

Hainan is often described as the Hawaii of China. The comparison is reasonably apt—Hainan is a tropical island with a traditional culture that is different than the mainstream culture of China (although, like Hawaii, a certain number of mainlanders have migrated there and brought their culture with them). As one might expect from an island province, there is a lot of great seafood to be had in Hainan. One great seafood of the street food persuasion available in Haikou is ding luó, translated as either whelks or oncomelania. The whelks are cooked in an oily, peppery broth in a large pot. As they are ladled out of the pot, they make a satisfying clattering noise, like pebbles dropped into a porcelain bowl. Although there isn't much to the presentation other than the shells themselves, eating this dish is a great pleasure for the senses. All you need to do is put your mouth over the top of the shell and suck. Before you know it, a small spiral of snail meat (and some spicy broth) has rocketed into your mouth (some might take a bit more sucking than others...I have the most trouble with the larger shells). The snail meat is seafoody, chewy, and a tad gritty. The broth has bits of pepper in it and is a salty, oily, spicy accompaniment to the tiny meat. This unusual street food is a lot of fun to eat.

Key words: whelks, spiral, chewy, spicy, gritty

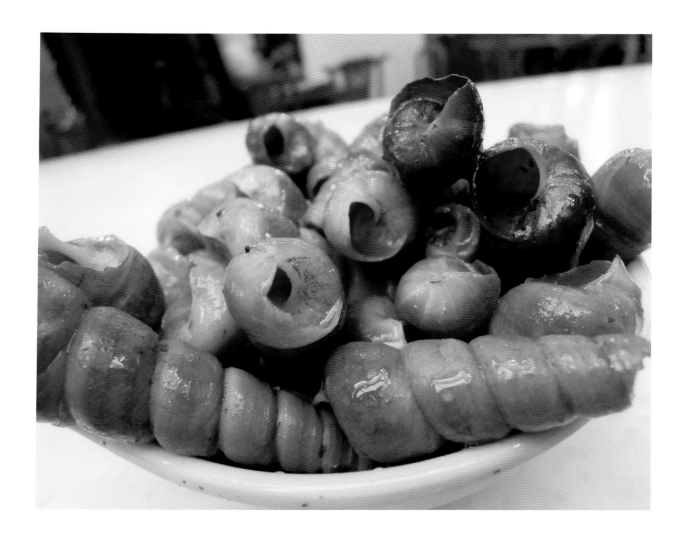

翻砂芋头

Fān Shā Yù Tou

COST: 5 RMB

One of the most exciting culinary revelations for me the first time I visited China was the astonishing number of ways that clever chefs could prepare taro. I grew up in the Midwestern United States, an area that tragically sees little to no taro production, so I was largely unfamiliar with this humble tuber. In China, I quickly learned that any food product that seemed to be unnaturally purple in hue probably had taro in it, which was as good a sign as any that I would enjoy it. Anything taro was added to (bread, stir-fries, candy, pastries—anything) would take on some of that subtly sweet, starchy taro flavor, and I was hooked. So you can imagine how pleased I was to find this sweet taro snack on the streets of Haikou. The preparation is simple: a whole taro is sliced into square columns, each about the length and twice the width of a finger, and then deep-fried like French fries. In a separate pan, the vendor will prepare a simple syrup made of sugar and water. Into that crackling syrup go the taro strips so that they can be well and truly coated with sugar. That about does it—the final product, fresh out of the fryer, has a crispy and bumpy sugar shell containing soft and crumbly sweet taro pieces. More often than not, an order will come with five or six sugary taro fingers, which should give you enough to share with a friend (or, if you're like me, not...). I recommend getting a handful of them after your dinner in Haikou—they make for an excellent dessert.

Key words: taro, sweet, fried, crumbly

椰子饭

COST: 5 RMB

As I've covered in several other entries, Haikou has a well-deserved reputation for being chock-full of terrific fresh seafood, a natural result of the city's proximity to the ocean. Of course Haikou isn't the only seaside city; a number of other cities have also earned accolades for their seafood. One thing that those other cities *can't* usually offer, however, is coconut, which is why yē zi fàn is such a uniquely Hainanese treat. Yē zi fàn only has two main ingredients, both abundant in tropical Hainan: rice and coconut. Milk and sugar are added as secondary ingredients to enhance the flavor. To make yē zi fàn, the vendor opens up a hole on the top of a coconut, pours out the contents, and fills the cavity with glutinous rice, milk, and sugar. The hole is plugged before the coconut is simmered for several hours, allowing everything inside to cook and absorb the fresh coconut flavor. When it is ready, the vendor will slice the coconut into wedges with the rice still sticking to the bright white coconut flesh. You end up with little coconut boats stuffed with subtly sweet sticky rice. The textures of the chewy rice and crunchy coconut contrast well. With its strong coconut flavor, it's impossible to eat yē zi fàn without being keenly aware that you are on a tropical island. Embrace that feeling, my friend.

Key words: coconut, rice, sweet, milk

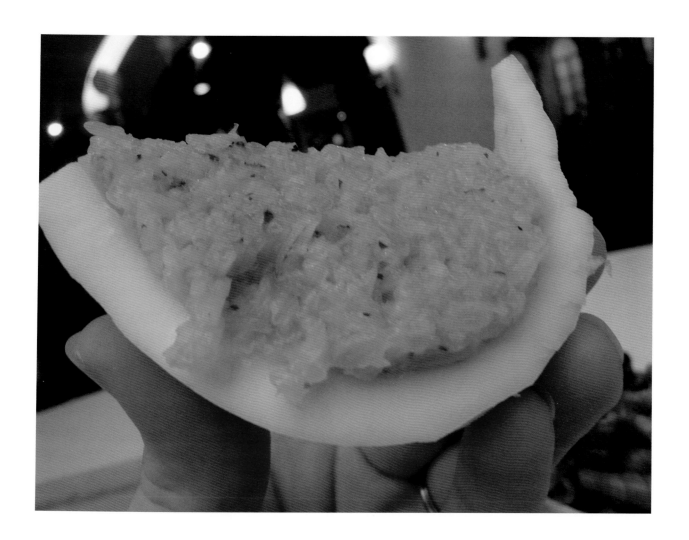

带子

Dài Zi

COST: 5 RMB

More seafood? More seafood. What else do you expect from an island province? In this case the sea-beast that has been scooped up from its home in the shallow waters near Hainan only to end up on your plate is atrina pectinata, a local species. Some readers might be wondering what an atrina is. An atrina is a primitive, bivalve mollusk noted for its peculiarly long, wedge-shaped shell. Their unusual shape helps them anchor themselves in the ocean. By burying the pointed end into the sand or mud, they can leave their top half exposed without running the risk of being tossed around by the ocean current. One of the many local ways to prepare atrina involves lots of garlic and oil, along with a handful of cabbage and green onions, and served on the atrina's dramatic shell. Atrina meat is delicate and silky, with a mild taste that's almost completely hidden behind the powerful garlic flavor. The long wedge of the shell, once used as an anchor in the sand, now makes a perfect handle with which to pick up the atrina and slurp it down (or you can use chopsticks if you're feeling civilized). Seafood lovers must put this on their lists— dài zi are a decadent and tasty ocean snack that you won't want to miss.

Key words: atrina, garlic, oily, delicate

毛蚶

Máo Hān

COST: 8 RMB

People who come to Haikou for the seafood will never leave disappointed. Here is another entry in the local sea/street food canon: máo hān, or "hairy clam." These small clams have ridged, alabaster shells that are coated with a dark brown fur (the source of their evocative name). The creature inside is orange or yellow and looks like a tongue. Máo hān can be prepared in a number of ways, but I've chosen to highlight a basic steamed version. Like any clam, they are rubbery and chewy, with a strong seafood taste. If you like seafood in general, you'll enjoy them. Máo hān embodies everything great about seafood for those who can't get enough of it, and vice versa for those who dislike seafood. If you find yourself in the prior category, you won't want to miss these hairy clams. They are fresh as can be in Haikou and make an excellent treat. One order will yield a big pile of máo hān, so bring a friend, get your prying fingers ready, and snack away.

Key words: clam, rubbery, seafood flavor

140

生蠔

Shēng Háo

COST: 4 RMB

One final seafood entry for Haikou: oysters! Once again, they can be prepared any number of ways; I've chosen to highlight the one pictured here. The oysters are baked on the half-shell with the same garlic and oil sauce as Haikou's dài zi. There are lots of textures and colors to look at here, making this a feast for the eyes as well as the taste buds. The outside of the shell is knobbly and rough, while the inside is sleek and nacreous. The oyster meat is dressed with a shiny, golden yellow sauce. Anybody who has ever eaten oysters with garlic should be able to imagine exactly what this tastes like. The oyster is slimy and chewy, with a nice oceanic taste that is enhanced by the powerful garlic flavor. Among the fresh seafood available in Haikou, shēng háo is a real highlight—this is what many are looking for when they come to Haikou for seafood.

Key words: oyster, garlic, oil

海南粉

COST: 6 RMB

Hǎinán fěn (Hainan rice noodles) is one of the island province's most distinctive street foods. It is hugely popular with Hainanese citizens, many of whom would not let a morning go by without having a bowl of Hǎinán fěn. One of the major attractions of Hǎinán fěn is how customizable it is. When you order a bowl of these slender, pearl-white rice noodles, you are basically giving yourself a blank canvas to work with. Each vendor has bunches of different add-ins for the plain noodles, and you can decorate your bowl however you like. Ingredients include dried fish, shrimp, peanuts, bean sprouts, fried noodles, bamboo, shredded meat, sesame oil, pickled vegetables, and lots more. In addition, the vendor will pour on some clear conch broth, which gives the noodles a distinctive seaside flavor, and a salty, sour brown sauce, which tastes a little bit like the standard brown sauce in American Chinese food. Hǎinán fěn has several local variations that arose in different cities and villages on the island, so you may not get the exact same dish from one vendor to the next. All of them, though, are slippery and slurpy and full of enticing flavors and aromas. You really can't go wrong with Hǎinán fěn.

Key words: rice noodles, conch broth, peanuts, vegetables, meat, customizable

猪血汤

COST: 3 RMB

Let's be honest with each other for a moment. No matter how enthusiastically I might tout their pleasures, there are certain street foods that are difficult to convince Western travelers to sample. I harbor no illusions about that. It's probably safe to say that zhū xuè tang, or pig blood soup, is among those "tough sell" foods. No matter that it has an interesting texture and a rich, meaty taste—some people will only read as far as "pig blood" before they decide to pass on this one. And that's okay; not every food is going to be a winner for every dinner. Those of you who are willing to keep an open mind, though, should definitely consider trying it out. It is not uncommon to see dishes made with animal blood in different parts of China, including cow blood, chicken blood, duck blood, sheep blood, and probably many others. They almost always look like blocks of rusty red tofu, and this one is no exception. One bowl will hold about fifteen or twenty blood cubes, as well as a salty, syrupy soup base and some sour cabbage. The blood has a smooth, slippery surface with a firm yet porous tofu-like texture. When you bite into one, rather than getting mushy or crumbly it bursts into smaller discrete pieces, like a certain cartoon mouse trying to hack an enchanted broom to pieces but only ending up with hundreds of smaller brooms. The blood has a rich, meaty flavor, which is paired well with the sour and salty soup. Zhū xuè tang is not destined to be a favorite of many travelers, but if you're up for trying it, I think you'll be pleasantly surprised. Even if you're not a huge fan, it's an interesting taste of the local culture in Haikou, and that's all one can ask for in a street food.

Key words: pig blood, soup, salty, sour cabbage

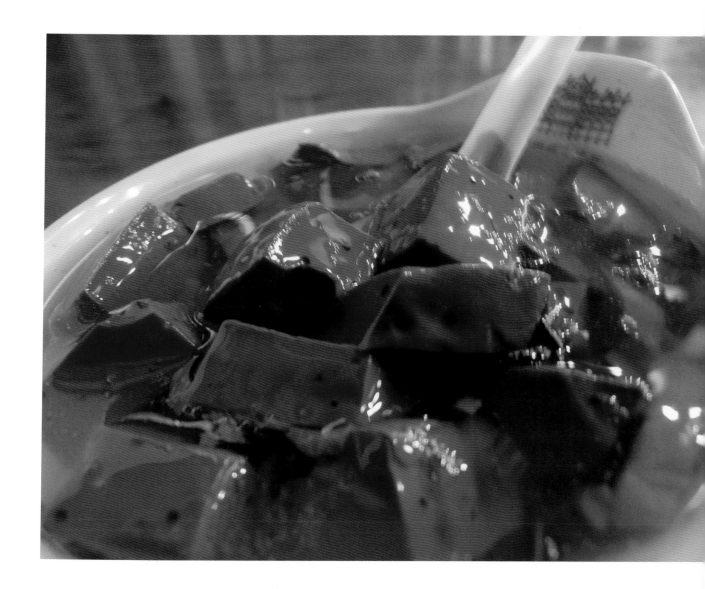

If you're having trouble finding some of Haikou's traditional street foods, you might consider checking out the Haikou Qilou Snack Street (海口骑楼小吃街). Established by the local government at the end of 2010, this indoor complex is devoted to serving (and thereby preserving) Hainanese street foods. It may not be as authentic or fun as stumbling across a vendor on a side street, but if your goal is to sample as many local dishes as possible, this place can't be beat.

Hebei

Baoding

驴肉火烧

Lǘ Ròu Huǒ Shao

COST: 5 RMB

In certain parts of China, they have a saying: 天上龙肉，地上驴肉. Roughly translated, this means "In heaven, there is dragon meat; on earth, there is donkey meat." That's right—the donkey, perhaps the humblest of all equines, is apparently the closest we have on earth to the ambrosia of the gods. If this seems unlikely to you, then you obviously haven't eaten lǘ ròu huǒ shao, a sandwich that makes a compelling argument in favor of donkeys as food. Historical records suggest that the regional tradition of eating donkey meat goes back to the Ming Dynasty (1368–1644). During the reign of the Yongle Emperor at the beginning of the 15th century, some starving military men in dire straits resorted to slaughtering their horses and eating the meat with bread. They were surprised to find that this was an excellent combination, and the custom soon spread to local peasants. Of course horses were not cheap, and the 15th-century peasants could not afford to keep up this practice for very long. In an effort to cut costs, they switched to the more economical donkey meat and found that it was even *more* delicious than horse meat. The rest, as they say, is history. To this day, donkey meat sandwiches are a popular repast in Baoding (as well as Hebei at large). Lǘ ròu huǒ shao begins with shredded donkey meat stewed with vendor-specific secret blends of spices and sauces, which is generously scooped onto a flaky

golden bun. The bread is thick and just a little bit greasy—a perfect complement to the lean, flavorful donkey meat. Sandwiches are a rare find in traditional Chinese food; after eating lǘ ròu huǒ shao, you might wish that weren't so. This is fantastic: buttery, juicy, carefully spiced, savory, and lots more. Donkey meat may not be dragon meat, but perhaps it's the closest we've got.

Key words: donkey meat, sandwich, lean, flaky, savory

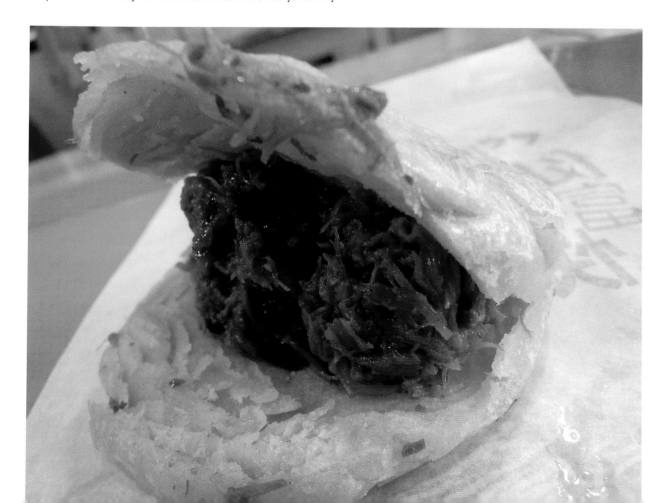

Chengde

棒子面窝头

Bàng Zi Miàn Wō Tóu

COST: 3 RMB

Cornbread! Foreigners visiting China for the first time might be surprised to find cornbread sold in the streets of some northern Chinese cities. And yet there's no reason to be surprised, for corn is available all over the world. This example from Chengde is a great showcase for the Chinese twist on cornbread. Think of it as a hybrid between American-style cornbread and the ubiquitous Chinese baozi. Stuffed inside of the cornbread bun you will find moist cabbage, both salty and sour. If it weren't for the radish taste thrown in as well, you might mistake the filling for sauerkraut. The cornbread itself has the traditional grainy texture and flavor. It is perhaps a bit less dry than Western cornbread because it has been steamed in the Chinese fashion. This is a tasty little snack that is well worth a try.

Key words: cornbread, sour, moist

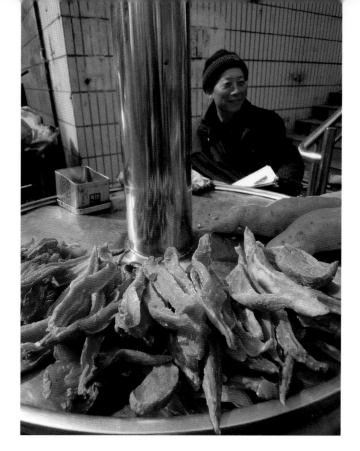

红薯干

Hóng Shǔ Gān

COST: 1 RMB

All across China, especially in the colder months, you will find street vendors selling baked sweet potatoes. This hóng shǔ gān is a nice variation on that theme. Rather than eating a whole baked potato, you have here the option to eat dried strips of sweet potato. It tastes exactly as you'd expect: sweet potatoey and chewy. It's sold by weight, so take as much as you want and carry them around for an on-the-go snack to keep your energy up while you explore Chengde's mountain resort.

Key words: sweet potato, dried, chewy

Heilongjiang

Harbin

麻辣面

Má Là Miàn

COST: 7 RMB

I was surprised to find the málà flavor—usually associated with the cuisine of Sichuan and its surrounding provinces—all the way up in Harbin. Málà is a combination of two words: má means "numbing" and là means "spicy." It is an immediately recognizable combination of oral sensations, equal parts tingly and burning. Harbin's má là miàn is a simple dish that takes advantage of the complex sensations of the málà flavor. A substantial heap of long, round noodles (like thick spaghetti) soak in an oily beef broth. On top of the noodles you will find a spoonful or two of fried ground beef, some bean sprouts, and a sprig of coriander. It is here, in the beef, where you will find the málà. Actually, it is pretty heavy on the má and light on the là, so those uncomfortable with spicy foods should feel free to dive in. The tingling feeling that comes with the má flavor is subtle, beginning almost imperceptibly and building up until it feels like your mouth is being painlessly pricked by tiny pins and needles. It's an unusual and enjoyable tactile sensation that is very surprising the first time you experience it. Add to that a serviceable bowl of beef noodles and you've got yourself a very fine lunch.

Key words: tingling, beef, noodles, soup

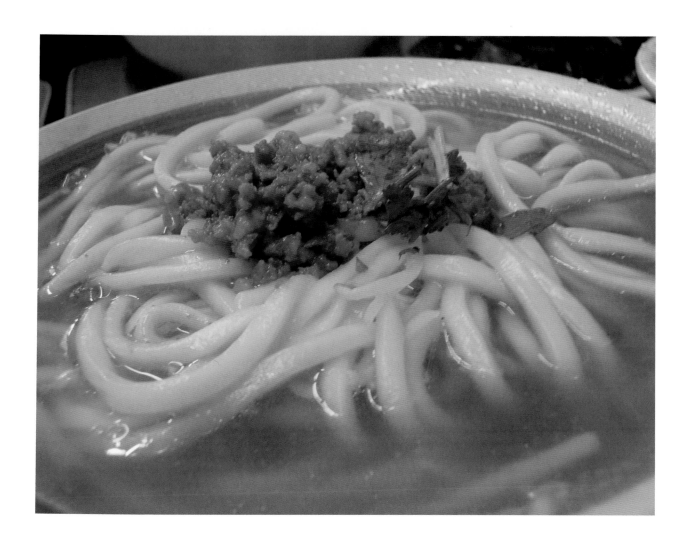

猪脑

Zhū Nǎo

COST: 8 RMB

Science tells us that pigs are among the smarter quadrupeds on the planet—even smarter than dogs. It can be hard to put this out of your mind when you eat a pig's brain. Sure, it's one thing to eat bacon or ham or pig feet; all they remind you of is how tasty pigs are. The brain, though, reminds you that a pig is more than just a meat factory. A clever living creature's thoughts, impulses, instincts, and desires all passed through this organ at one time. It's only natural to have a few reservations about eating the seat of intelligence of a fellow mammal. That is, of course, until you take your first bite and all reservations are forgotten in the presence of such a marvelous delicacy. In Harbin you can purchase and eat whole roasted pig brains. Three brains for under 10 RMB is a great deal. The wrinkly, brown brains are each about the size of a child's fist. They are soft enough to slice through with chopsticks, yet firm enough to pick up with those same utensils. Harbin's pig brains boast a creamy texture and a mild flavor, with hints of smokiness. In terms of taste, it is almost like smoked Gouda, though the texture is quite different. Unfortunately, they can be somewhat difficult to find these days in Harbin, but they are worth seeking out. If you have the opportunity and the interest, though, they shouldn't be missed—they are a real highlight in the city.

Key words: pig brain, creamy, smoky, mild

红肠

Hóng Cháng

COST: SOLD BY WEIGHT

Hóng cháng, or "red sausage," is one of the many meat-based foods in Harbin, as well as a testament to the Russian influence in the city. This beef sausage has its origins in Lithuania; it made its way through Russia to Harbin in the early 20th century and is now considered an authentic Harbin specialty. As sausages go, hóng cháng is fairly dry and moderately hard. The wrinkly, desiccated intestinal casing is mottled red, orange, and brown, and gives a certain degree of pushback when you try to bite into it. Inside, the meat is dry, fatty, and somewhat grainy, with a really nice, mildly smoked flavor. Most recipes incorporate a bit of garlic, which contributes a pleasant aftertaste. Hóng cháng is served in links, each about 8 inches long and 1 inch thick. They save well, so I'd recommend getting two or three links and snacking on them for the next day or two.

Key words: red sausage, mildly spicy, dry

粉肠

Fěn Cháng

COST: SOLD BY WEIGHT

Here we have a second Northeastern Chinese sausage. Like hóng cháng, fěn cháng is a European transplant (this time from Belarus) that made its way to Harbin through Russia. But where hóng cháng is hard and dry, fěn cháng is soft and oh-so-moist. This distinction can be explained by the different production methods and the use of pork instead of beef. Fěn cháng is slippery, plump, and tender—hold it too firmly and the casing will burst open right in your hand. The sausage skin is so thin, it yields to your teeth with just the slightest pressure, allowing the succulent insides to spill out. Inside, the meat is fatty and juicy, with a garlicky cured flavor. It tastes something like a less spicy variation on kielbasa. This orange sausage is a lovely snack and a fine counterpoint to the also-popular hóng cháng.

Key words: orange sausage, plump, tender, moist

马迭尔冰棍

COST: 3 RMB

By far the most famous thing about Harbin is its bitterly cold winter. Average winter temperatures reach down towards -20° C, with occasional days below -35°. Every year, Harbin capitalizes on this reputation by hosting a month-long Ice and Snow Sculpture Festival, world famous for its enormous artworks made of ice and snow. So why, in a city renowned for its biting winters, is ice cream on a stick one of the most popular street foods? Locals claim it is good for warming up the body, but as far as I'm concerned, the taste is enough justification. These days, you can find mǎ dié ěr bīng gùn in a number of different flavors, but the traditional off-white ice cream is flavored very simply. Actually, it mostly just tastes like lightly sweetened milk. This strong milk flavor can be a bit surprising for people who have grown up on chocolate, vanilla, and mint ice creams. It boasts a rich, creamy texture that melts in the warmth of your mouth, spreading the flavor to every corner of your tongue. For the most authentic version, head over to the Modern Hotel, where they were first sold in 1906 by the Russian Jews who owned the hotel. You will know that you have found the real deal when you see "马迭尔", the transcription of "modern", imprinted in the ice cream. Whatever season it might be, you won't want to miss this creamy treat with more than a century of tradition.

Key words: ice cream, creamy, milk-flavored, lightly sweet

马迭尔酸奶

COST: 3 RMB

This delightful yogurt is another local specialty available from the storied Modern Hotel on Zhongyang Dajie. (The Modern Hotel is one of many buildings on the street that shows off Harbin's famous early 20th century Russian architecture.) As you would expect, the yogurt is milky white in color and gently sour in taste. In a nice twist, a spoonful of white sugar is scattered on top of the yogurt skin—stir gently to mix it in. The sugar sweetens things up a tiny bit without masking the natural yogurt flavor. In contrast to some of the yogurt available in the Northwest of China, this is a bit smoother (no chunks here) and more watery. Served cold, this white yogurt in a white bowl topped with white sugar reminds one of the snow and ice for which Harbin is famous. It is a suitable companion to the ice cream options available at the Modern Hotel, especially if you prefer a little sour with your sweet.

Key words: yogurt, thin, smooth, sour, sweet, cold

烤冷面

Kǎo Lěng Miàn

COST: 5 RMB

When you get right down to brass tacks, the quintessential street foods are fast, cheap, and greasy. Hear this: kǎo lěng miàn is a quintessential street food. A thin, rectangular sheet of dough, about the size of a half-sheet of paper, is fried on a griddle with an indecent amount of oil. After a while, the vendor cracks an egg or two on top and continues to fry it on both sides. A minute or so later, the sheet is slathered with a surprisingly non-spicy red sauce and sprinkled with chopped onions, coriander, and sesame seeds. Roll it up, slice it into wide strips (about two-finger widths), put it in a bowl, and you've got yourself a street food. As you might expect, kǎo lěng miàn tastes like greasy fried eggs and vegetables in a thin wrap. The eggs stick to the inside of the wrap to make each slice a chewy delight. The red sauce that was so generously ladled on top has a slightly acidic tomato flavor, which works nicely with the rest of the dish. This is the kind of street food that is best after a late night of painting the town red, when all you want in the world is something fast, cheap, and greasy.

Key words: noodles, eggs, greasy, red sauce

Henan

Kaifeng

开封拉面

Kāifēng Lā Miàn

COST: 7 RMB

One well-known hometown dish that has escaped the confines of its native city is the Lanzhou pulled noodle. These bowls of long noodles and beef in a spicy broth are truly one of the most widespread noodle dishes in the country, available in virtually every city in China—that is why it came as such a surprise to me when I learned that Kaifeng offered their own take on pulled noodles. The preparation in Kaifeng begins in much the same way as in Lanzhou. Starting with a block of dough, the vendor grabs the ends and swings it up and down to stretch out the dough to two arms' length. He then brings the ends together, halving the length, and again grabs the ends and bounces the dough. As the dough stretches out longer and longer, he keeps folding and bouncing it until the original block of dough becomes one incredibly long thread of dough. The vendor cuts off the folded ends, leaving himself with a handful of long, round noodles. Although the best noodle pullers make this whole process look remarkably easy, I have been told it actually takes years of practice to get it just right. Here, Kaifeng noodles diverge from Lanzhou ones—the difference lies in the way they are served. Where Lanzhou noodles are known for their spicy chili flavor, kāifēng lā miàn are much milder and more savory. They come with a generous pile of sour, cubed winter melon on top, and a bit of mutton or beef for flavor. The noodles are served in soup, but not swimming in it like their Lanzhou brethren. The sour chunks of melon—kind of a rarity in Chinese street food—are a welcome experience for the taste buds. I enjoyed my noodles

164

immensely and came away wondering why the Lanzhou version had spread so thoroughly across China, but the equally delicious Kaifeng version had barely made it past the city borders. It's kind of a shame (to be honest, I liked the Kaifeng noodles better), but on the other hand, it can serve as a nice reward to the people that make their way off the beaten path and into Kaifeng.

Key words: noodles, sour, meat, slippery, winter melon

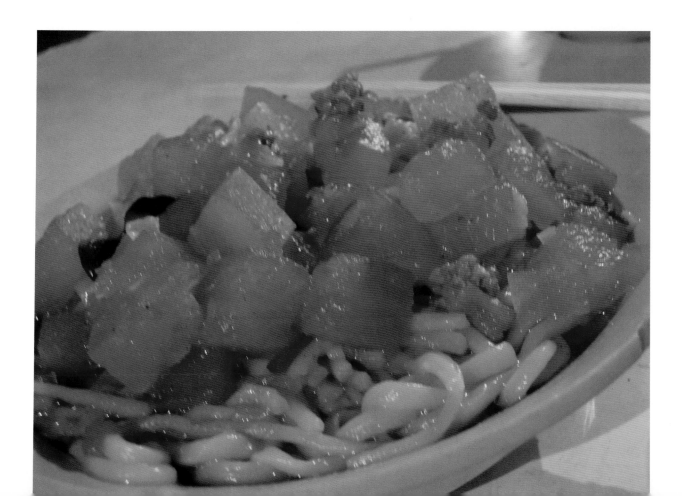

冰赤豆

Bīng Chì Dòu

COST: 4 RMB

Some people like to cool off on a hot day with a refreshing glass of lemonade. For those who are tired of lemonade (or never liked it in the first place), Kaifeng offers an interesting alternative: bīng chì dòu. The drink is made with red adzuki beans, crystal sugar (not granulated sugar), and ice cold water. Some recipes also include honey or chrysanthemum syrup for additional sweetness. The beans are soaked in the sugar water so that the water plumps the beans and the bean starch seeps out into the water. The resulting beverage is cloudy pink, sweet, beany, and very refreshing. You needn't eat the beans if you don't want to, as this is primarily a beverage, but they can add a nice texture. If you're looking for a way to ward off the summer heat in Kaifeng, look no further than bīng chì dòu.

Key words: sweet, red beans, cool

玫瑰切糕

Méi Gui Qiē Gāo

COST: 5 RMB

Méi gui qiē gāo, often available at the same locations as bīng chì dòu, is a delightful mound of sticky rice, red beans, and syrup. Rather than thinking of it as one big mound, you might consider it as three separate mounds: two layers of sticky rice sandwiching a layer of chunky red bean paste. The caramel-colored, not-too-thick syrup on top and within tastes of honey and roses—a delicate and fragrant mixture. They call it a "cake," but perhaps "pudding" would be a better description (like a sliceable Christmas pudding, not a creamy tapioca pudding). It is soft and sticky and syrupy sweet. The rose and red bean flavors play nicely together. Given its size and consistency, it is also a good choice if you are looking for a street food to share. Get a couple of spoons—you and your friend will be in dessert-town in no time.

Key words: rice, red beans, rose, sticky, sweet

胡辣汤

Hú Là Tāng

COST: 4 RMB

Popular as a spicy breakfast soup in much of Northern China, hú là tāng was born here in Henan Province. Several different Henan cities, including Kaifeng, boast their own unique versions of hú là tāng, but it's a real challenge to discern any difference between the versions. The base of the soup is a spicy beef or mutton broth, flavored with chili oil, black pepper, sesame oil, and vinegar. Inside the soup you will find long, glassy vermicelli noodles, shreds of soft fried tofu, and little bits of meat. None of those ingredients add too much flavor, but they add excellent texture: slipperiness from the noodles, sponginess from the tofu, and chewiness from the meat. The prominent tastes are from the chili oil (hot), black pepper (sharp), and the vinegar (sour). Although this dark, opaque soup with a powerful flavor can be found any time of the day, it is typically eaten at breakfast. I recommend following the custom on this one—a steaming, spicy bowl of hú là tāng is an excellent way to start one's day.

Key words: soup, spicy, sour, vermicelli

水煎包

Shuǐ Jiān Bāo

COST: 4 RMB

Chinese dumplings, fried or boiled, typically have pretty similar skins: thin and smooth, maybe a little bit glossy or sticky. Here in Kaifeng you can get a pan-fried dumpling with a thicker, lumpier casing. The dough for the dumpling skin actually has some yeast in it, which makes it less of a pasta and more of a bread. When preparing the dough for shuǐ jiān bāo, the flour and yeast are mixed with warm water and then covered with plastic wrap to prove. Once it has blown up to about double the original size, it is ready to be stuffed with a mixture of pork or mutton, chives, and spices, and then fried in a pan. At this point, the process is basically the same as any other pan-fried dumpling. Each dumpling sizzles around the pan until its flat bottom is golden brown and lightly crispy. They taste great—thick, doughy, savory, and juicy. The casing tastes a lot like a fried version of one of China's many steamed bāo zi, and the insides are rich and greasy with pork or mutton. Any dumpling lovers out there would do well to check out Kaifeng's shuǐ jiān bāo—it is a fine member of the dumpling family.

Key words: dumplings, fried, pork, mutton, bready

炒饼

COST: 6 RMB

They might look like noodles, but the fried strips in this greasy Henan specialty are actually somewhere between the batter of a pancake and a crepe. The batter is made of flour and eggs, spread thinly on a griddle and fried until it is soft but firm. Once it is cooked, the pancake is shredded into strips and then tossed together with vegetables, eggs, and meat. Different vendors have different recipes, but common ingredients include cabbage, bean sprouts, egg, pork, red pepper, chicken, and other similar items. Everything is stir fried in a glorious, greasy potpourri of comestibles. The pancake slices are chewy and soft, the vegetables are fresh and crunchy, and the whole thing is greasy and filling. Delicious!

Key words: pancake slices, vegetables, stir fried, greasy

花生糕

Huā Shēng Gāo

COST: 10 RMB

One of China's most addictive snacks, huā shēng gāo is a mouth-watering biscuit of peanuts and sugar. It comes bundled up in a handsome package of red and white paper and twine. Within this wrapper you will find a pile of flaky, layered bricks—the huā shēng gāo. To make this delicacy, you must first pulverize a bunch of peanuts with a large, wooden hammer. Then, you need to boil a basic syrup from sugar, water, and more peanuts. Let that syrup cool, then mix in the peanut powder from the first step. Once that hardens up a little bit, all that's left to do is slice it, wrap it, sell it, and eat it. The final product is sweet and delicate. It melts in your mouth into a sticky, peanut-flavored mash. Each slice is about two bites, and it's awfully difficult to stop at just one slice. I managed to go through the whole bundle in one evening, despite my plans to save it for a train trip the next day. The bottom line is that huā shēng gāo is a lovely, sugary, peanutty snack—don't miss it.

Key words: peanuts, sweet, flaky

羊肉炕馍

COST: 4 RMB

Yáng ròu kàng mó is the kind of street food you wish you could eat every day, even though your arteries might get more clogged each time you eat one. To make this Kaifeng specialty, you start with flat discs of lào mó (basically a Chinese tortilla made of unleavened flour). One of these tortillas is dropped onto a round griddle, and then the vendor digs into a large tub of pure, solid mutton fat and spreads a generous layer of suet all over the lào mó. As the tortilla browns and the suet softens, the vendor will add on a handful of minced mutton, some green onions, a dash of cumin, and maybe some shredded lettuce. When the cooking is complete, the vendor rolls and folds the tortilla around the other ingredients, creating a conveniently portable snack. The final product is outstanding—savory, rich, greasy, and moderately crispy, with that characteristically potent mutton flavor infused throughout. It's one of life's great disappointments that some of the tastiest foods are also the worst for your health. What a pity! Once in a while, though, it's worth indulging your taste buds and digging into these sorts of dishes. Count yourself lucky if you find yourself in Kaifeng on one of these indulgent days, as you will have the opportunity to try out yáng ròu kàng mó.

Key words: mutton, fatty, tortilla, savory

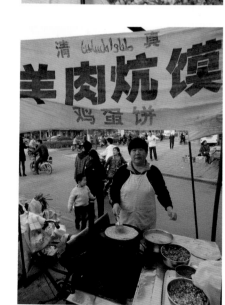

清 (haluch)966 真
羊肉炕馍
鸡蛋饼

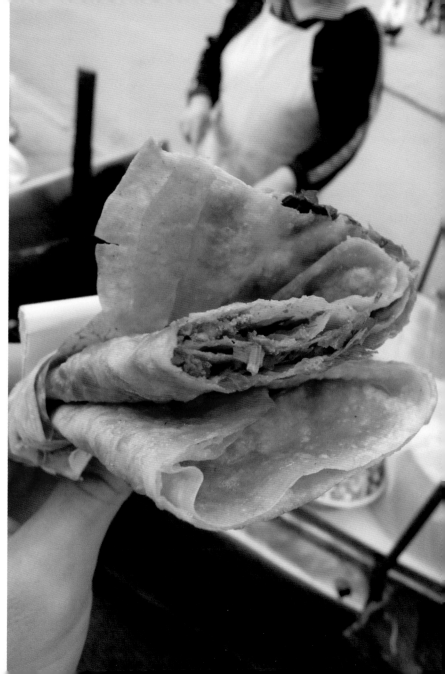

酱牛肉

COST: 5 RMB

This braised beef is good for a quick snack or as a part of your dinner. It is prepared with a complex mixture of soy sauce, aniseed, cinnamon, chili, ginger, and sundry other spices. It is soaked and slow roasted so that the juices and spices and whatnot can soak deep into the beef. The meat has a rich, brown color; a fragrant, spiced aroma; a tender texture; a little bit of fat (without being greasy); and a complex, beefy flavor. It is sold by weight, so get as much as you like. Locals will often buy a bunch of it to take home for dinner. For the casual traveler and street food seeker, though, a couple of ounces make for a quick and yummy snack.

Key words: beef, braised, spices

桶子鸡

Tǒng Zi Jī

COST: 10 RMB

Tǒng zi jī is one of Kaifeng's most well-known and historical foods, street food or otherwise. The name, which means "bucket chicken," might bring up mental images of fried chicken in glossy paper buckets made transparent from rubbed-off grease, but it actually refers to the tubular shape of the prepared chicken. To some eyes, tǒng zi jī might not look too appetizing. Vendors selling it display their wares whole—wan, yellow, and covered in goose (or chicken) pimples. Fortunately, they taste much better than they look. Like Kaifeng's jiàng níu ròu (which is often sold at the same stand), tǒng zi jī is sold by weight. Depending how much you ask for, the vendor will slice off a few strips that can be eaten immediately or saved for later. They are crispy, tender, salty, and much less greasy than those other bucket chickens you might be thinking of. As tǒng zi jī straddles the line between street food and regular food, you can also buy it in the city's fancy restaurants. Of course eating it on the street gives it a little extra flavor, so that's what I recommend.

Key words: chicken, salty, crispy, yellow

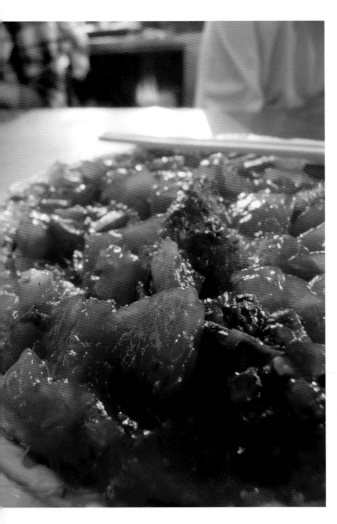

炒凉粉

COST: 6 RMB

Liáng fěn—a popular street food in several different regions of China—is generally served in long, cool slices. Here in Kaifeng, locals prefer to chop and fry their liáng fěn before they eat it. The liáng fěn itself is basically the same as it is elsewhere in the country. It's a cool, wobbly jelly made from mung bean or yam flour. This jelly is chopped into bite-sized cubes and stir-fried with soy sauce, ginger, shallots, chili pepper, onions, and garlic (actual ingredients may vary from vendor to vendor). By the time it is finished, the liáng fěn (now officially chǎo liáng fěn) has taken on an orange-brown color. The fried cubes are soft and jiggly and shiny with grease. It has a lovely flavor full of spices, chili-heat, and garlic. Some people might not enjoy the texture. Others might have difficulty picking it up with chopsticks. For everyone else though, chǎo liáng fěn is a definite winner.

Key words: fried, jiggly, soft, spicy

176

炒红薯泥

Chǎo Hóng Shǔ Ní

COST: 6 RMB

American travelers feeling nostalgic for Thanksgiving should run, not walk, to Kaifeng's chǎo hóng shǔ ní. It's basically a Chinese version of sweet potato casserole (without the marshmallows on top that are regionally popular in the United States). It is orange and sludgy (ní means "mud"), with pea-sized chunks of sweet potato throughout. The mashed sweet potato is flavored with sesame oil, walnuts, peanuts, brown sugar, rose water, and honey, making it delightfully sweet. Everything is fried together in a large pan to create the final product. One taste will bring you right back to the holidays. It's thick and goopy, sweet and nutty, and through-and-through delicious.

Key words: sweet potatoes, sludgy, sweet

杏仁茶

Xìng Rén Chá

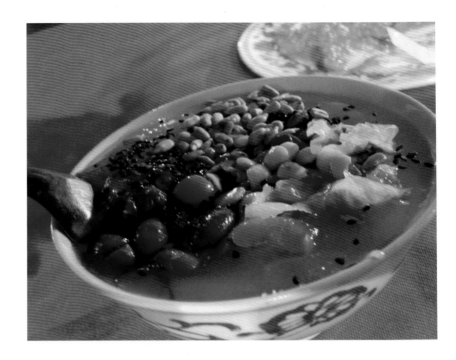

COST: 4 RMB

On the surface, xìng rén chá is replete with vibrant colors and diverse textures; this impression belies the true nature of this dish. Just below the surface is a thick, silver-white goo that is less visually stimulating than the surface layer. It almost has a calming effect, as if you would want to ease yourself into a vat of it in a spa in an effort to cleanse your mind of unnecessary clutter. What is the source of this substance? Mostly almond powder and water boiled together in a large copper pot. Just before serving this pearly paste, the vendor will add in all of that other stuff: sugar, sesame seeds, raisins, peanuts, almonds, cherries, rose water—the list goes on and varies from one stall to the next. You, the consumer, only need to stir the condiments into your almond paste and then dig in to this sticky, sweet, nutty, fragrant bowl of goo.

Key words: almond powder, sticky, sweet

黄焖鱼

COST: 8 RMB

Believe it or not, one single bowl of huáng mèn yú contains fifteen to twenty small whole fish. The fish are nearly always a small type of carp, closely related to the common household goldfish. A whole pile of them are cleaned (but not filleted, since the bones are small enough to eat safely), battered (with a mixture of eggs, flour, and water), fried to a crispy golden brown, and then simmered in an aromatic soup seasoned with onions, ginger, garlic, star anise, chili oil cinnamon, cumin, cooking wine, and soy sauce. (Oof! What a lot of seasoning!) It is the spicy chili oil and the piquant ginger flavors that come through the strongest, though careful eaters will be able to detect hints of everything. Of course the seasoning is all well and good, but the carp are the highlight of the soup. They have a moderately strong fish flavor and a chewy consistency. Everything works together beautifully. One taste of huáng mèn yú will make it clear why this flavorful bowl of braised fish in a spicy soup is one of Kaifeng's best-known street foods.

Key words: whole fish, soup, spicy, starchy, ginger

烩面

Huì Miàn

COST: 8 RMB

I love a food with a fun backstory. Huì miàn supposedly has a history of about 1400 years, beginning when the Tang Dynasty emperor Li Shimin was still a lowly foot soldier. As the story goes, it was a bitterly cold, snowy night and Li Shimin was ill. Being very hungry and having no food, he wearily wandered to a small house where he met an old woman. She was very poor but also very kind. She made the best with what she had and cooked him up some wide noodles in a sheep-bone broth. Although the dish was simple, it was enough to warm him up and restore his energy. He was so grateful to the old woman that when he eventually became the emperor, he ordered his imperial cooks to learn to make the same dish so that it would live on in perpetuity. His orders must have been clear, because people in Henan continue to eat huì miàn more than a millennium later. It's a pretty straightforward noodle dish, made up of long, wide wheat noodles; a broth made from sheep bones (usually the spines) and flavored with medicinal herbs; a bit of mutton; some mushrooms, day-lily, caraway, and bean curd skin; and, if you're lucky, some hard-boiled quail eggs. The noodles are silky and chewy, the broth is salty and oily, and the mutton is gamy. Don't be deceived by its simplicity—as Li Shimin recognized, huì miàn's simplicity is its strength. Even now, centuries after it was invented, a steaming bowl of huì miàn is an excellent way to warm up on a cold winter's day.

Key words: mutton, soup, noodles

ALSO TRY:

麻辣花生 (Má Là Huā Shēng), 卤面 (Lǔ Miàn)

Luoyang

糊涂面

Hú Tú Miàn

COST: 7 RMB

This creamy noodle stew with its olio of ingredients was born out of hardship. In times of food shortages, locals low on rice and wheat developed a method of cooking a filling dish that was light on the noodles. The solution they came up with was to boil cornmeal and millet to thicken the water and then throw in a bunch of hearty vegetables (carrots, potatoes, etc.). The mixture this all created was nice and thick, a satisfying meal for any appetite. When everything was nearly cooked, the cooks finally added in some noodles. Not as many as they would have liked, perhaps, but enough. These days you can find a few more noodles in the dish than before, in addition to some green vegetables and peppers. Even with the modifications, it is still a robust bowl of stew (it's much too starchy and dense with ingredients to be considered a soup) that will keep your body warm and your stomach full all day long in Luoyang.

Key words: noodles, hearty, vegetables, cornmeal

浆面条

Jiǎng Miàn Tiáo

COST: 7 RMB

Jiǎng miàn tiáo may look an awful lot like hú tú miàn, but it tastes completely different. In fact, it has a different taste than most any other noodle dish you can think of. The noodles themselves are fairly standard golden wheat noodles. Rather than boil them in water, though, the vendors selling jiǎng miàn tiáo boil them in a sour milky substance made of mung beans. You can basically think of this milk as soy milk that uses mung beans instead of soy beans; the process is virtually the same. It turns out that noodles cooked in mung bean milk have the same texture as noodles cooked the normal way, just with a much sourer flavor. In addition to these mung-bean-infused noodles, jiǎng miàn tiáo also includes celery, corn, carrot slices, and optional chili oil and garlic. The opaque grayish-white soup is starchy and creamy. It has a sour, garlicky flavor, rather unusual for a dish of this sort. Each bowl of jiǎng miàn tiáo is packed to the brim with noodles, vegetables, and sour mung bean milk, so bring an empty stomach and an open mind about how noodles ought to taste and you won't be sorry.

Key words: noodles, mung bean milk, sour, vegetables

炒兔肉

Chǎo Tù Ròu

COST: 8 RMB

Rabbit meat, red and green peppers, onion, garlic, and oil—that's about the extent of this spicy dish. The rabbit meat is chopped up haphazardly, with bones and flesh sticking out every which way. Rabbit, as a rule, is a pretty lean meat with a mild, almost sweet flavor. Of course, that subtle sweetness is barely evident in this dish, which is overpowered by the powerful heat of the peppers. That spiciness is surprisingly potent and sneaky. By the time your taste buds have registered how spicy this dish is, the heat has settled in for the long haul, trapped on the surfaces of your mouth by the oil used to fry everything up. There is a lot to like about chǎo tù ròu—its simplicity, its rawness (of spirit, not of temperature), its heat, and its succulent rabbit meat. It doesn't pretend to be anything fancy—what you see is what you get, and what you get is delicious.

Key words: rabbit, peppers, onion, garlic, spicy, oily

不翻汤

Bú Fān Tāng

COST: 8 RMB

Ask any Chinese person about Luoyang cuisine, and it's a good bet that the first thing they will think of is soup. Local history says that Luoyang has so many different kinds of soups because of the cold winter and the necessity of feeding people when food was scarce (see also hú tú miàn). Even Luoyang's most famous contribution to the culinary universe, the water banquet, includes several different varieties of soup. One of the city's best-known soups is bú fān tāng. The base of bú fān tāng is a simple broth that contains mushrooms, leeks, glass noodles, vinegar, seaweed, black pepper, and occasionally shrimp. The soup has a peppery flavor with a sour tang from the vinegar. With all of the different ingredients within, there's no surprise that there are a number of other textures and flavors in addition to the sourness of the soup. On top of all of that, an order of bú fān tāng comes with a side of thin mung bean pancakes, which can be added to the soup for some interesting texture and additional substance. The soup has a peppery flavor with a sour tang from the vinegar. With all of the different ingredients within, there's no surprise that there are other textures and flavors in addition to the sourness of the soup. Bú fān tāng is a complex dish and a worthy entry in the pantheon of Luoyang's famous soups.

Key words: soup, mung bean pancakes, black pepper, sour

燕菜

Yàn Cài

COST: 8 RMB

Another of Luoyang's famous soups, as well as one of the highlights of the city's famous water banquet, is yàn cài. Its most notable feature is the mound of shredded radish in the middle of the soup, but it also includes mushrooms, shreds of chicken, seaweed, minced pork, and other miscellaneous vegetables. Supposedly it tastes like bird's nest soup (which is where it gets the "yàn" part of its name—it means "swallow"). Now I've never had real bird's nest soup, but if the comparison is accurate I can surmise that it tastes succulent and sort of tart. Legend has it that this dish was created after a farmer presented a massive radish to the 7th century empress Wu Zetian. The imperial chefs were tasked with cooking the immense vegetable, but radish was not considered to be very tasty at the time (what were they thinking?) and they were somewhat stumped. Eventually, they shredded it and cooked it in a style resembling one of the empress's favorite dishes. She loved it, and all of the other aristocrats felt compelled to follow suit. Before anyone knew what had happened, this radish soup became one of the most popular dishes in the area. I don't know if the story is true or not, but I do know that it is a major part of Luoyang's cultural heritage. Try it and taste what was in fashion in the imperial court 1300 years ago.

Key words: soup, radish, mushroom, chicken, tart

假海参

COST: 8 RMB

Another Luoyang soup? Yes, and in fact, like yàn cài, it's another Luoyang soup made to imitate another food. In this case, it is yam starch jelly pretending to be sea cucumber (hǎi shēn). This jelly, while definitely the most obvious ingredient of the soup, has nearly no flavor of its own. What it *does* have is texture. Think of it as a lumpy gelatin—it's jiggly, mostly firm, and breaks d0wn easily. Besides the fake sea cucumber, the soup also includes real wood ear mushrooms, chives, small pieces of pork, ginger, and vinegar. Like the yam jelly, the mushrooms mostly exist to give texture to the soup, though they do have a mild earthy taste. Most of the flavor comes from the sour vinegar, the sharp ginger, and the mildly oniony chives. If you manage to get a bowl of jiǎ hǎi shēn prepared by one of the best cooks in Luoyang, you will be eating a true delicacy, though average kitchens do make decent bowls of jiǎ hǎi shēn as well. If you're a fan of sour soup with interesting texture, look no further than jiǎ hǎi shēn.

Key words: soup, yam jelly, wood ear mushrooms, sour

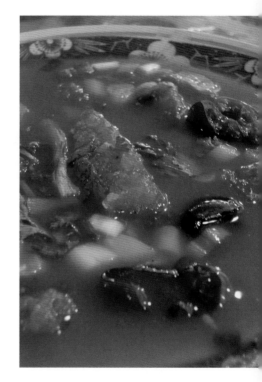

蜜汁红薯

COST: 6 RMB

Here we come to the final entry in this book's short series of Luoyang's famous soups. Unlike the sour soups explored above, mì zhī hóng shǔ is delightfully sweet, nearly to the point of being a dessert soup. It's a pretty simple recipe: peeled and lightly fried slices of sweet potato float on the surface of a no-frills syrup of sugar, water, and sweet potato juice. The sweet potato slices are soft and chewy (think dehydrated apples for a textural comparison) and the cola-colored soup is sweet without being oppressively so. All in all, it's a light and pleasant member of Luoyang's stable of soups.

Key words: soup, sweet potatoes, sweet

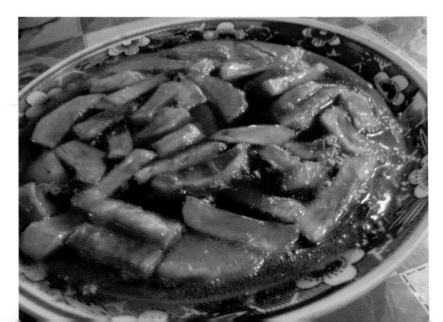

冰糖炖梨

Bīng Táng Dùn Lí

COST: 4 RMB

Similar in basic structure to the rè dòng guǒ you can eat in Lanzhou, Luoyang's bīng táng dùn lí is a sweet, refreshing, fruity snack. Both dishes feature a stewed pear as the centerpiece, sitting in some sweet soup. While the Lanzhou version is hot, the one here in Luoyang is served chilled. Otherwise it's basically the same. The pear is grainy and soft enough to be eaten with a spoon, and the soup is dark and subtly sweet. Try it for a light and refreshing dessert that has some semblance of nutrition to it.

Key words: pear, soup, chilled, sweet

Hong Kong

Hong Kong

咖喱魚蛋

Gaa³ Lei¹ Jyu⁴ Daan²

COST: 6 HKD

Fish balls! One of the quintessential Hong Kong street foods, fish balls can be found all over the city, particularly in the Mong Kok area. In nearly all cases they are cooked with a tasty curry sauce for flavor. If you've never had a fish ball before, it might not sound too appetizing. Perhaps, in that case, you might think of it as a meatball made of fish instead of beef or pork. There are actually two kinds of fish balls available in Hong Kong: fancier white ones sold in restaurants and cheaper yellow ones sold on the street. Most of the street vendors these days serve a product made of fish (typically inexpensive fish such as flathead mullet or conger pike), flour, salt, and sugar. The fish meat is pounded into a mash instead of ground up, which is what gives it its peculiarly smooth texture and springy consistency. Vendors boil these gumball-sized fish balls in a curry sauce, giving them a yellow color and a lightly spicy curry flavor. Both the fish and the curry make their presence known to your taste buds, but neither flavor is overpowering. An order of fish balls will give you five or six balls on a bamboo skewer or in a small bowl. Grab a handful to snack on while you wander around the most densely populated block in the world—you won't be disappointed.

Key words: fish, springy, chewy, curry

格仔餅

Gaak³ Zai² Beng²

COST: 5 HKD

I'll be honest: when a friend told me I should be sure to try the waffles in Hong Kong, I was skeptical. Waffles don't exactly scream "East Asia" to me. And yet these local waffles are indeed an indelible part of the street food scene in Hong Kong. Hong Kong waffles taste fairly like regular old Western waffles, you know, rich and buttery, perhaps just a little bit sweeter and with a stronger egg flavors. When you order a Hong Kong waffle, the vendor will slather the top with peanut butter, butter, and sugar, and then fold the circular waffle in half like a giant taco shell. It is sweet and salty and buttery, with a light, fluffy texture. Traditionally, the waffles were made on griddles over coal fires, but these days most vendors use electric waffle irons. Nonetheless, they are a part of Hong Kong's street cuisine and worth trying while you are in the city.

Key words: waffle, peanut butter, eggy, fluffy, sweet

雞蛋仔

COST: 5 HKD

Gai daan zai is a delightful cousin to *gaak zai beng*. The batter for each of the two is similar—the difference comes primarily in the cooking. The pock-marked griddle used to cook the *gai daan zai* gives you a waffle that looks like a honeycomb of golden ping-pong balls. The small crust between the waffle spheres is crisp and thin, and really only serves to maintain structural integrity. It has a sweet, eggy taste reminiscent of but distinct from the standard Western waffles. Each waffle globe is light and fluffy, nearly hollow, making the whole thing a fairly insubstantial snack. Just like *gaak zai beng*, it seems a bit odd for a waffle to be a local specialty, but it has maintained its status as one of Hong Kong's most popular street foods for many years, and it seems that its popularity will continue for years to come.

Key words: waffle, spheres, eggy, sweet

砵仔糕

But³ Zai² Gou¹

COST: 5 HKD

But zai gou technically originates from Taishan, a city in Guangdong less than 100 km west of Macau, but these days they are mostly associated with Hong Kong and Macau. *But zai gou* are delightful little steamed, rice-based puddings that come in a variety of flavors. Traditional flavors include plain white sugar, red bean, and brown sugar, but modern vendors may also offer contemporary twists on the classic by including ingredients like chocolate, milk, and different fruits. Each *but zai gou* is steamed and served in its own disposable aluminum bowl, though some traditional stores still serve them in reusable clay bowls. *But zai gou* are cute and fun bite-sized snacks—a pleasant little diversion and a hit with children of all ages (and that includes me).

Key words: pudding, rice, bite-sized, rubbery

八爪魚串 and 雞腎/ 雞胗

Baat³ Zaau² Jyu⁴ Cyun³ and Gai¹ San⁶/ Gai¹ Zan¹

COST: 6 HKD

Everywhere you look in the right parts of downtown Hong Kong, you will see vendors selling a wide variety of skewered animal parts and other edible items. You can get octopus, pork intestines, squid, chicken gizzard, siu mai, tofu, and all sorts of other things. In general, all of these are prepared in roughly the same way, so I'm only going to highlight two popular and representative options here: octopus and chicken gizzard. In the picture, you can see the octopus on the left and the chicken gizzard on the right. On top, the vendor deposited a generous squirt of hoisin (seafood) sauce and another of spicy, sinus-clearing mustard. The orange octopus parts, served cool, are slippery and chewy, while the gizzards are dense and flavorful. With the sauce on top, there are a bunch of different flavors going on at once—spicy (mustard spicy, not chili spicy), sour, sweet, seafoody, and savory. It's a lot to take in, but it's also clear why this is one of the most prevalent street foods in Hong Kong. It's portable, cheap, fast to prepare, and tastes great. As I mentioned, there are a number of choices beyond octopus and gizzard, so see what looks good to you and eat to your heart's content.

Key words: rubbery, savory, spicy, sour, sweet, choices

煎釀三寶

Zin¹ Joeng⁶ Saam¹ Bou²

COST: 8 HKD

Here we have my personal favorite Hong Kong street food: *zin joeng saam bou*, or "three stuffed treasures." As with many others of Hong Kong's skewered street foods, you are presented with an array of meats and vegetables from which you can choose three to five. The most traditional choices are eggplant, green pepper, sausage, and tofu, but you may find other options as well (for example, see the meatball in my photo). Whichever you choose, the vendor will skewer and fry them on a flat griddle, making them hot, lightly crispy on the fringes, and shiny with oil. This alone would not be enough to merit its place as my favorite—what makes it special is that each vegetable or piece of meat is stuffed with a salty paste made with mud carp, which adds a lovely and surprising fish flavor. With this added secret, these pieces of vegetable and meat are transformed into an unusual and very pleasant taste experience. Each morsel is rich and greasy with distinct flavors, making these one of the finest treats available on the streets of Hong Kong.

Key words: vegetables, meat, fish paste, savory

碗仔翅

Wun² Zai² Ci³

COST: 5 HKD

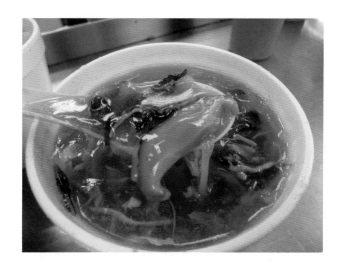

Traditional shark fin soup is high on the list of the most inhumane dishes in the world. Thankfully, though, your culinary curiosity doesn't have to go wholly unsatisfied, because one of Hong Kong's most popular street foods is imitation shark fin soup. The salty, brown soup base is thick and starchy, enough to suspend the other ingredients in some sort of stasis. Within the soup you will typically find some vendor-specific combination of mushrooms (both oyster and wood ear), vermicelli, chicken shreds, egg drops, and tofu skin. These ingredients are meant to replicate the apparently smooth, velvety texture of shark fins (I've been told that shark fins themselves have very little flavor—it's the texture they add to a soup that is so prized), while also offering a nice variety of flavors. I can't speak to how well this simulacrum imitates the real shark fin soup, but that's okay; it is tasty enough to stand on its own merits.

Key words: soup, thick, mushrooms, vermicelli, egg, salty

生菜魚肉

COST: 5 HKD

In this world there are four kinds of people: 1) people who like fish; 2) people who like lettuce; 3) people who like neither; and 4) people who like both. This Hong Kong specialty, which translates as "lettuce and fish," is clearly geared towards the people in the fourth category. To prepare this soup, you must first make a handful of chewy fish globs by chopping up some fish (typically mud carp) and mixing it with corn starch, shrimp, and spices. These fishy chunks are dropped into an oily broth with a few lettuce leaves and possibly some chili oil. It's a fairly simple recipe that yields fairly positive results. If you've ever had gefilte fish, imagine having it in a broth with some lettuce and you'll have a pretty good idea of what you're getting yourself into here: dense fish chunks, soggy lettuce, and salty broth. Don't let that description turn you off, though—it's better than it sounds.

Key words: fish, lettuce, broth

Hubei

Wuhan

豆皮

Dòu Pí

COST: 5 RMB

Dòu pí is one of Wuhan's most famous and well-loved foods—it is one of the tastiest dishes Wuhan has to offer. What you have here is a fried mixture of eggs, tofu, chopped beef, mushrooms, green onions, and sticky rice. The whole concoction is stir-fried and then spread evenly around the pan about one inch thick. A thin tofu skin is added on top, and then the mixture is sliced into individual servings each about the size of a deck of cards. The skin is thin and chewy, while the rest has a greasy, savory taste to it. Imagine a rice casserole that is fried instead of baked—that is pretty much what dòu pí is. For 5 RMB you receive two or three squares of dòu pí, a quick, mouth-watering snack that will leave you wanting a second helping.

Key words: sticky rice, tofu skin, beef, greasy, mushrooms, chewy

面窝

COST: 3 RMB FOR 5

Miàn wō may look like miniature donuts, but don't bite in thinking that it will taste that way; you would be in for a salty surprise. In fact, these Wuhan treats share little with their doughy counterparts other than shape. The primary ingredients of miàn wō are rice, soybeans, salt, green onions, ginger, and sesame seeds—note that there is not a gram of sugar to be found. These ingredients are mixed into a batter that is poured into an iron mold and deep fried. The final product tastes salty with a welcome hint of ginger. The outside is fried to a crispy, golden brown, while the inside retains a pleasant softness. They are thinner than a Western donut, and definitely saltier, but they are definitely worth a try when you're in Wuhan.

Key words: salty, ginger, fried, donut

糖油粑

COST: 3 RMB

Readers with a predilection for sweet foods will want to take note of this one. Táng yóu bā are fried balls of sweet, glutinous rice coated in a sugary glaze. Some vendors will include a bit of sesame or osmanthus for a slightly different flavor. Sounds pretty good, yes? It is. The glaze is sticky and slightly hardened, giving each ball a mild crunch on the exterior. The inside is warm, gooey, and sticky. Each of the two parts—outside and inside—are wonderfully sweet. This is like warm, chewy candy on a stick.

Key words: sticky, sweet, glazed, glutinous rice

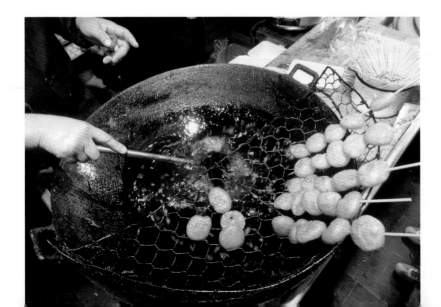

糯米包油条

COST: 6 RMB

This yummy street food is akin to a sticky rice burrito. To make nuò mǐ bāo yóu tiáo, you must first create a thin disc of soft sticky rice (approximately 10 cm in diameter and 1 cm thick) and then lay it out on a cloth. On top of this rice patty, add a piece of yóu tiáo (see Shanghai for more on yóu tiáo), a few pinches of pork floss, sugar, salt, and possibly some radishes or other vegetables. Next you use the cloth to roll the rice up, trapping the contents inside like a burrito. Dip each end into a powdery mix of sugar, salt, and spices to add some flavoring to the exterior, and you have completed your nuò mǐ bāo yóu tiáo. Flavorwise, this is a fairly complex dish that your taste buds don't really know what to do with. The rice and yóu tiáo are lightly sweet, the pork floss is salty and tangy, and the spices add all of their own flavors. There are a lot of flavors going on at once here, but salty and sweet stand out as the primary culprits. Nuò mǐ bāo yóu tiáo is a fun little snack, and, thanks to the rice, it is reasonably filling as well. One of these would certainly be enough to tide you over for an hour or two before dinner.

Key words: burrito, rice, pork floss, yóu tiáo, sweet, salty

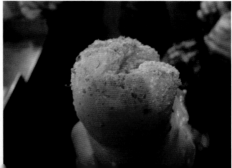

热干面

COST: 5 RMB

Here it is, the crown jewel on any list of Wuhan's street food: rè gān miàn. This staple dish of Wuhan is typically eaten for breakfast, although it is available any time of the day. The Chinese name translates to "hot dry noodles." It's worth noting that "hot" here refers to temperature rather than spiciness. Rè gān miàn is deceptively simple for how great it tastes. The long spaghetti-like noodles are made in a special way so that they do not stick to your teeth. Once ready, they are pre-cooked the night before serving so that when you order them, they only need to be flash-boiled for about 30 seconds. After the boiling, the cook drops them in a bowl, tops them with sesame paste (sometimes peanut paste, but sesame is more authentic), and your choice of radishes, scallions, sour vegetables, and chili sauce. All that remains is to mix it up and eat. Of course that is the best part, because this stuff is delicious. The sesame paste adds a pleasing grainy texture to the noodles, while the dish as a whole has that sweet, nutty taste of sesame, with just the right amount of spiciness (enough to give it some kick but not so much as to overwhelm). The optional vegetable add-ins also add their own flavor to the dish. Rè gān miàn has been a staple in Wuhan for roughly a century, and it isn't hard to see why. If you only eat one street food in the city, make sure it is this one.

Key words: noodles, sesame, sticky, grainy

黄石港饼

COST: 5 RMB

These cookies are technically a product of Huangshi, a small city a little over 100 km southeast of Wuhan, but they are widely available in Wuhan as well. They have a rich history in the region—you can trace their origins all the way back to the turn of the 19th century during the Jiaqing period of the Qing Dynasty. Each cookie is about 5 cm in diameter, with a crisp, flaky outside and a softer, grainier, crumblier middle section. The outside is coated in yellow or black sesame seeds for flavor and texture. Although the cookie shell has a pretty standard wheat flour flavor, the inside is rather unique. Recipes vary, but most bakers include some variation of brown sugar, sesame, crystalized sugar (rock candy), orange flavor, and sweet osmanthus. Depending on the recipe, the cookies either have a sesame seed nuttiness or a more delicate fruity, floral flavor. If I had to choose between the two, I would probably go for the latter variety as it is a truly unique and surprising taste in Chinese food. Thankfully for you, though, there is no reason to pick one over the other—I say sample all of them. I don't think you'll regret it.

Key words: cookies, sesame seeds, sweet, floral, fruity

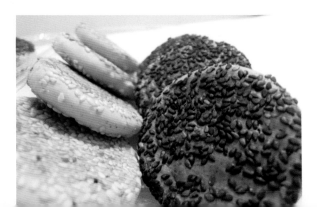

Hunan

Changsha

臭豆腐

Chòu Dòu Fu

COST: 5 RMB

You can always smell it before you see it: chòu dòu fu, or stinky tofu, has an incomparable and instantly recognizable smell. Several different cities in China have their own versions of stinky tofu, but they are all variations on a theme: it's tofu and it smells terrible. Changsha's version is one of the more famous and more fetid of the varieties. Imagine you are casually walking down the street in Changsha, checking out the local shops and doing some people watching, when out of the blue you run into a wall. You are surrounded by a mephitic fug, as if somebody were burning a pile of Satan's unwashed gym socks. It takes a moment to track down the source of this olfactory assault until you see the guy on the street frying up what looks like soft charcoal briquettes. There's your stinky tofu. How does it get so stinky and so black? It has been fermented with a special, secret brine for several months. Now, I'm not the first to say it and I hope I won't be the last, but here's the thing: it tastes much better than it smells. For about 5 RMB, you get a couple of chunks of stinky tofu topped with some pickled vegetables and some cilantro. This being Hunan, there is some spicy stuff thrown in as well. The tofu is soft and warm, with a taste like a fine cheese. The black part adds a touch of crispiness

to the outside of each brick, holding the insides in just long enough to get into your mouth. When mixed with the toppings, it is a perfect representation of Hunanese cuisine: salty, spicy, and mouth-wateringly good. So, I urge you: next time you have the chance, go against anything your nose is telling you and give chòu dòu fu a try. I think you'll find it worth your while.

Key words: tofu, stinky, black, spicy

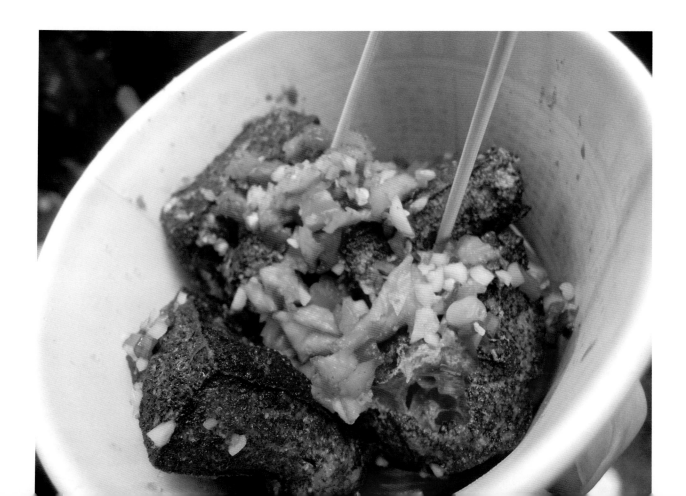

糖油粑粑

Táng Yóu Bā Bā

COST: 3 RMB

The táng yóu bā bā in Changsha is nearly identical to the táng yóu bā in Wuhan; any differences between them are slight, although not non-existent. Just like in Wuhan, táng yóu bā bā begins with a golf-ball-sized glob of glutinous rice. The rice is fried and then coated with a sugary, caramel glaze. As the glaze cools, it hardens into a sugary shell, giving the final product a satisfying crunch. Of course, underneath that crunchy exterior, the glutinous rice is soft and gooey, even more so than the táng yóu bā in Wuhan. There are no flavors involved here except pure sweetness, making it a great snack for those with a sweet tooth (you know who you are). No surprises here; just warm, gooey rice inside a crispy, caramelized shell.

Key words: glutinous rice, gooey, sweet, crunchy

红烧猪脚

Hóng Shǎo Zhū Jiǎo

COST: 10 RMB

Braised pig's feet, a specialty of Hunan Province, are a rich and delicious snack. They are boiled with water, scallions, ginger, and wine until nice and soft, and then fried with ginger, scallions, peppers, star anise, soy sauce, and other spices. What you end up with is a bowl of perfectly cooked pig's feet sitting in a shallow pool of salty, spicy broth. The skin on the feet is rubbery and chewy, while the meat within is rich and fatty. They are extra juicy from the braising process, meaning that you are very likely to need a napkin to wipe the grease and soup from your chin. Hot, spicy, and fresh, these pig's feet are a far cry from the pickled feet lying on dusty supermarket shelves in the West. For an alternative cooking method that might be even better, check out the roasted pig's feet in Kunming.

Key words: pig's feet, fatty, spicy, salty, rubbery, juicy

甜酒冲蛋

COST: 5 RMB

Fermented rice, a dash of rice wine, and egg, when combined in just the right proportions, make for an excellent soup. Tián jiŭ chōng dàn, popular all over Hunan Province, is that soup. It begins with glutinous rice, which is soaked for two hours to soften and plump, and then steamed for another hour or so. Technically, the rice is ready to eat at that point, but not if you want tián jiŭ chōng dàn. After the steamed rice has been prepared, the vendor will add in a fermentation catalyst called jiŭ qū and then cover the rice for about a day and a half, giving it ample time to take on the sweet fermented flavor of the rice wine. Once all that is done, the newly fermented rice is boiled with some eggs, rice wine, and sugar, finally resulting in a hot bowl of tián jiŭ chōng dàn. The rice is puffy and soft, and everything has a sweet, lightly alcoholic tang. It works equally well as an appetizer or as a dessert, making it a wonderfully versatile dish that comes highly recommended.

Key words: rice, egg, wine, sweet, soup

214

葱油粑粑

Cōng Yóu Bā Bā

COST: 3 RMB

Don't let the donut-like appearance fool you—cōng yóu bā bā shares little with those sweet tori of dough. In fact, their only similarities are their shape and the fact that they are deep fried. The batter for cōng yóu bā bā is made from rice flour and water, with a generous mound of chopped green onions thrown in for color, flavor, and texture. This batter is scooped into a donut-shaped mold and fried, bubbling and sizzling until it is golden brown and firm. Since this is not a wheat- and yeast-based dough, it doesn't rise at all in the cooking process. The final product is flat, like a deflated donut. On the outside it is crisp and greasy; the inside is soft and airy, nearly hollow in some places. With its salty, oniony taste, it is a very pleasant, if rather unhealthy, Hunan snack.

Key words: salty, oniony, rice flour, fried

刮凉粉

Guā Liáng Fěn

COST: 5 RMB

Chances are good that almost anybody who has spent a decent amount of time eating street food in China has eaten liáng fěn. You remember that milky gray jelly made with mung bean starch, usually sliced into long rectangles, right? That's liáng fěn.It's both common and popular in a number of different cities in Western and Northern China. Here in Changsha, you can try an interesting variation on traditional liáng fěn: guā liáng fěn. Changsha's version begins in roughly the same way as the regular liáng fěn—mung bean starch is boiled, and then cooled to create a block of wiggly, opaque jelly. Instead of slicing the block up, vendors serving guā liáng fěn will scrape off pieces with an unusual implement that looks like a cross between a spoon and a cheese grater. Just like cheese oozing through the holes of a cheese grater, the mung bean jelly slides out in thin, noodly slivers. All that's left to do now is to mix the strips of liáng fěn with some sesame seeds and oil, pickled vegetables, and spicy chili sauce. It is slimy and cool, with a tasty mixture of spicy and sour flavors. Any variation on chilled mung bean starch jelly is okay by me, and this one is no exception—give it a shot for a refreshing, spicy snack on a hot day.

Key words: mung bean, slimy, cool, spicy, sour, pickled vegetables

白粒丸

Bái Lì Wán

COST: 5 RMB

Generally, when you see a Chinese soup full of squishy rice balls, it is going to be sweet. However, you'll find an exception here in Hunan, where nearly everything has some kick to it. Bái li wán are marble-sized balls made of soaked rice that is mashed into a sludge, packed into a tight box, and then drizzled through holes in the bottom of the box into boiling water. While they cook, the vendor will toss in some sesame oil, mustard greens, celery, peppers, green onions, and other similar vegetables. In the end, you're left with some squishy globs of rice hanging around in an oily, spicy, light brown broth speckled with green and red flecks of vegetables. Because they are prepared differently, the rice globules are not as dense and firm as the rice balls in some other Chinese dishes. They are, in fact, quite soft—closer to a pudding consistency than a rice consistency. It's a wonder they can hold their shape at all. Visually, there is a lot going on with this soup, but taste-wise it's fairly simple—just prepare yourself for spiciness, oiliness, and squishiness.

Key words: spicy, soup, rice balls, squishy, oily

龙脂猪血

Lóng Zhī Zhū Xuè

COST: 6 RMB

There's something admirable about a culture that utilizes every part of an animal (if you're going to take a life, you might as well wring as much good use out of it as possible, right?). So I have to admire the Chinese for the ways they use animal blood, such as in Changsha's lóng zhī zhū xuè. In this case, the blood in question is pig's blood (zhū xuè). As with most edible blood in China, it has been solidified and looks like a rusty-red tofu. The block of blood is sliced into mahjong-tile-sized morsels, and then cooked in a broth very similar to the one in bái lì wán (water, sesame oil, chili oil, green onions, and soy sauce). Pig's blood has a rich, meaty taste that isn't nearly as ferrous as you might expect. It has the consistency of firm tofu, with a slimy-smooth surface and a porous, spongy interior. The broth is spicy and salty, dappled with small puddles of oil on the surface. Like bái lì wán, lóng zhī zhū xuè has a festive, speckled appearance, with its reds and greens and yellows. The final verdict: if you're looking for a tasty way to eat every part of an animal, Changsha's pig's blood soup is as good a place as any to start.

Key words: pig's blood, spicy, soup, oily, rich

湘宾春卷

COST: 5 RMB

Anyone with even a passing knowledge of Chinese food is probably familiar with spring rolls. Not only are they popular in different parts of China (and elsewhere in Southeast Asia), they are available in virtually every single Chinese restaurant in the Western world. The only reason to include them in a book meant to highlight extremely local street foods would be if a city has their own local twist on the old favorite. For Changsha, xiǎng bīn chūn juǎn is that local twist. Like all spring rolls, these have crispy, golden shells that are stuffed with vegetables and meat. This stuffing is what distinguishes xiǎng bīn chūn juǎn from other spring rolls. On the vegetable side of things, they offer cabbage, chives, and shepherd's purse (a protocarnivorous plant in the mustard family). Representing the meat, you will find savory shreds of smoked pork. As spring rolls go, these are the tops—they have a really wonderful smoky flavor, as well as the greasy, crispy goodness you already expect from a spring roll.

Key words: spring roll, greasy, crispy, vegetables, smoked pork

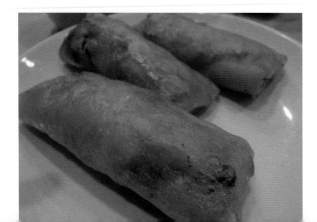

长沙米粉

Chángshā Mǐ Fěn

COST: 7 RMB

Although its cousin to the southwest (Guìlín mǐ fěn) is arguably both more well-known *and* more delicious, Chángshā mǐ fěn is still a pleasant enough bowl of noodles. There's not much to it—long, semi-round rice noodles bathe in a bowl of spicy broth underneath large chunks of beef or pork. The meat is juicy and tender, the broth is peppery and oily, and the noodles are slurptastic. That sums up this perfectly serviceable bowl of rice noodles.

Key words: rice noodles, spicy, oily, beef

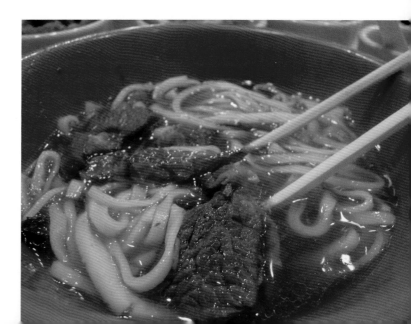

Inner Mongolia

Erlian

蒙古包子

Měnggǔ Bāo Zi

COST: 15 RMB FOR 10

Erlian is primarily known and visited as a border town. A gateway to Mongolia, and the edge of China. As such, it is no surprise that the city's culture and cuisine have just as much in common with Mongolia as with China. A good example of a food that straddles the border is měnggǔ bāo zi, or Mongolian steamed buns. Bāo zi are one of the most immediately identifiable Chinese street foods. They are prevalent in virtually every city in the country. In Erlian, though, the bāo zi offer a somewhat different flavor due to the Mongolian influence on the city. They have just as much in common with Mongolian buuz as they do with Chinese bāo zi (some researchers note that they even have similar etymological roots). In terms of size, these Mongolian bāo zi are a bit smaller than the standard Chinese bāo zi, but larger than, say, xiǎo lóng bāo. The thick skins are stuffed to the brim with large, juicy chunks of mutton, onions, scallions, and garlic. It is nearly impossible to eat them without ending up with a shimmering trail of mutton grease on the corners of your mouth—to me, that is a clear indication that you are eating

something delicious. These are the kind of succulent steamed buns that will make your mouth water just to think of them, and make you wish there were a few more after you have finished. Most people only end up in Erlian on the way to and from Mongolia, treating the city as a mere backdrop. While you are passing through Erlian, though, I encourage you to consider grabbing a plateful of měnggǔ bāo zi—it's hard to ask for a better way to transition between the two cultures.

Key words: dumplings, mutton, onions, juicy

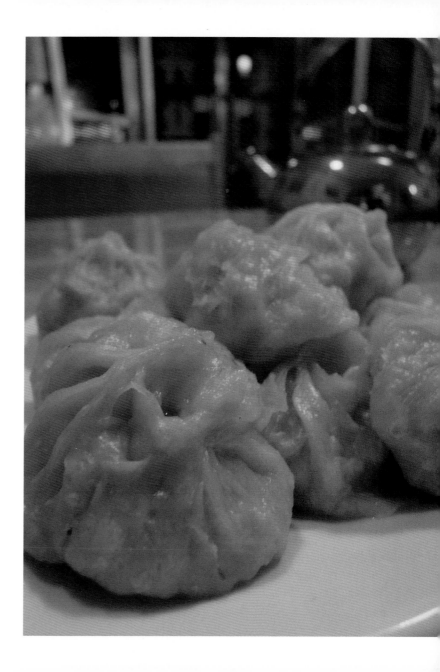

Hohhot

烧卖

Shāo Mài

COST: 8 RMB

Shumai are well-known outside of China, as they make frequent appearances on dim sum menus around the world. As they are typically associated with dim sum, they are generally thought of as a Cantonese food originating in Guangzhou. It may come as a surprise, then, that there is a strong historical case for Inner Mongolia to be the birthplace of shumai. Of course, the shumai that you can eat in Hohhot are somewhat different than those down in the southern part of China. They look roughly the same: steamed dumplings with thin wrappers and a frilly, open top. The differences are mainly in the fillings. Hohhot shumai are stuffed with a mixture of mutton, ginger, green onion, and spices. They have a piquant flavor thanks to the ginger and a rich, greasy flavor from the mutton. As with other shumai, Hohhot shumai are steamed in bamboo baskets and served in groups of six or eight with a dipping sauce (usually vinegar or chili oil). They are lovely little bundles of flavor that are well worth investigating when you are in Inner Mongolia.

Key words: dumplings, mutton, ginger

炒羊杂

COST: 7 RMB

Sheep organs: come and get 'em! Stomachs and livers and kidneys and hearts and intestines and sundry other innards all make an appearance in this dish. They are sliced and stir-fried with peppers (green, red, and chili), potato, ginger, garlic, and scallions to make a great big pile of food. It is aesthetically pleasing to all of the senses except hearing: vibrantly colored, fragrant, full of diverse textures, and, of course, quite tasty. Every organ has its own flavor and texture, which contributes to the complexity of the dish. Sheep organs aren't for everybody, but if you are comfortable with the general idea, then this dish will likely be a winner in your book.

Key words: sheep offal, ginger, stir-fried

酸奶炒米

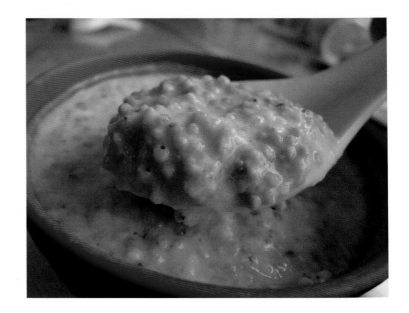

COST: 4 RMB

Here we have a delightful breakfast food that will be at once familiar and unusual to Western palates. All it is, really, is millet and yogurt. Think of it as Mongolian breakfast cereal—it is, after all, grains and dairy. The millet has been processed in a complicated way that involves soaking, steaming, frying, and grinding, until you are left with crunchy little puff balls. Millet like this pops up with some regularity in Chinese Mongolian food, presumably in part because it grows well in that climate. For this dish, the millet is mixed in with some sour yogurt and maybe a little bit of sugar. There's not much to it, but its simplicity is its charm. It's a creamy, crunchy, sweet-and-sour way to start your day in Inner Mongolia.

Key words: yogurt, millet, sour, creamy, crunchy

黄油炒米

COST: 4 RMB

Huáng yóu chǎo mǐ originated in Mongolia—its presence in Hohhot is a good example of the ways that Mongolian culture has permeated this part of China. There are three main ingredients, listed here in order of prominence: butter, crispy millet pellets (the same ones you'll find in suān nǎi chǎo mǐ), and sugar. Butter is the reason why huáng yóu chǎo mǐ is such a guilty pleasure. You are essentially eating a bowl of butter, with some millet for texture and sugar for taste. It is as delicious and unhealthy as it sounds. The butter is rich, sweet, and creamy; the millet offers a satisfying crunch for contrast. It is served chilled, so the butter is firm enough to retain its shape while you dig in. All in all, this is a rich, decadent treat. Though I personally ate it in below-freezing temperatures, I suspect eating this dish would be a wonderful way to pass a lazy, hazy Inner Mongolian summer afternoon.

Key words: butter, sugar, millet, sweet, cool, crunchy

奶茶

Nǎi Chá

COST: 3 RMB

If you are used to milk tea in the Hong Kong style, or even just tea with milk, you are in for a surprise. Inner Mongolian milk tea is usually made from black tea that has been pressed into a block for easy storage. Whoever is preparing the tea will break off a piece of a tea block and steep it in boiling water. The tea leaves are filtered out and milk is added for more boiling. After the second round of boiling, the chef will add butter, salt, and probably a bit of fried rice or milk skin for texture (the milk tea I ate and photographed also included some mushroom, although I understand that is not very common). This tea is somewhat unusual to a Western palate, with its salty, buttery, and bitter flavors. This particular combination turns some folks away, but I'd encourage you to give it a try. If nothing else, most times you order it at a restaurant or roadside stall it is served in an ornate brass tureen, making it feel like a special occasion every time you drink it. Inner Mongolian milk tea is a popular drink in homes and in restaurants throughout the region—if you want to experience the local culture, milk tea is a must-try.

Key words: tea, milk, butter, salty, rice

莜面窝窝

COST: 6 RMB

For two reasons, it might not make sense to include this visually striking dish here. First, it is not endemic to Inner Mongolia—it is also popular in the northern part of Shanxi Province, where some say it originated. Second, it is right on the border of what one might accurately consider a "street food." I have included it here because 1) I ate it in Hohhot, where I was told it was invented, and 2) although it is widely available in fancy restaurants, it is also commonly found in hole-in-the-wall joints that I would consider street food vendors. The name yóu miàn wō wō roughly means "oat noodle honeycomb," which is a pretty fair approximation. Tubes made of oat noodles (yóu miàn) are arranged upright and shoulder-to-shoulder in a bamboo steaming basket. Each tube is about the size of a short, fat finger. When you eat yóu miàn wō wō, you pick these tubes up one at a time and dip them into a dipping sauce of your choice. Sometimes they are served with soy sauce and vinegar, sometimes chili oil, and sometimes a mutton soup. By themselves, yóu miàn wō wō are somewhat bland, with a dry, wholesome, oaten flavor, so the dipping sauces are a tasty necessity. To be honest, I'm not sure how this dish evolved. The tubes are not a very efficient way for the diner to fill up, nor are they a particularly effective vehicle for sauce delivery. However, they do have a distinctive and pleasing look, and they are excellent for sharing. It seems to me that these noodle tubes, hearty and easy to eat, would be an ideal snack to order with a group of friends to munch on over good conversation.

Key words: oat noodles, hearty, dipping sauce

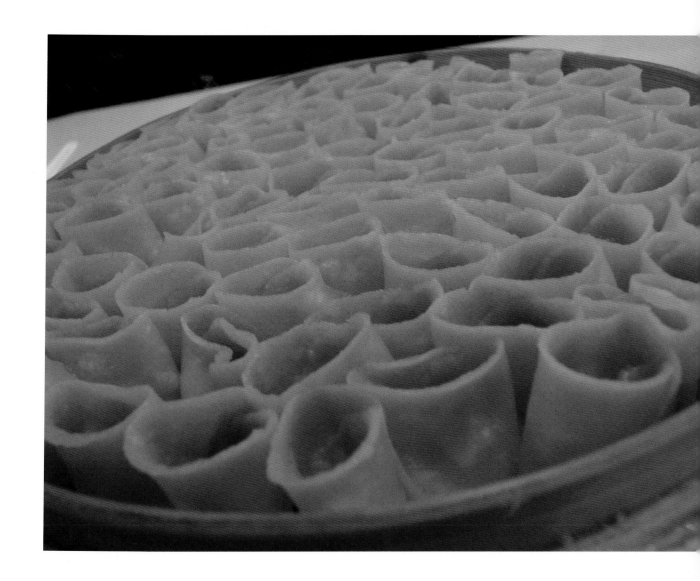

莜面洞洞

COST: 10 RMB

Yóu miàn dòng dòng is an interesting cousin to yóu miàn wō wō. Its base is also yóu miàn (oat noodles), but instead of rolling it into a finger-sized tube, it is topped with a mixture of vegetables (usually potato, carrot, cucumber, or cabbage) and then rolled up into a spiral. It resembles an American-style sandwich wrap that has been cut into slices. Once again, you will receive a dipping sauce for the yóu miàn dòng dòng; the best choice, for my money, is vinegar and garlic, which adds a certain sour sharpness to the rolls. Between the soft (but firm) oat noodles and the crisp julienned vegetables, each bite offers a nice contrast of tastes and textures. These don't share as well as yóu miàn wō wō, but they are redeemed by their superior flavor, so all is well.

Key words: oat noodles, vegetables, spiral, dipping sauce

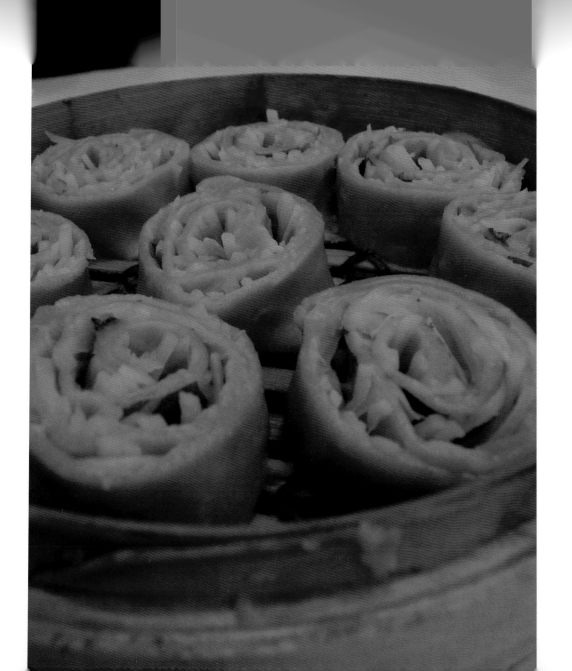

焖面

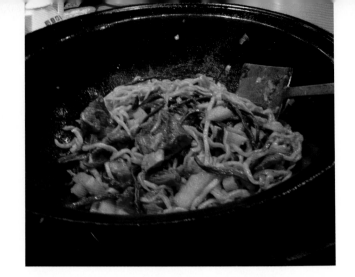

Mèn Miàn

COST: 10 RMB

Fair warning from the outset: bring a friend with you if you are going to try Hohhot's mèn miàn. The portions most vendors prepare are meant to be shared. That being said, this is a very tasty pan of braised noodles, so I don't think you'll have any trouble finding a friend willing to join you. To prepare mèn miàn, a vendor begins by frying wheat noodles in a large pan with some chili oil, aniseed, onion, ginger, garlic, and any other spices the cook deems necessary. Most times, the recipe will also include some large chunks of meat (pork, beef, or chicken), potato, and what I've been told are called "hyacinth beans" (they resemble what we might call "string beans"—green beans that are cooked and eaten without being removed from their long, thin pod). After pan-frying all of these ingredients for a little while, the vendor adds some water to the pan and covers it to steam for five to ten minutes. When it is uncovered again, you are left with a big pile of chewy, savory noodles; juicy, braised meat; wrinkly, withered bean pods; and lots of flavor. The braising process allows the ingredients to comfortably soak up all of the flavors from the oils and herbs and spices. This is a heavy, greasy dish that will fill you right up, so be sure to bring an appetite.

Key words: braised, noodles, meat, beans, filling, greasy

Jiangsu

Nanjing

鸭血粉丝汤

Yā Xuè Fěn Sī Tāng

COST: 7 RMB

Everything you really need to know about yā xuè fěn sī tāng is right in its name: duck's blood and vermicelli soup. This soup is an irreplaceable part of Nanjing cuisine. The broth is oily with a touch of spicy chili heat, and densely packed with long and slippery vermicelli noodles. The glassy noodles are made of either mung beans or yams. Although they don't have much flavor on their own, what they do superbly is function as a base for the broth and the duck's blood. Naturally, the highlight of this dish is the duck's blood. Upon hearing the name of the dish, you might suspect the blood to be the liquid basis of the broth in the soup. In fact, the blood has been fermented, and is served in solid blocks with the shape, texture, and consistency of tofu. The taste, however, is quite unlike tofu. It doesn't have the metallic taste you might expect from fresh blood, nor does it taste like duck. That being said, there is a very clear taste of an undefined "meat" in the blocks. Sort of like a meat-based broth—you can tell it came from an animal, but it doesn't exactly taste like beef or chicken. Traditional yā xuè fěn sī tāng also includes some duck entrails such as gizzards, intestines, and livers for additional taste and

texture, but not all vendors use them. The noodles, broth, and duck's blood work together to create a complex and delicious bowl of soup. In short, Nanjing is a city with a rich cultural history, and yā xuè fěn sī tāng is an indelible part of that history. If you want to get a taste of the local culture, you can't leave the city without trying a bowl of this.

Key words: soup, duck blood, vermicelli, dense, spicy

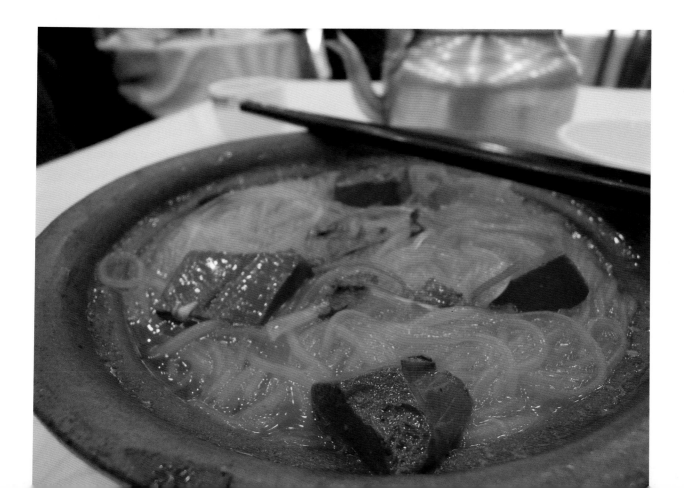

酒酿小元宵

COST: 4 RMB

In China, regional spins on the basic sweet glutinous rice balls in soup abound, though many of the local versions may seem essentially identical to an outsider's palate. Here in Nanjing, jiǔ niàng xiǎo yuán xiāo is the traditional take on the standard recipe. Small, plump marbles of glutinous rice and grains of fermented rice are suspended in a sweet, viscous syrup. Sometimes the recipe includes small osmanthus blossoms, giving it a fragrant floral quality. The rice has a subtle hint of alcohol thanks to the fermentation process, which mixes nicely with the sweetness of the syrup. Texturally, the dish is dominated by the gummy balls of rice and the thick syrup—also a nice combination. Jiǔ niàng xiǎo yuán xiāo isn't a particularly complex dish, nor is it hugely different from similar dishes in other Chinese cities. However, it would be a shame for you to skip this snack, because special or not, it is a delicate and refreshing dessert soup—an enjoyable end to any meal.

Key words: glutinous rice balls, fermented rice, syrup, sweet

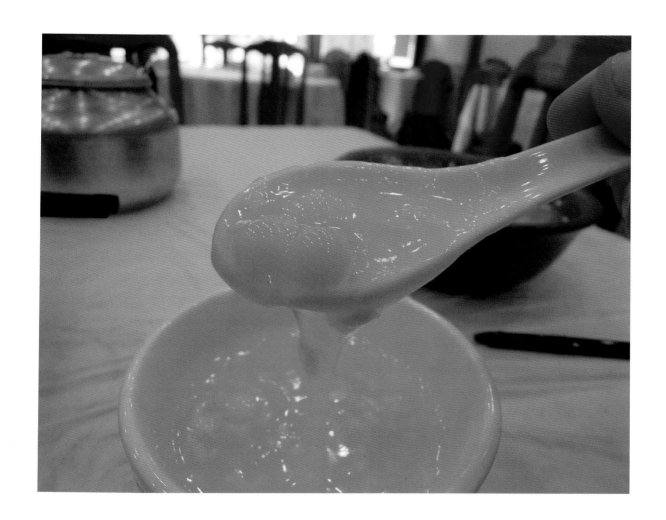

七家湾牛肉锅贴

COST: 4 RMB

Qī jiā wǎn niú ròu guō tiē, the fried dumplings which originated in the Qī Jiā Wān district of Nanjing, are one of the Muslim community's contributions to Nanjing cuisine. The name Qī Jiā Wān, or "Seven Family Bay", refers to seven aristocratic Muslim families that settled in the area about 600 years ago. The district became a hub of Muslim activity in Nanjing, and it remains so today. Although qī jiā wān niú ròu guō tiē are available in all parts of the city, your best bet is to look in the district after which they are named. And I do recommend seeking them out, for they are fantastic. In the simplest terms, qī jiā wān niú ròu guō tiē are pan-fried beef dumplings. These plump, crescent-shaped dumplings, each about four inches long, are little packets of joy. Inside each dumpling you'll find minced beef mixed with spices such as salt, ginger, and pepper, as well as a dash of soy sauce. (These fellas don't bother messing around with any vegetables.) They are fried with a generous layer of oil in a wide pan until the outside is crispy and golden. Beneath that crisp shell, however, the insides remain soft and unbelievably moist—each bite is literally bursting with beef juice and oil. Crisp, juicy, rich, and oily, qī jiā wān niú ròu guō tiē are truly delectable Nanjing treats. One order will yield you five or six dumplings; as good as they are, you might want to get a double order.

Key words: beef, dumpling, pan-fried, juicy, recommended

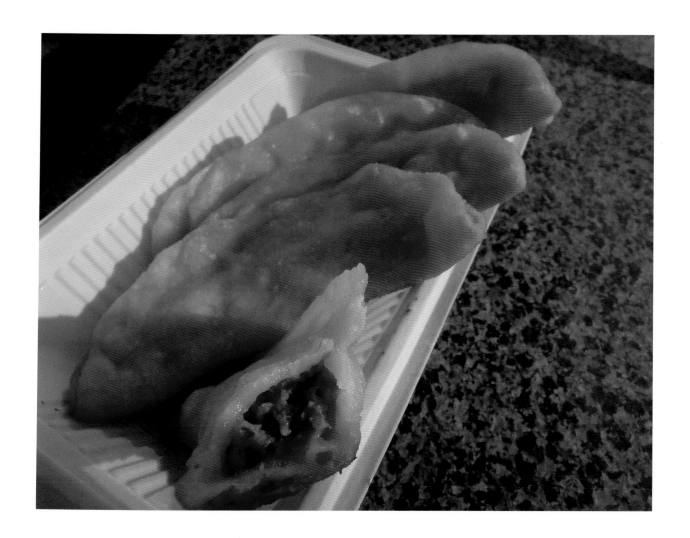

鸭头

COST: 10 RMB

Believe it or not, duck heads don't have a whole lot of meat on them (shocking, right?). A less enterprising culture might consider throwing them away in favor of the more succulent duck meat below the neck, but not China. "Just because there isn't a *lot* of meat doesn't mean there is *no* meat," they say. So why let it go to waste? It's a fair question and a noble instinct. While noble instincts do not necessarily create enjoyable meals, Nanjing's duck head is actually pretty good. There are several ways to prepare this part of the duck. More often than not, though, you'll find it marinated in chili oil, which gives it a spicy flavor and slippery texture. It's up to you to work out how to eat it. If you can come up with some good strategies, you'll find that a duck head offers some interesting textures and tastes to an intrepid eater. Among other sections, you'll find some fatty skin around the cheeks, some chewy tongue meat (complete with an unexpected tongue bone), and a soft, mild-flavored, walnut-sized brain inside. To be sure, duck head is not an easy food to eat. If you keep at it though, I think you'll find it is worth the effort. I wouldn't eat it every day, but once in a while, when the urge strikes, it is nice to know that it is there.

Key words: duck head

ALSO TRY:

煮干丝 (Zhǔ Gān Sī), 旺鸡蛋 (Wàng Jī Dàn), 什锦豆腐涝 (Shí Jǐn Dòu Fu Lào)

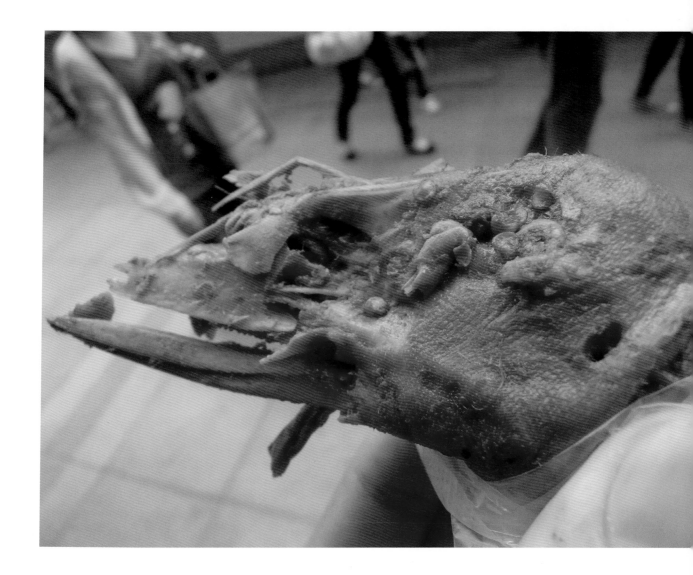

Suzhou

藏书羊肉面

Cángshū Yáng Ròu Miàn

COST: 15 RMB

When you think of mutton in China, you typically think of it as Northwestern kind of meat. A meat that comes from the areas of the country that are cold and have a large Muslim population. In other words, the parts of the country that are more closely related culturally to Central Asia than to East Asia. And yet here is a mutton and noodle soup in Southeastern China. It may seem like an anomaly, but this dish is famous throughout the region. The mutton technically comes from a small village near Suzhou called Cangshu, which means "hidden books." The town's legend goes back 2,000 years ago to the Qin Dynasty when the emperor was trying to root out intellectuals, killing scholars and burning books left and right. Suzhou was well-known at the time as one of the centers of China's scholarly world. The intellectuals and Confucianists in Suzhou, fearing for their lives, went out into the countryside and found a good place to bury their books before retreating back to the city to lay low for a while. Some years later when the danger had passed, they returned to dig up their books and resumed their studies. Unbeknownst to those scholars, though, during the years the books were buried, the wisdom contained within had seeped out and made its way through the soil to the sheep feeding on the pasture. Ever since, Cangshu sheep, having fed on the wisdom of the ages, have gained a reputation for their wonderfully mild taste. (Some people say that the taste comes from the castration inflicted on the Cangshu rams, but those people don't understand the value of a good story.) All of that is to say that the Cangshu

mutton is what makes Suzhou's mutton noodle soup so tasty. The noodles are long and slippery—slurping is required—and the soup is oily and salty. Most diners add in an optional dollop of chili sauce for a spicy kick. I'm told that this soup is most often eaten around the Spring Festival, but you can likely find it all year round. Give it a try and see if you can taste the 2,000-year-old wisdom.

Key words: mutton, noodles, soup

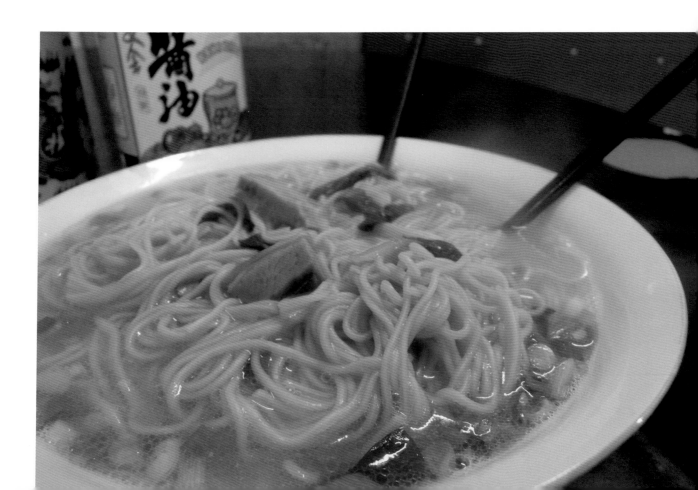

年糕

COST: 5 RMB

Nián gāo, or New Year cakes, are available all over China in a wide variety of shapes and sizes. Suzhou has a particularly unique variation. What all nián gāo have in common is that they are sweet and made of glutinous rice; they are also generally considered to be a Spring Festival treat (but don't let that limit you—you can buy them any time you like). Suzhou's nián gāo are thick and rectangular, like small bricks, and come in a wide variety of colors and patterns (checkers, stripes, zigzags, etc.). That alone is special enough, but what really separates Suzhou's nián gāo from their peers is the flavoring. Instead of the honey or sugar flavors you often get in other parts of the country, Suzhou's nián gāo are flavored with mint, fragrant osmanthus, or other similar floral tastes. They are chewy, aromatic, dense, and sweet—a lovely way to ring in the new year.

Key words: glutinous rice, colorful, fragrant, chewy

海棠糕

COST: 4 RMB

A close cousin of méi huā gāo, hǎi táng gāo is a sweet baked pastry stuffed with red bean paste. Shaped like a hockey puck, white on the bottom and golden on top, it is a nice little treat. Ingredients of the cake itself include rice flour, sugar, sesame seeds, and lard, all of which are mixed together, stuffed with sweet red bean paste, and baked in a special iron mold. The base of the pastry is soft and airy, but the top is caramelized to a light crisp. Inside, the red bean paste is smooth and sweet-but-not-too-sweet. Tasty and simple, it's a lovely pastry that's worth checking out.

Key words: rice cake, red bean paste, soft, crispy

烧饼

Shāo Bǐng

COST: 1 RMB

These small, round sesame breads are made with a fun and unusual method of baking. The sticky dough is rolled out into discs about the diameter of a grapefruit and a centimeter thick. These discs are slapped onto the inner walls of a giant metal drum with a heat source inside (coals, fire, etc.). Because the dough is sticky, the discs adhere to the inner wall for the duration of the cooking time. Occasionally the vendor will flip them onto the other side to ensure balanced baking. When they are nice and toasty, they are removed from the inside wall, sprinkled with sesame seeds, and placed on the flat ring surrounding the entrance of the drum, where they can stay warm for any passersby such as yourself. Taste: a little bit sweet with a familiar doughy flavor. Texture: thin and crispy on the outside, soft and chewy on the inside. Verdict: yummy and cheap.

Key words: bread, sesame seeds, soft

梅花糕

COST: 3 RMB

This simple trifle of a street food is nothing to write home about, but it fits the bill if you are looking for something cheap and sweet. White flour is made into a light dough that is cooked in a special griddle riddled with cone-shaped molds. After the dough cones have cooked a bit, red bean paste is added into each cone. A glutinous rice cap is added on top, making this look a bit like an all-white ice cream cone. The cap typically includes other sweet ingredients such as rose water, raisins, rice balls, or dried plums. It tastes light, floral, and sweet, though the red bean flavor dominates. Be careful when you bite into it—the red bean paste can be tongue-burningly hot.

Key words: sweet, light, red bean paste, rose, dried plum, glutinous rice

Wuxi

酸辣汤

COST: 6 RMB

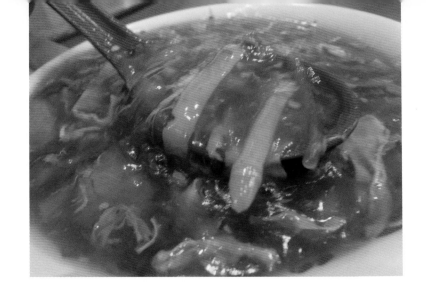

Here is a local variation on a street food popular in many parts of China, as well as in Chinese restaurants around the world: hot and sour soup. The yam-starch based soup is so thick that it is very nearly a gravy. Within you will find bamboo strips, beef, earthy wood ear mushrooms, shredded bean curd, glassy noodles, wisps of egg, wheat gluten, and peppers (the source of the "hot"). On top of all that, it is flavored with soy sauce and vinegar (the source of the "sour"). The thickness of the soup suspends the ingredients within, allowing them to languorously curl around the bowl. The hot and sour flavors are distinct from one another. Wuxi's hot and sour soup is a local take on a classic dish—if you have only ever tried the American strip mall Chinese restaurant version, make it a point to try the real thing.

Key words: hot, sour, thick, winter bamboo shoots

252

玉兰饼

Yù Lán Bǐng

COST: 2 RMB

Yù lán bǐng has to be one of my favorite Chinese street foods in the "small snacks" category. The basic description is simple: a fried, hollow ball of glutinous rice is stuffed with a sweet pork meatball. That's all it is. And yet it is completely delicious. The glutinous rice ball is fried to a crisp golden brown on the outside, while the interior is left white and sticky. The pork meatball inside is mildly sweet (some vendors' recipes include rosewater!) and succulent—very juicy. A lot of meat-in-dough foods in China end up with the stuffing clinging pretty closely to the casing, but in the case of yù lán bǐng the pork and the rice are distinct from one another. Like two nesting dolls, the meatball just sits inside of the glutinous rice ball. This unassuming little snack is oily, sweet, chewy, and meaty, just bursting with juice and flavor. Buy yourself one or two, or even ten—you won't regret it.

Key words: recommended, glutinous rice, fried, pork, succulent

无锡小笼包

Wúxī Xiǎo Lóng Bāo

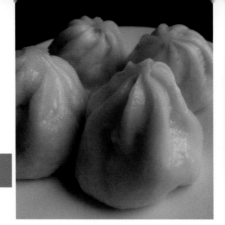

COST: 8 RMB

It's no surprise that Wuxi and Shanghai might share some street foods—they are only about 125 km apart. With Shanghai's immensely popular xiǎo lóng bāo available just down the road, Wuxi would have to make a compelling case if they wanted their xiǎo lóng bāo to count as a separate street food. Well, I've tried both and I can tell you this: the case has been made. In fact, I'd go so far as to say that depending on your preference, Wuxi might actually have the *superior* xiǎo lóng bāo (a bold statement, I know). The basic product is mostly the same as the Shanghai version: steamed dumplings, usually filled with pork, onion, ginger, and some spices. Alongside the solid dumpling filling you will find a spoonful of hot pork broth that will explode into your mouth when you puncture the skin with your teeth. There are two main differences between the two cities' xiǎo lóng bāo. First, Wuxi's dumpling skin is a little bit thicker, making each dumpling feel a bit more substantial. Second, and more excitingly, Wuxi's xiǎo lóng bāo have a wonderful sweetness to them. The meat and soup in the Shanghai version is salty and savory. The Wuxi dumplings have the salty and savory as well, but they are marvelously balanced by the sweet aftertaste. You'll have to try both versions to see which one suits you better, but for me and my major sweet tooth, the Wuxi xiǎo lóng bāo is the clear winner.

Key words: recommended, sweet, savory, dumpling, soup, steamed, pork

254

开洋馄饨

COST: 6 RMB

For those who have grown accustomed to Chinese food in the West, this bowl of wonton soup will be a largely familiar taste and a fine entry point for those looking to ease into Chinese street food. The key difference between kāi yáng hún tun and wonton soup at your average American Chinese restaurant is the filling: dried shrimp. Other than that, the dish is virtually indistinguishable from what you would get in the West. Soft wontons with loose, undulating edges sit in a thin, salty broth dappled with miniature pools of oil. Inside each dumpling you will find a mixture of dried shrimp, onions, garlic, and maybe some ginger. The soup keeps the dumplings soft and saturated with flavor. This isn't a flashy or exciting street food, but it is tasty, familiar, and warm—a Chinese comfort food.

Key words: wontons, dried shrimp, salty, soup

酒酿圆子

COST: 5 RMB

Soups are rarely desserts. They are often appetizers and occasionally entrees, but rarely outside Cantonese cuisine are they the sweet conclusion to a meal. Thankfully, rarely isn't never. Wuxi's jiǔ niàng yuán zi is one of the few dessert soups out there, and it makes a compelling case for the whole concept. The most immediately apparent ingredients in the soup are the marble-sized pellets of glutinous rice swimming around in the bowl. Surrounding the rice balls is a sweet, syrupy soup and some fermented rice, which gives the whole thing a subtle alcohol flavor. To top it all off, the vendor throws in some golden osmanthus buds for a floral taste and smell. This dish is the complete package: the rice balls are soft and squishy, providing some real substance to the soup, and the fermented rice, osmanthus blossoms, and syrupy soup base provide the flavor. Eat a bowl of jiǔ niàng yuán zi and you'll wonder why there aren't more dessert soups in the world.

Key words: sweet, syrupy, glutinous rice, fermented rice, osmanthus

Xuzhou

蛙鱼儿

Wā Yú Ér

COST: 6 RMB

Wā yú ér is essentially an orange soup full of chunks of potato starch. By the looks of it, you might expect it to taste like bland potato starch suspended in a slightly sweet watery fruit syrup. Thankfully, the looks are deceiving—the mix of flavors here is stunning. Every bite delivers a swirling mix of sweet, spicy, vinegary, and sour. As expected, the gelatinous potato starch globules are slippery and jelly-like. They provide texture and body to the wā yú ér, but the taste is all in the syrup. Individual house recipes vary (apparently it also varies between winter and summer—it can be served hot or cold). Mine contained pickled vegetables, some vinegar, a healthy dose of chili sauce, and an unidentifiable sweet ingredient. Other recipes include soy sauce, sesame oil, garlic, dill, mustard, and more. Apparently, the gelatinized potato starch can also be replaced with mung bean or pea starch. This dish was outstanding; consider it recommended most highly.

Key words: potato starch, spicy, sweet, sour, soup

羊角蜜

COST: SOLD BY WEIGHT

Here's another dish with an aptly descriptive name: "yáng jiǎo" means sheep horn, while "mì" means honey. These scrumptious little pastries are shaped like sheep horns, and locked inside each sheep horn is a secret cache of pure honey. These little guys are a delight. The wheat dough used to make the horn is fairly dry and brittle on its own. To add some flavor to the exterior, the horns are dusted with a fine powdered sugar. Be careful, as this sugar is liable to end up coating your hands and lips much like a powdered doughnut (woe unto he who attempts to eat them with a mustache). Inside, of course, the honey is sweet and gooey, just waiting for the cue of your bite to ooze out into your mouth. These sheep horns are like tiny treasure boxes with a golden surprise inside. Readers with a sweet tooth, like me, should note that these are sweeter than most things you are likely to find in China, so stock up while you can. Buy a handful or a bagful and snack away.

Key words: sweet, honey, pastry

蜜三刀

Mì Sān Dāo

COST: SOLD BY WEIGHT

Like Xuzhou's yáng jiǎo mì, mì sān dāo is a sweet, honeyed pastry with a colorful name and hundreds of years of history. In fact, you can usually buy both of them at the same bakeries. Mì sān dāo means "honey three knives," which refers to both the honey flavor and the three cuts traditionally gouged into the top of each pastry with a knife. This pastry is basically made with stacked layers of dough. The outside layers are soaked in a honey or malt sugar solution to create a glazed shell. This dough is fried in vegetable or peanut oil, dipped in more honey or malt sugar, coated in sesame seeds, and then cut up and served. The outside is crispy and glazed, with a sweet taste of honey and sesame. The inside is softer and tastes like dense fried dough. In some ways, this dish reminds one of both baklava (for the crispiness and the "soaked in honey" flavor) and doughnuts (for the fried dough). Like yáng jiǎo mì, you can buy as little or as much as you like. They last a while, so if you are a fan of sweet foods, you might consider getting a bag of them and keeping them with you while you travel.

Key words: sweet, honey, pastry, fried

烧饼狗肉

Shāo Bǐng Gǒu Ròu

COST: 15 RMB

One of the oft-cited reasons that Westerners are hesitant to try Chinese street food is the worry that they will unwittingly eat dog meat. In actuality, it is fairly unlikely that you will eat dog without planning to. For one thing, it's not a very common dish in most of China. Even where it is common, most locals, knowing that Westerners have an aversion to dog meat, will try to steer you away from it. That being said, if you are determined, dog meat is not impossible to find. This traditional dish from Xuzhou—basically a dog meat sandwich—is evidence of that. The bread for the sandwich is shāo bǐng, a disc-shaped, oven-baked flatbread common in Northern and Western China. Shāo bǐng tends to have a somewhat dense, spongy interior with a crispier exterior sprinkled with sesame seeds. Of course nobody buys this sandwich for the bread. The sandwich filling is all meat—no lettuce or tomatoes here. Dog meat is typically a bright, brownish-pink, giving a pleasing look to this dish. The meat is stringy, succulent, and fatty, with a strong gamey flavor. The vendor I visited included some peppercorns in the meat, giving it a bit of kick. To be honest, this dog meat sandwich was marvelous. The only thing keeping it from being the perfect sandwich is the nagging awareness that you are eating a dog. In the grand scheme of things, though, that's only a minor quibble. If you are an adventurous eater who can get past the idea of eating man's best friend, this should definitely be on your list of street foods to seek out.

Key words: dog, sandwich, peppercorns

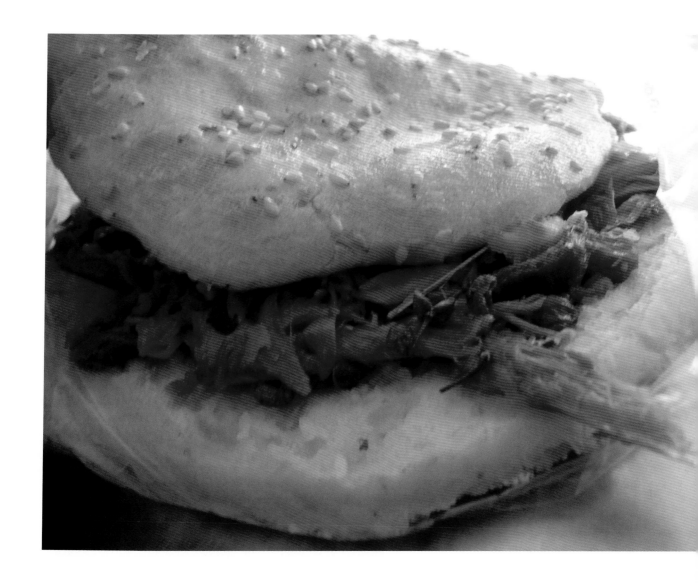

烙馍

COST: 5 - 15 RMB

Lào mó, also known locally as "luo mo" or "lo mo," is something like a Chinese tortilla that is quite popular not just in Xuzhou but all over the Northern parts of Jiangsu and Anhui Provinces. It is made of unleavened wheat flour rolled very flat and cooked on a covered griddle. People in Xuzhou eat lào mó in a variety of ways. My favorite way is the version pictured here. The vendor's stall will have a whole panoply of ingredients laid out for you to choose, such as meat, vegetables, tofu, eggs, and so on. The three or four you select will be wrapped up like a burrito. What's nice about this dish is that you can make it taste however you like. Feel like having something spicy? Choose the spicy meat. In the mood for some fresh vegetables? Limit yourself to some cabbage and cucumbers. The point is that you can do as you like. The price will, naturally, vary based on your selections. All options are good, so just follow your heart's desire.

Key words: flour tortilla, wrap, choice

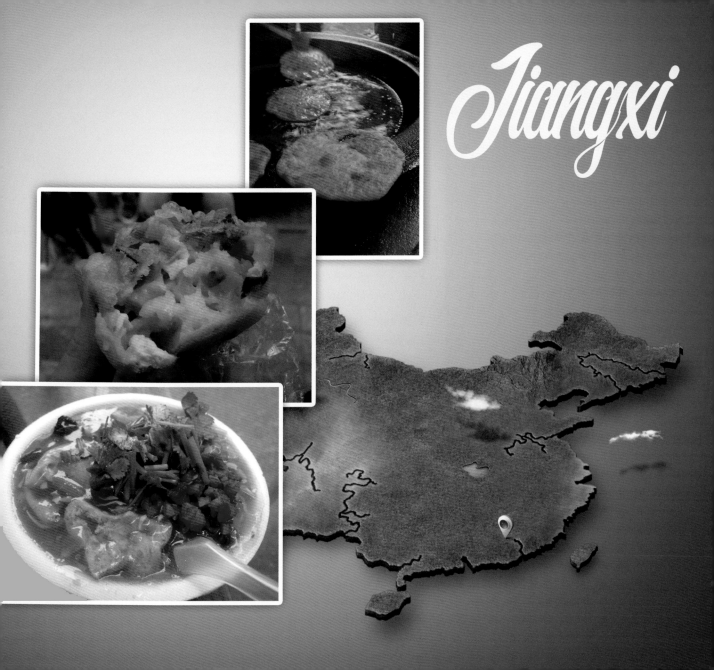

Jiangxi

Jiujiang

油糍

Yóu Cí

COST: 3 FOR 2 RMB

Believe it or not, this humble snack is the street food that started it all for me. After living in Jiujiang for a few months, I stumbled across a vendor selling these fried mystery pucks. I had never seen them before, and they beckoned to me. One taste was all it took: I was hooked. I had, of course, eaten street food before, but it was this little ball of flavor that turned it from a general interest in the street food scene to a passion. Yóu cí is made of a gooey batter consisting mainly of crushed glutinous rice, water, tofu, scallions, salt, and maybe a dash of sliced chili pepper. Globs of this batter are deep fried in a shallow cylindrical mold until they are golden brown and lightly crispy on the outside. The final product glistens with residual oil, signaling its intentions to be deliciously unhealthy. Within the oily shell, spongy glutinous rice and silky tofu compete for space, and we all win. Biting into a yóu cí is like sinking your teeth into a greasy pillow of pure joy—not a brand new fluffy feather pillow that

is mostly just air, but a denser, worn-in one that has already conformed to the shape of your head. The flavor is just what you would expect from this sort of street snack: salty and savory. Nothing complex or fancy; just humble deliciousness. Two or three bites and it is gone. Maybe it isn't anything special when compared with some of China's greatest street foods, but to my mind it epitomizes the very best of the street food culture in China. It's quick, cheap, portable, and so, so tasty. Not many tourists pass through Jiujiang, but those who do will enjoy seeking out this hidden gem.

Key words: oily, glutinous rice, tofu, spongy

春卷

Chūn Juǎn

COST: 2 RMB

Imagine the kind of spring roll you would get in a Chinese restaurant in the United States. Now stretch it out to about twice its length and half of its width. Replace the carrots, shredded cabbage, and whatever other fillings you find inside with jiǔ cài, a vegetable sometimes translated as garlic chive. Are you picturing it? Good. Then you are picturing Jiujiang's chūn juǎn (literally "spring roll"). It tastes exactly as you might expect it to. The golden, deep fried exterior is brittle, greasy, and crunchy, while the insides are moist and garlicky. Jiǔ cài has a terrific flavor, like a combination of leeks and garlic, and it is highlighted well in this simple snack.

Key words: greasy, spring roll, garlicky

萝卜饼

COST: 1 RMB

These scrumptious fried pancakes are primarily made of sliced radish, flour, and lard. The vendor will mix them together to make a batter, shape it into pancakes, and then fry them in a shallow pan of oil. After a few minutes of sizzles and pops, you are served a dense, brown disc. These thin pancakes are floppy and greasy, with a really nice pickled radish flavor and a chewy texture. Like the other street foods indigenous to Jiujiang, it's nothing complicated, but it's an enjoyable snack and a good way to cheer up your taste buds for pocket change.

Key words: radish, pancake, greasy

Nanchang

糊羹

Hú Gēng

COST: 4 RMB

The name hú gēng literally means "paste soup," which happens to be a pretty good description of this Nanchang specialty. The base is so thick and brown that it might be more accurate to call it a translucent gravy instead of a soup. Suspended inside the gooey soup base you will find chunks of chewy tofu, wood ear mushrooms, carrots, cilantro, chili sauce, tofu skin, bamboo shoots, and occasionally duck intestines. The tofu, full of flavors soaked up from the soup with its spongy pores, provides the dominant texture in the soup. This dish is hearty, savory, and served hot enough to warm you up on a cold day, which is exactly what people look for in a soup or a stew. Look for large metal pots cooking on the street corners to identify this—the best local dish in Nanchang.

Key words: thick, soup, tofu

南昌米粉

COST: 6 RMB

To be honest, Nanchang's take on rice flour noodles is not hugely inspiring. If you have ever eaten lo mein at a Chinese restaurant in the West, you have a pretty good idea of how this will taste. The massive pile of golden brown fried noodles is greasy, gummy, and salty, while the vegetables are few and far between. Different purveyors will include different ingredients with the noodles; the plate I got included some leafy greens and a couple paltry pieces of pork. The best thing to say about this dish is that it will fill you up quite handily (and sit heavily in your stomach) for a reasonably small price.

Key words: noodles, gummy, greasy

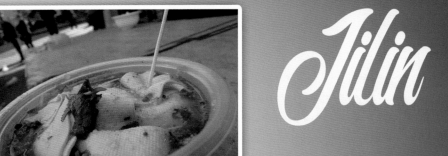

Jilin

Changchun

炒粉

Chǎo Fěn

COST: 6 RMB

Are you the type of person who likes gelatin desserts but wishes they were spicy instead of sweet? Yes? Good—in that case, you'll love this street food. The main ingredient is yam starch that is mixed with water, alum, and salt, and then stir-fried. This process gives you a glassy, golden-yellow pseudo-jelly that wiggles delightfully when shaken. This fried jelly is dropped into a bowl of oily sesame and chili-flavored soup along with some cilantro. The opaque, peanut-brown soup, dappled with bubbles of oil, is a pleasing mixture of sesame-sweet and chili-spicy flavors which readily soak into the starchy jelly. The spicy kick of the chili oil tends to overwhelm the sweeter sesame oil, so you might want to shy away from this if you aren't a fan of spicy foods. This unusual dish is a trademark of Changchun and should be near the top of your list if you want the most authentic street foods in the city.

Key words: yam starch, jelly, spicy, sesame

鸡汤豆腐串

Jī Tāng Dòu Fu Chuàn

COST: 4 RMB

There are two main components to this street food: tofu and chicken soup. The plain, white tofu is shaped like a belt—long, thin strips about the width of two fingers. It is firm, rubbery tofu, but quite flexible because it is sliced so thin. This tofu is also characterized by tiny, texture-giving goose bumps that cover its flat sides. The chicken soup is oily and spicy (thanks to the added chili oil), with a rich chicken flavor. Jī tāng dòu fu chuàn is served in a small bowl loaded with tofu ribbons, leaving a relatively small amount of space for the soup. This is a great snack; just enough food to stave off the hunger pangs earned from an afternoon walking around the city.

Key words: tofu, chicken soup, spicy

菜团子

COST: 2 RMB

Fairly similar to Chengde's bàng zi miàn wō tóu, this stuffed cornbread bun is a quick and scrumptious snack. If you were to make a standard Chinese bāozi with cornbread instead of rice or wheat flour, and then stuff it with Changchun's local version of sauerkraut, you would have cài tuán zǐ. The bun tastes sweet and corny, just as any good cornbread should. The bun is mostly dry on the outside, except for a few spots where the steaming process has left some condensation to soak into the bread. The inside is pleasantly soft and moist, thanks to the sour, vinegary juices of the sauerkraut seeping into the surrounding bread. These steamed buns are cheap and local, two of the best adjectives one could use to describe street food.

Key words: cornbread, sauerkraut, steamed bun

275

拌凉皮

Bàn Liáng Pí

COST: 8 RMB

Although liángpí originated in Shaanxi Province, it has spread all over Central and Northern China, and allowed individual cities to put their own stamp on the dish. Many of these regional variations are excellent, but for my money, Changchun has the best liángpí in China. The process of making liángpí involves soaking a wheat or rice dough in water until the starch from the dough has thoroughly muddied the water. The dough is removed and the starchy water is allowed to sit out overnight. In the morning, the starch in the water has settled into a paste at the bottom, which is then boiled, steamed, and chopped into the shape of noodles. These long, white noodles are usually coated in vinegar and chili sauce and served chilled. What makes Changchun liángpí extra nice is the addition of some thicker, spongier noodles. Local friends informed me that these noodles are made in a similar way to the standard liángpí noodles, but they are culled from a different part of the process. I'm not too sure how they are made, but I can say for certain that they are a marvelous addition to an already yummy dish. Their texture is unusual (always a plus in my book), and their porousness soaks up the flavor in new and exciting ways. Liángpí in Changchun generally comes with some cucumber strips, tofu, and coriander. It's spicy but not too spicy, sour but not too sour, and an amazing variation on a common Chinese dish. The best liángpí is not always found where you would expect (my best bowl was in a mall food court), so ask around and look for long lines. This stuff is worth the hunt.

Key words: noodles, spongy, spicy, sour

百合饭包

COST: 5 RMB

There are a number of ways that bǎi hé fàn bāo is prepared in Changchun. The unchanging basics are a large leaf of lettuce or cabbage wrapped around a mound of rice. Beyond that, the specifics may vary. Sometimes the rice is fried, sometimes it is steamed. Some vendors include meat in the rice, some do not. Most times the rice is mixed with vegetables and salty sauce, but occasionally it is plain. No matter how it is prepared, the way to eat this is to fold the lettuce around the rice and eat it like a sandwich. This dish offers two main textures: crunchy (thanks to the fresh lettuce) and sticky (compliments of the rice). Taste-wise it is nothing special. The best things this has going for it are its portability and the relative novelty of having uncooked leafy greens in China.

Key words: lettuce, rice

麻花

COST: 2 RMB

Má huā is more famously known as a Tianjin street food, but Changchun offers a variety just different enough to merit its own entry in this field guide. The easiest way to describe this sweet treat is as a braided Chinese doughnut. Compared to the Tianjin version, Changchun's má huā is sweeter, softer, and longer (about 20–25 cm). The frying process leaves the surface of the dense, chewy dough crispy and shiny with oil. Really, the only encouragement most readers will need to give má huā a try are the words "Chinese doughnut".

Key words: Chinese doughnut, braided, dense

姐弟俩土豆粉

Jiě Dì Liǎ Tǔ Dòu Fěn

COST: 10 RMB

Changchun boasts a lot of smaller, snackier street foods, so I was pleased to come across this more substantial dish. You would have no problem making a meal (or two) out of jiě dì liǎ tǔ dòu fěn—it is quite filling. Tǔ dòu fěn means "potato flour noodles," which make up the bulk of the dish. These noodles are thick, round, and glassy. Other than being a bit clearer and thicker, they are fairly similar to the yam flour noodles one finds in suān là fěn in the Southwest of China. Inexperienced chopstick users may have some trouble holding onto these eely noodles, so be prepared for that. The noodles are mixed with tofu, green vegetables, hard-boiled pigeon eggs, and chili oil to make a hearty and moderately spicy concoction, the whole of which is cooked and served in a heavy-duty clay pot, allowing the ingredients to stay hot and oily the whole time you are eating it. As noted above, this is a very filling dish, so I recommend either coming to the table very hungry or bringing a couple of friends along.

Key words: potato flour noodles, clay pot, oily

豆腐脑

Dòu Fu Nǎo

COST: 5 RMB

Dòu fu nǎo is a tofu soup available in several parts of Northeastern China. It is most often eaten for breakfast, so be on the lookout before 10 a.m. or so. The tofu in dòu fu nǎo is very soft, almost liquidy. It seems hard to believe that it retains any form at all. This soft tofu is served in a caramel-brown soup with carrot strips, coriander, and a small amount of chili oil, making it mildly spicy. Soy milk is a popular morning beverage throughout China, and it seems to me this is a natural extension of that trend. Dòu fu nǎo is almost like jellified soy milk in a spicy broth. Changchun, like much of China's Northeast, can get bitterly cold in the winter. A steaming bowl of dòu fu nǎo first thing in the morning is a great way to warm up and face a new day.

Key words: tofu, soup

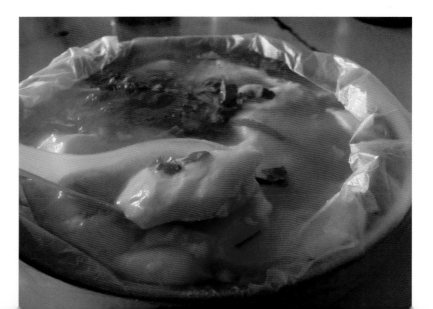

烤菜卷

COST: 5 RMB

Kǎo cài juǎn, or "roasted vegetable rolls," is a member of the "skewered and grilled" family of Chinese street food. For each serving, you will receive two bamboo skewers impaling three to five vegetable slices individually wrapped up in tofu skins. The tofu wrappers here are similar to the tofu strips in Changchun's jī tāng dòu fu chuàn. They are thin, firm (yet flexible), and covered in tiny goosebumps. Each sheet of tofu wraps around a slice of cucumber, scallion, radish, or other vegetable, creating a little bundle about the size of a small cigar. These little rolls are skewered, topped with chili sauce, sesame seeds, and other seasonings, and then grilled. When served, the tofu is chewy and a bit spicy, while the vegetables are crunchy and fresh-tasting. Most "skewer and grill" food in China is meat, making this a worthy and welcome alternative for traveling vegetarians who want to get in on the action.

Key words: tofu, vegetable, rolled, grilled

蜜汁梅肉

Mì Zhī Méi Ròu

COST: 5 RMB

Like kǎo cài juǎn, we have here another "skewer and grill" food. In every corner of China you can find vendors selling seasoned grilled beef strips. Mì zhī méi ròu has the same cuts of meat, but the seasoning is much different. In place of a coating of herbs and spices, you will find here a sweet honey glaze and sesame seeds. The glaze makes the beef shinier, stickier, pinker, and moister than your standard Chinese grilled skewers, and the sesame seeds add a neat nutty flavor. I wouldn't venture to say whether it is better or worse than those other beef skewers—that depends on your own preferences—but it is certainly different, and to my mind that's enough to make it worth trying.

Key words: grilled, beef, honey, sesame seeds

烤筋皮子

Kǎo Jīn Pí Zi

COST: 5 RMB

The third in a series of Changchun's "skewer and grill" foods. This snack is made of beef tendons. Many visitors from the West may not be accustomed to eating this part of a cow, but that shouldn't stop you from giving them a try. Tendons don't have too much flavor on their own, so these glistening, ivory-colored grilled tendons are sprinkled with chili powder and caraway seeds before serving. Unsurprisingly, they are tough, chewy, and slippery, like gristle. The caraway seeds add a subtle anise flavor, while the chili powder gives them a bit of oomph. These tendons are definitely more of a snack than a meal, so order a few to snack on while you wait for your dinner.

Key words: beef tendons, slippery, chewy

烤蚕蛹

Kǎo Cán Yǒng

COST: 8 RMB

The next in our series of Changchun's skewered foods is, from a Westerner's point of view, likely to be counted among the more "adventurous" street foods in China. What we have here are deep-fried silkworm pupae. Biting into one, you encounter several distinct parts of the pupa. First, the exterior shell is very thin, crispy, and shiny. The cooking process has made it hot and oily, as well as salty—this is where most of the seasoning has stuck. Next is the inner layer of the pupa, which holds most of the flavor. It is creamy and rich like pâté, with a buttery, nutty taste to it. At the core of the pupa you will find the remnants of the silk worm itself, which is considered an optional part of the dining experience since it doesn't add much to the taste. These snacks are a treat, with a much nicer flavor than you might expect. Entomophagy is not as common in China as it is in Southeast Asian countries, so if you are looking to try some insects here, seize the opportunity when you can.

Key words: silk worm pupa, crispy, creamy, nutty, salty

五花肉卷金针菇

Wǔ Huā Ròu Juǎn Jīn Zhēn Gū

COST: 5 RMB

The last in our set of skewered street foods in Changchun is sure to delight many. These little rolls, each about the size of one's thumb, are made of enoki mushrooms ("golden needle mushrooms" in the Chinese translation) wrapped in thin slices of what is essentially uncured bacon. The rolls are fried and seasoned with some sesame seeds, just a touch of chili powder, and other spices before being skewered and served. The pork belly is mouth-watering on its own, but throw in these long, golden mushrooms and you've got a whole new set of flavors and textures mixed in. You've got savory, earthy, meaty, chewy, crunchy, and greasy all going on at the same time. The bottom line: these little guys are delicious and definitely worth trying if you run across them.

Key words: bacon, mushrooms, fried

Jilin

糖醋鸡骨架

Táng Cù Jī Gǔ Jià

COST: 8 RMB

If you know enough Chinese to be able to understand the name of this dish, then you might be thinking that this evocative name is meant to be taken figuratively instead of literally. If so, you will probably be surprised to learn that you are (mostly) wrong. Táng cù jī gǔ jià ("sweet and sour chicken skeleton" for those who don't know Chinese) is, in fact, a pretty accurate description of what this is. I, too, was skeptical when I first heard of this dish; how could a chicken skeleton be considered food? Of course that's where the "mostly" qualifier comes into play. This dish is only *mostly* a skeleton. In other words, there is just enough meat left on the bones to make this an enjoyable culinary experience. To make táng cù jī gǔ jià, you first must remove most of the substantial meat from a whole chicken. Breast meat, leg meat, thigh meat—none of it is welcome here. What you are left with are bones with some scraggly pieces of meat hanging on between ribs, around joints, and in other similar hard-to-reach spots. The skeleton with its bits of meat is broken up, coated with a sesame-seed-infused, honey-sweet, vinegar-tangy sauce, then blackened on a grill. You, the diner, will receive a pile of chicken pieces to eat with your fingers. Because the only meat left is fairly insubstantial, you have to do a lot of digging with your teeth and fingers, a process which leaves your hands, lips, and chin greasy and sticky. It is a messy experience, not suitable for finicky eaters. The good news is that the taste

more than makes up for the mess. The sauce tastes quite similar to Western barbecue sauce (with sesame seeds), which naturally goes well with the char-grilled flavor. Honestly, it tastes just like the barbecued chicken you could eat in any United States backyard in July. The only difference is the ratio of sauce (read: flavor) to meat. For people who prefer more sauce to meat, táng cù jī gǔ jià could be the perfect solution. The best place in Jilin to buy a sweet and sour chicken skeleton is at Du Brothers (杜家哥俩烧烤). At only 8 RMB per chicken, this is a cheap and flavorful snack or meal. Just be sure to bring some napkins.

Key words: grilled, chicken, sweet, sour

烤明太鱼

Kǎo Míng Tài Yú

COST: 10 RMB

A quick glance at a map will show that Jilin Province and neighboring Liaoning Province are as close to North Korea as you can get while still being in China. Inevitably, Korean culture has infiltrated parts of this corner of China. One example of this is Jilin's kǎo míng tài yú. To be precise, kǎo míng tài yú actually comes from Yanji City, part of the Yanbian Korean Autonomous Prefecture within Jilin Province, but it has spread north to Jilin City. You can identify the vendors selling this street food by the rows of dried fish dangling from the eaves of their carts. When you order, the vendor will pull a fish down, fry it up, coat it in powdery spices, and serve it up. It tastes just the way you might expect—like dry fish with spices on it. The dry fish is something of an acquired taste and texture. It's thin and sharp, almost bony, with a strong fish flavor. The spices generously sprinkled on top are not "hot" spicy, but they are quite potent. If you are looking to try a taste of nearby Korea, I would recommend putting this near the top of your list of foods to try in China.

Key words: dry fish, spices

Liaoning

Dalian

烤鸡脖

Kǎo Jī Bó

COST: 4 RMB

Fans of chicken legs or wings take heed: roasted chicken necks taste just the same. The only major difference is that there are a lot more bones to contend with. They are spiced, lightly sauced, and roasted on a long grill. When you order them fresh off of the grill, they are hot, dry on the outside, juicy on the inside, and tender. Eat them slowly so that you don't accidentally swallow a bone. There isn't a ton of meat hugging those bones, but what is there is worth eating.

Key words: chicken, juicy, spiced, neck

老汤干豆腐

Lǎo Tāng Gān Dòu Fu

COST: 5 RMB

What looks like chicken skin or pimply noodles in a bowl of lǎo tāng gān dòu fu are actually sheets of thin tofu. This dried tofu skin, now remoistened by the soup, is pale yellow and covered in tiny goosebumps. It is sliced into rectangular sheets that are crumpled into a pile in the bowl. Surrounding the tofu is a spicy red soup, opaque with chili oil and ginger, along with a smattering of green onions, coriander, pork, and shallots. The tofu sheets billow in the soup, allowing the spicy broth to coat all of the nooks and crannies of the tofu. The tofu is firm without being rubbery, and the soup is a nice mix of flavors without being overly spicy. All in all, it's a pleasing dish that makes a fine dinner.

Key words: tofu skin, spicy, soup

294

炸鸡串

Zhá Jī Chuàn

COST: 3 RMB

Zhá jī chuàn is a perfect choice for travelers who are tired of being adventurous with their food choices in China. It is simple, familiar, and not challenging in any way. What you have here is chicken on a skewer, coated with batter, roasted, and covered in a spicy tomato paste. The coating is soft, like on beer-battered fish, the chicken is juicy and warm, and the sauce is tangy and just spicy enough. There's not much more to say—it is uncomplicated, easy to eat, and tasty.

Key words: chicken, battered, tangy, spicy

鱿鱼蔬菜炒饭

Yóu Yú Shū Cài Chǎo Fàn

COST: 8 RMB

Fried rice doesn't get much fresher than this. Yóu yú shū cài chǎo fàn is fried rice with vegetables and squid, and this combination is hard to beat. When you order this dish, you can select your favorites from a wide array of vegetables and other ingredients (e.g. eggplant, lettuce, eggs, tofu, mushrooms, etc.) to be fried on a large griddle with a whole gutted squid. It's nice being able to choose which specific vegetables you want to include; that way, the final product is really tailored to your individual tastes. As Dalian is a coastal city, the squid is extremely fresh. So fresh, in fact, that you can hear the flesh squeaking while the vendor slices it up on the griddle. One order gives you a massive mound of greasy rice, rubbery squid, and fresh vegetables. It is garlicky, heavy, and quite filling. It's nice being able to choose which specific vegetables you want to include; that way, the final product is really tailored to your individual tastes. Like the chicken above, this street food is a fine entry point for travelers uncomfortable with some of the more unusual street foods in China. This is quite similar to fried rice in Chinese restaurants around the world—just fresher and tastier.

Key words: fried rice, squid, fresh, vegetables, greasy, garlicky

Shenyang

吊炉饼

Diào Lú Bǐng

COST: 4 RMB

This scrumptious treat falls squarely into the "fried dough" category of street foods. The vendor rolls a tube of dough out, stretches it by hand, and then coils it into a tight spiral about the size of a hand. Next comes the frying. All fried food is greasy—that's part of its charm—but diào lú bǐng takes it to the extreme. The grill is liberally doused with oodles of oil. Sensitive eaters are advised not to watch how much oil ends up in this recipe, lest it should dissuade them from eating it. You want to avoid being dissuaded because the finished product is very tasty: golden and crispy on the outside, smooth and doughy on the inside. It's neither too sweet nor salty—just a very nice fried dough taste. These snacks are a culinary highlight in Shenyang.

Key words: fried dough, coil

鸡蛋糕

Jī Dàn Gāo

COST: 5 RMB

This steamed egg custard is a frequent companion to diào lú bǐng; they are often sold and eaten together. At first glance, the pale yellow custard looks like tofu, but I have been assured that it is made of eggs. It is so soft that it barely holds its shape long enough to get from the spoon to your mouth, and then it instantly liquefies under gentle pressure from your tongue. This is not a sweet custard—it tastes strongly of egg. It is served with a brown, transparent, and moderately thick sauce. The only other ingredients are the bits of wood ear mushroom and carrots sprinkled around the custard for some texture. This dish is tasty and goes well with diào lú bǐng—if you get one, I recommend you get the other as well.

Key words: egg custard, soup

毛鸡蛋

Máo Jī Dàn

COST: 5 RMB

Ah, the "hairy chicken egg." A classic street food for adventurous palates. It can actually be found in several cities in Northeastern China as well as Nanjing (where it is called 旺鸡蛋 (wàng jī dàn)). This delicacy is basically a chicken egg, but not just any chicken egg—a fertilized one. After an embryo has developed but before the egg has hatched, it is boiled, just as you would a standard egg. When it is peeled, you find a combination of chicken embryo and egg, including the yolk. The embryo is coated in fine hairs, the precursor to feathers, which is where it gets its name. Traditionally, these were cooked in a number of ways. Now, you are most likely to find them shelled and then fried. In Shenyang I received three fried eggs on a skewer for about 5 RMB. They can be eaten right off the stick, bones, hair, skin, and all. For some, it might take a little bit of mental preparation to eat a chicken embryo—if it helps, you can remind yourself that in many ways, it isn't all that different than eating an adult chicken. These eggs taste salty and a bit meaty, with the fried oil taste you might get from any fried food. The yolk in the center tastes just like any other yolk. As you might expect, the texture is very different than a regular egg. The hair is chewy, while the bones and skin are crunchy (but not unpleasant). Though it may sound heartless, in my opinion the best part of the egg is the embryo's skull. When you chew it, the skull bursts open, releasing a juicy flavor explosion into your mouth. Máo jī dàn is not going to be a must-try on everybody's list. Those willing to sample it, however, will find it juicy, unique, and well-worth the effort.

Key words: chicken embryo, fried

Macau

Macau

肉乾

Juk⁶ Gon¹

COST: SOLD BY WEIGHT

These sheets of sweet and salty dried meat are a popular Macanese snack. There are a bunch of variations made with different flavorings and different meats (mostly pork or beef), so there should be something for everybody (unless you're a vegetarian). The basic recipe begins by mixing up the ingredients: usually some combination of minced meat, soy sauce, fish sauce, vinegar, honey, rice wine, sugar, salt, and spices. The mixture is left to marinate overnight, and then rolled into a wide, flat sheet and dried either in the sun (more traditionally) or in the oven (more modernly). When these sheets of meat are dried, they are basically like flat jerky. The texture is tough and chewy, and with each bite come the flavors of succulent honeyed meat and whatever spices are in the batch. *Juk gon* is sold by weight, so buy a few pieces for a quick, on-the-go snack, or five or six full sheets to bring home. Also, all of you cheapskates out there will want to be aware that many vendors are willing to let you try a bite-sized sample of one or two flavors—an excellent way to get a taste of this traditional food without spending too many Macanese Patacas.

Key words: dried meat, sweet, salty, chewy

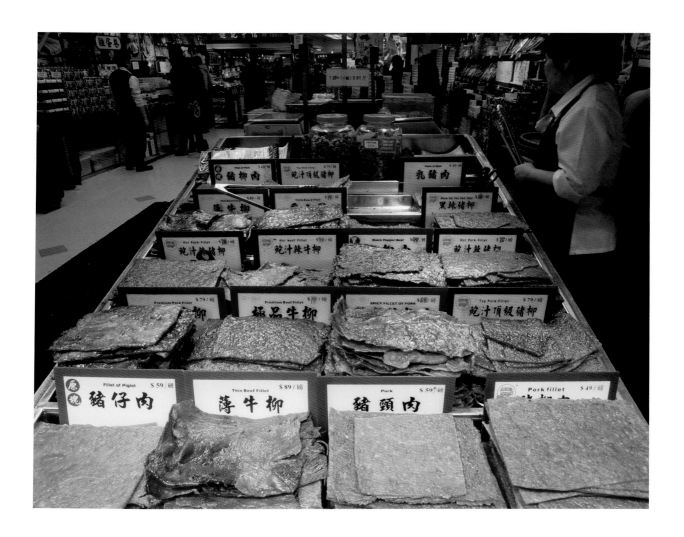

305

雞絲翅

COST: 10 MOP

Shark fins are one of the most controversial foods eaten in the world today. On one hand, they are considered a luxurious delicacy with a rich cultural tradition in Southern China. On the other hand, the fin harvesting process is cruel and inhumane and probably should not have a place in modern society. What is a curious yet sensitive diner to do? It's a tough call which each traveler must make on his or her own. Fortunately, the decision is made easier when a vendor is willing to eschew actual shark fins for imitation ingredients. It's not always easy to know if you're ordering real or imitation shark fin, but the price is a good indication—real shark fins are a notoriously high-priced commodity. If a bowl is 10 MOP or under, chances are good that you are looking at fake shark fins (that being said, the only way to be absolutely sure is to avoid these dishes altogether). Most people associate shark fins with traditional shark fin soup, a popular delicacy in Hong Kong, but here in Macau you can find a pleasant chicken-based variation. Macau's *gai si ci* is basically a chicken soup with shark fins for texture. Slivers of egg and shreds of chicken meat hover in a thick, almost glutinous soup base. The shark fins (imitation or real) are like jellied vermicelli, giving the bowl of soup a silky consistency. Most recipes include a splash of wine or vinegar for some tartness, which really rounds out the richness of the rest of the ingredients. Whether you are comfortable eating actual shark fins, take comfort in knowing that this tasty dish awaits you on the streets of Macau.

Key words: shark fin, chicken, soup, egg, silky, thick

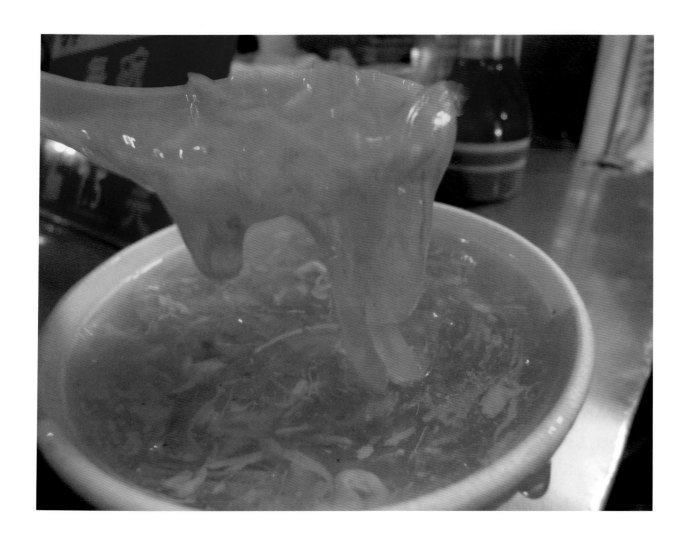

蛋撻

COST: 4 MOP

Macau is often overshadowed by its glitzy, be-skyscrapered neighbor to the east, Hong Kong. Which is really too bad. Like Hong Kong, Macau was occupied by a colonial power (in their case, Portugal) for many years before being handed back over to China in the late 1990s (in fact, Macau was both the first and last European colony in China), and it now operates somewhat independently from mainland China under what is known as the "one country, two systems" policy. Because of this mixed-up history, modern-day Macau is a fascinating blend of cultures. The downtown area is loaded with historic churches and temples, and street signs are written in traditional Chinese characters and in Portuguese. The food has also been influenced by both Chinese and European cuisines. The most famous of Macau's street foods is the Portuguese egg tart. The crust of an egg tart, about 3–4 mm thick, is flaky and buttery. The egg custard nested within is rich and creamy, with just a hint of sweetness. It is browned on top to provide a nice, crispy cap. The whole thing is about the diameter of a silver dollar and maybe an inch thick. You could eat it in two bites (one if you're blessed with a big mouth), but I don't recommend it—this is a food worth savoring. Egg tarts are available all throughout the city (though sources say that the best ones are available at Lord Stow's Bakery in Coloane Village) and will probably run you about 3–8 MOP per tart. You'd be crazy to leave Macau without giving one of these must-try items a go.

Key words: buttery, flaky, egg, custard, rich

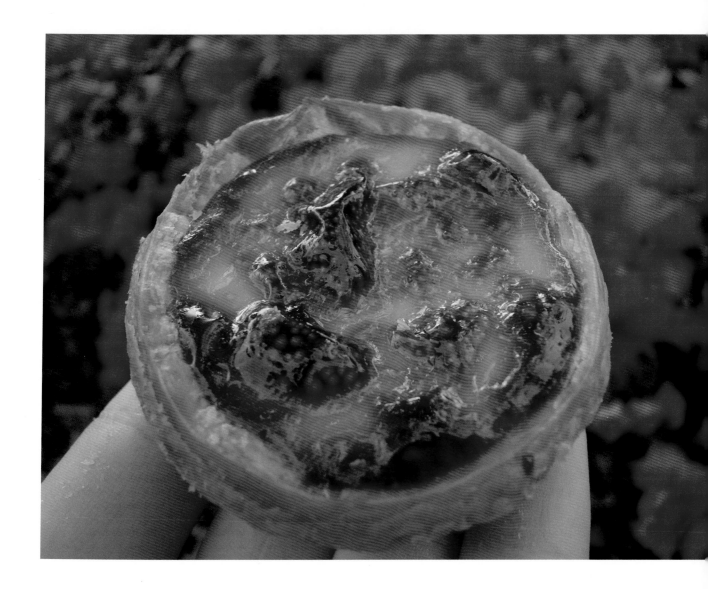

蘿蔔糕

Lo⁴ Baak⁶ Gou¹

COST: 2 MOP

Radish cakes are common snacks in several parts of Southern China, including Hong Kong, Macau, and much of Guangdong Province. Local recipes do vary from one city to the next, though differences are minor and virtually imperceptible. I've chosen to highlight the one in Macau. A Macau radish cake has three basic ingredients: shredded radish, rice flour, and water. All three are stirred together into a thick batter and then pan-fried—it's as simple as that. Vendors will often put their own spin on the dish with some additional ingredients such as shrimp, ham, or spices, but the base is pretty much the same wherever you go. Radish cakes are thick, a little bit sticky, soft, and slightly greasy, with a satisfying umami flavor. Macau's radish cakes are cheap and only about the size of a deck of cards, so they will ruin neither your budget nor your appetite. Seek them out if you are looking for a quick and easy snack.

Key words: radish, rice flour, umami

ALSO TRY:

杏仁餅 (Hang⁶ Jan⁴ Beng²)

Ningxia

Yinchuan

辣糊糊

Là Hú Hú

COST: 10-20 RMB

Ningxia and Yinchuan's answer to Sichuan's famous hot pot is là hú hú. The basic mechanism is the same: 1) You receive a bowl of boiling hot soup and a variety of uncooked ingredients of your choosing (lotus root, boiled pigeon egg, tofu, mutton, beef, fish balls, cabbage...you name it); 2) You put the uncooked ingredients in the soup to cook them and absorb the soup's flavor; 3) You remove the now cooked ingredients and feast. Là hú hú distinguishes itself from the better-known Sichuanese hot pot in two ways. First, the add-ins are served on bamboo skewers (which is why this makes a better street food than other varieties of hot pot). Second, and perhaps more importantly, the soup itself is much thicker, as indicated by the word "hú" (meaning "muddled" or "paste") in its name. Some have described it as something like a spicy gravy. Recipes for the soup typically include some combination of sesame paste, chili powder, cumin, and tomato. Due to its starchy thickness, the soup clings to your ingredients more than it would in other hot pots (and perhaps soaks in less). It is sort of like boiling your food in a complexly spiced chili paste. Whatever mix-ins you choose will be moderately spicy and cooked to your liking (since you are doing the

cooking). The wide variety of potential ingredients makes it difficult to pin down an exact price for là hú hú, but you can expect to pay between 10 and 20 RMB for a satisfying meal. Là hú hú comes highly recommended if you are looking for a unique twist on a well-loved Chinese dish.

Key words: spicy, thick, hot pot

羊杂碎

Yáng Zá Suì

COST: 8 RMB

In an interesting linguistic mix-up, the words "zá suì" mean something different in Cantonese and Mandarin. If you point to zá suì on a Cantonese menu outside of China, you will receive chop suey, an American-born Chinese dish. In mainland China where Mandarin is spoken, however, ordering "zá suì" will get you a bowl of entrails—possibly a nasty surprise if you were hoping for chop suey. One of the specialties in Yinchuan is yáng zá suì: sheep innards. Typically eaten at breakfast time, the offal is served up in a bowl of thin, murky soup and topped with some chili powder and perhaps some green onions or parsley. Most vendors will also supply you with some flatbread as a side. Of course the best parts of yáng zá suì are the innards themselves. Most bowls will include some combination of kidneys, intestines, lungs, hearts, and liver. Each organ has its own unique taste and texture, making this dish a fun and delicious experience. A big, steaming bowl of yáng zá suì is a mouth-watering way to start the day, particularly in the cold winter months that plague this part of China.

Key words: sheep organs, soup, spicy, flatbread

灌汤包

Guàn Tāng Bāo

COST: 10 RMB

Guàn tāng bāo, or soup dumplings, are popular in a number of Chinese cities. Yinchuan's local spin on the dish is a fine addition to the list. Since this is a Muslim-dominant area of China, Yinchuan's guàn tāng bāo are pork-free. Each dumpling is filled with some juicy mutton and a steaming spoonful of soup that will burst into your mouth when you puncture the skin with your teeth. If you are looking for some additional flavoring, you can dip the dumplings in the provided chili/soy sauce. The dumplings are steamed, which makes them loose and floppy, like an old-time coin purse; it is surprising sometimes that they maintain their structural integrity long enough to go from the basket to the dipping sauce to your mouth. These dumplings are a treat—savory, salty, spicy, and oh-so-juicy. They are highly recommended.

Key words: dumplings, soup, mutton

羊蹄

COST: 7 RMB

Yáng tí are sheep hooves. If the idea of eating sheep hooves doesn't appeal to you, you probably won't like yáng tí. If you're into the idea, however, then these are absolutely worth a try. The hooves are slow cooked with a mixture of garlic, spices, and sauces (the exact concoction will vary from vendor to vendor) to the point where the skin and meat is falling right off the bone. The meat is unbelievably soft and succulent (presumably from all of the fat); one can't help but lick the bones dry when the meat is gone just to get that last bit of flavor out. Like barbecue ribs, this is not a food for fastidious diners—the meat is positively dripping with grease and sauce. I can't imagine these are healthy to eat every day, but as a once-in-a-while indulgence, they are excellent.

Key words: sheep hooves, succulent, fatty

Qinghai

Xining

牛肉饼

Niú Ròu Bǐng

COST: 3 RMB

Similar to other round, fried pastries in other cities (see, for example, Shanghai's cōng yóu bǐng), Xining's niú ròu bǐng is a greasy and decadent snack. The process is simple: make a wheat-based dough, coil the dough into a ball, stuff a beef and vegetable mixture into the center of a ball, flatten it into a disc, fry it in a generous amount of oil, and then roast it to crispy, golden perfection. The dough is crispy on the outside and soft and chewy on the inside. Inside the dough, the juicy beef awaits, hot and greasy to tantalize your tongue and dribble down the sides of your mouth. Alongside the beef you will also find some onions, scallions, and butter for added flavor. Take note that while some regions of China might include pork in such a pastry, Xining uses beef, demonstrating the influence of Muslim culture on the region. The bottom line is that niú ròu bǐng is a quick snack, easy to buy and eat while on the move through downtown Xining.

Key words: dough, beef, fried, crispy

酿皮

COST: 5 RMB

Niàng pí is a relative of liáng pí, and both are available in different parts of Northern and Western China. The most immediate features of this dish are the blocky brown noodles, which aren't actually noodles at all. The process of creating these pseudonoodles is both interesting and complicated. A basic dough is made of mung bean powder (or occasionally wheat or sorghum), wrapped in cheesecloth, and placed in a basin of water to soak. As the water seeps into the dough, the starch seeps out through the cloth and into the water. After some time, the cloth is removed, leaving a spongy, tofu-like gluten substance inside. A few hours later, all of the starch in the water has settled onto the bottom. If you drain the now-clear water you are left with a starchy solid paste that is then steamed, cooled, and sliced into the caramel-colored noodly strips that are served in your bowl. The chewy, porous gluten that was left in the cheesecloth is also included in the final dish, adding a nice contrast to the smooth, jelly-like texture of the starch noodles. Both parts are served cool and have a strong beany taste. Atop these two main ingredients you will find small pieces of beef, some fried scallions, and a mildly spicy chili sauce. This dish is full of pleasant flavors and is not too spicy for most palates, making it a crowd-pleasing street food.

Key words: bean starch noodles, spongy gluten, beef, chili sauce

酸奶 （藏族）

Suān Nǎi (Tibetan)

COST: 4 RMB

Tibetan yogurt is a popular street food in some quarters of Xining. There is also a Hui yogurt available (see the Lanzhou section), and they taste slightly different, so if you want this one, your best bet is to go to a Tibetan area of the city. Tibetan yogurt is similar to unsweetened Greek yogurt. It is milky-white, sour, and chunky, with a thick skin on top. Cool and refreshing, this yogurt is an excellent treat on a hot summer's day.

Key words: yogurt, chunky, sour

毛牛头肉

Máo Niú Tóu Ròu

COST: SOLD BY WEIGHT

We have here a delicacy that truly can only be found in certain parts of the world: yak head meat. The meat is sliced into rectangles about half a centimeter thick and marinated in oil, chili sauce, and peppers. It's sold by weight, so get as much or as little as you like. Now, I'm going to be honest with you here—yak head meat is not all that great. It's fatty and oily with a tough and chewy texture, but without enough flavor to be as good as jerky. Don't get me wrong, it isn't bad—it's just sort of uninspiring. Novelty food junkies should consider giving this a try. Everyone else is probably safe skipping this one.

(Disclaimer: it's possible I just got a bad batch. Feel free to prove me wrong!)

Key words: yak, fatty, oily, tough

尕面片

Gǎ Miàn Piàn

COST: 8 RMB

Perhaps the most famous of Xining's street foods is gǎ miàn piàn. In fact, it is popular all across Qinghai. Its characteristic barley noodles are squares about an inch on each side. Traditionally these noodles are hand-pulled, broken off of a sheet of flattened dough, but these days not every vendor will make them in the traditional way. The noodle squares are lightly coated in a viscous brown sauce and mixed with lamb, zucchini slices, and peppers. It doesn't sound like much based on the ingredients alone, but let me tell you this: it is delicious. This dish is slimy, a bit salty, and rich with the flavor of mutton—it is a delight for the taste buds. What's more, it is dense and carb-heavy, so it fills you right up. A person could eat a big bowl of this for lunch and not need to eat again until breakfast the next day. Apparently, legend has it that gǎ miàn piàn was developed by nomads, shepherds, and other people who spent their days traversing the grasslands of Qinghai. A rolling pin, a pot of boiling water, and your fingers were the only tools needed to make the noodles; a perfect solution for people who are traveling light, and eager for a quick and filling meal after a long day of tending their flocks. Many of the travelers passing through Qinghai these days don't have any flocks to tend, but they can probably sympathize with traveling light and wandering around all day. Learn from the wisdom of Qinghai's nomadic shepherds: eat gǎ miàn piàn.

Key words: noodles, salty, slimy

Shaanxi

擀面皮

COST: 5 RMB

If you've traveled (and eaten) much in the North of China, you've probably come across liángpí. If you haven't, liángpí is a Shaanxi-native wheat noodle made with sort of an interesting process. Pure wheat flour is mixed with water to make a very basic dough, which is then plopped into a tub of water for some rinsing. As the vendor rinses the dough, the starch leeches out, turning the water cloudy and gray. When the vendor deems the water sufficiently opaque, out goes the dough, no longer necessary for this recipe—the focus is now on the cloudy water. Next, the tub of water sits still for a day or so, during which time all of the wheat starch settles on the bottom and the water, once again clear, sits on top. The vendor only needs to pour off the water, and he or she has the necessary dough for liángpí. This dough is spread into a thin layer on a tray, boiled, and sliced into noodle shapes, giving you traditional liángpí. Baoji's gǎn miàn pí is a regional offshoot of the former. The process for making gǎn miàn pí is virtually the same as liángpí, but the result is a little bit firmer, thinner, and darker. Furthermore, once the noodles have been made, the ingredients added to complete the dish are somewhat different. Mixed in with the noodles, you have wheat gluten, bean sprouts, chili oil, vinegar, and garlic, giving this dish a distinctly

"Northern China" flavor. It is spicy, a bit sour, moderately greasy, and served cold regardless of the season. It's every bit as tasty as its more famous cousin, so be sure to give it a try if you happen to come across it.

Key words: wheat, noodles, spicy, bean sprouts, gluten

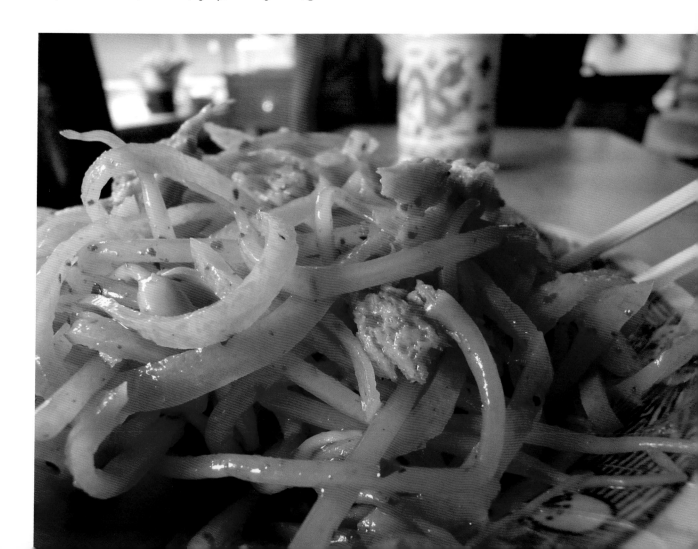

肉夹馍

COST: 6 RMB

Many people associate ròu jiā mó, one of Shaanxi's most famous foods, with Xi'an. It's not surprising—Xi'an is the capital of the province, it has a long and fascinating history, and it has a reputation for being a great city for foodies. Nonetheless, I've chosen to include ròu jiā mó here in Baoji for two reasons: 1) although many do consider ròu jiā mó a Xi'an specialty, it actually belongs to the province at large (there is even some evidence to suggest that its official origins are closer to Baoji than to Xi'an); and 2) the ròu jiā mó I ate in Baoji happened to be much tastier than the one I ate in Xi'an. Of course the latter reason may be entirely dependent on the vendors I chose, but my extremely limited data set says ròu jiā mó is better in Baoji, so that's where I'm putting it. Ròu jiā mó is often described as a Chinese hamburger, which is not really fair because the modern hamburger was invented sometime in the 1800s (with related dishes going back to the 13th century) while ròu jiā mó reportedly dates back as far as the Qin Dynasty (more than 2,200 years ago). Really, we should be calling hamburgers "European ròu jiā mó." There are two components to authentic ròu jiā mó: bread and meat. The bread is a dense, steamed pancake, about the circumference of a grapefruit, and the meat is traditionally chopped pork that has been slow-cooked with a complex combination of spices (Muslim vendors will often use beef instead of pork). To serve, the vendor will cut a slice in the bread, creating a deep pocket, and then spoon in a few scoops of pork. Some vendors also throw in a vegetable or two, but that's about it. The completed ròu jiā mó is delicious. Tender, succulent, richly flavored pork smashed between two layers of soft and chewy

bread—what's not to love? Very few traditional foods in China can accurately be called sandwiches, a fact that makes this one something of a novelty. Give it a try in Baoji or Xi'an and you'll never look at a hamburger the same way again.

Key words: pork, bread, sandwich, tender

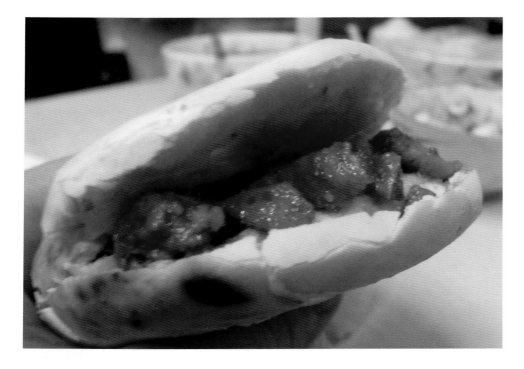

ALSO TRY:

岐山臊子面 (Qíshān Sào Zi Miàn)

Xi'an

Biáng Biáng Miàn

COST: 5 RMB

In this book, we've covered some dishes that are notoriously bitter, spicy, smelly, or otherwise challenging to eat. Here's a dish notorious not so much for its taste but for the way its name is written. Biáng biáng miàn is a traditional street food in Xi'an, and it uses one of the most ridiculously complex characters in the entire Chinese language. It is so complex that a Unicode version of it doesn't exist and I have to insert an image instead. It has 58 separate strokes, and requires most people to use mnemonic devices to remember how to write it (if they ever bother to write it at all). Biáng is almost certainly the most complex character you will see in modern China. Nobody is really sure what the origin of this character is, but there are lots of fun folk etymologies floating around out there that I'm sure you can investigate on your own time. For a food with such a complex name, it's actually very simple ingredient-wise. The wheat-based noodles are long and very wide (some people liken them to belts). They are served swimming in a chili-red oily soup with some mutton or beef and chives. Like many spicy foods in China,

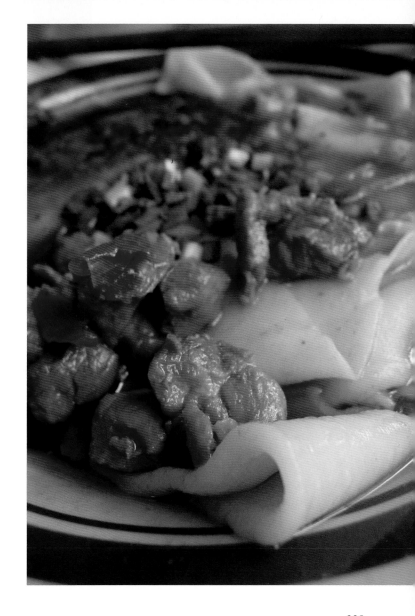

the chili here is considered to keep you warm in the winter and cool in the summer (due to the sweat). On a scale of 1–10, I would say the spice is no greater than a 6, so if you don't get along with spicy foods, this might work for you. The verdict? Simple, tasty, and filling.

Key words: wide noodles, spicy, meat, soup

水盆羊肉

COST: 6 RMB

Shuǐ pén yáng ròu is an ancient food (sources put its origins as far back as the Shang or Zhou Dynasties...two or three thousand years ago) primarily sold by the Muslim population in Xi'an. Considering the age of this dish, it's probably no surprise that it is not hugely complex. It's really not much more than a mutton soup topped with green onions and served with fire-baked crescents of bread. The mutton for the soup comes from sheep in the one- to one-and-a-half-year-old range, so it has a mild flavor, not too sweet and not too strong. Sometimes there will be bits of actual mutton in the soup; other times it is just a broth. The bread is soft and warm with that dusty texture on the surface you get from bread that has been baked near an actual flame. There are different schools of thought on how to eat the bread. Some people dunk it into the soup like a donut, others shred the bread and add it to the soup to give it some substance, and others open it up like a pocket and drip the soup inside. However you choose to eat it, you can be assured that it is going to be a decent and very traditional meal.

Key words: soup, mutton, broth, bread

乾县豆腐脑

COST: 4 RMB

This local variation on dòu fu nǎo (a soft tofu served in several different Chinese cities) was reportedly a favorite of Emperor Yongzheng of the Qing Dynasty nearly 300 years ago. There are a lot of variations on dòu fu nǎo in China, and the differences between them can be fairly minor. Like all dòu fu nǎo, qiánxiàn dòu fu nǎo is made from mashed, soaked, and boiled soy beans. The tofu is yogurt-soft, creamy, and smooth. In all actuality, it's probably closer in structure to soy milk than tofu, as if it were just jellified soy milk. It is served in a bowl with a spicy, vinegary soup that has been flavored with a special mix of spices. This spice mix is where this dish distinguishes itself from other dòu fu nǎo you'll find in China. Ingredients include star anise, garlic (especially prominent in my bowl), salt, chili oil, mustard, and other secret spices. Regardless of how similar or dissimilar to other dishes it might be, Shaanxi's qiánxiàn dòu fu nǎo is a hot and flavorful breakfast that locals have eaten for hundreds of years.

Key words: tofu, soft, soup, spicy, sour, garlic

羊肉泡馍

Yáng Ròu Pāo Mó

COST: 10 RMB

I'm sure that I will have some readers quibbling with me over the fact that I am classifying yáng ròu pāo mó, one of Xi'an's most representative foods, as a street food, but I'm going to go ahead with it anyway. My justification? It's cheap, it's often served in small, hole-in-the-wall shops, and it's a common food for local citizens of all types. I'll grant that it's borderline, but borderline is close enough for me. So what is yáng ròu pāo mó? It's a hearty mutton stew full of shreds of very dense, steamed bread. When you order a bowl of yáng ròu pāo mó, the vendor will give you two or three of the bread patties and a bowl while he or she works on the stew. Now you can sit down and get to work on shredding the bread by hand. Ideally, the pieces should be about the same size as the tip of your index finger or smaller (some locals shred it down to pea-sized chunks). It's tedious work and it's tempting to take the easy route and tear it into big pieces, but I'd encourage you to have patience and keep on course with the smaller chunks. If you are lucky enough to time it right, you'll finish tearing up the bread just as the vendor finishes cooking your stew. Now you get to combine the two parts by dropping the bread shreds into the hot stew so that they soak up all of the juices. There you have it: yáng ròu pāo mó. The stew is stuffed with glass noodles, mushrooms, green onions, and (of course) juicy slices of mutton. Once the heavy bread is thrown in as well, you've got an awfully filling dish on your hands. It's hearty and hot and wonderful and it's one of my favorite dishes in the city. Try it out; I think you'll agree.

Key words: mutton, noodles, bread, dense, hearty, stew

柿子饼

Shì Zi Bǐng

COST: 2 RMB

If your taste buds share the same characteristics as mine—and I can only assume that they do—then you have a natural proclivity for sweet tastes and mushy textures. Yes? Good. Because friends, for my money shì zi bǐng is basically the gold standard of sweet, mushy foods. This fried persimmon cake is, by far, one of the most addictive street foods I've eaten in China. Shì zi bǐng is made of a persimmon dough stuffed with a variety of different pastes, including osmanthus, peanut, black sesame, and more. The dough is flattened into a disc (perhaps the diameter of an American silver dollar, except about an inch high) and then fried in a crackling pan of oil. They are best eaten shortly after cooking when they are still hot and oily. Reader, believe me when I tell you that these things are amazing. They have a very thin crispy layer on the outside from the frying, but the inside is all mush and goo. Just below the crispy surface, the dough is soft and glutinous, while the paste on the inside oozes out as soon

as you penetrate that inner wall. It's sweet (fruity sweet, not sugary sweet), gooey, and warm. One patty will only set you back about 2 RMB. Something that delicious for such a good price means that I went back for seconds, thirds, and fourths. If I had stayed in Xi'an any longer, I am sure I would have had many, many more. Shì zi bǐng are available in many places in the city, but the best place to look is in the Muslim quarter behind the Drum Tower. In my book these are a definite must-try in Xi'an—don't miss them.

Key words: persimmon, sweet, mushy

羊蹄

COST: 4 RMB

With all of the other sheep-based street food available in Xi'an, it should come as no surprise to find sheep feet on the menu as well. A pan full of yáng tí looks almost villainous; a wild tangle of clenched, gnarly ankles; tight skin hugging the bone; and sharp, cloven hooves (not to mention the various black and red spices and oils). It's not just the looks that are less than appealing, though. To be frank, there's not a lot a ton of enjoyment to be had in these sheep hooves. The spices are gritty and occasionally overpowering, the skin is tough, and what little meat remains on the bones is dry and lacks that gamy flavor that mutton is known for. I'm open to the possibility that I happened to get a non-optimal sheep hoof, so perhaps you'll enjoy them more than I do. For me, though, I think you'd be better off passing on these and trying the much more succulent yáng tí in Yinchuan, just a short 10-hour train ride away.

Key words: sheep hooves, spicy, gritty, dry

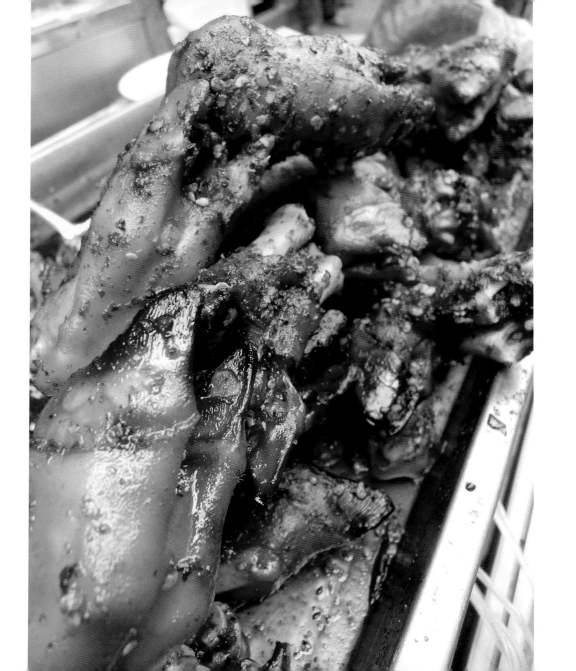

337

冰糖梨

Bīng Táng Lí

COST: 3 RMB

Bīng táng lí, a sweet-but-not-too-sweet pear juice, has the distinction of being the only drink I am writing about in Xi'an. The ingredient list is as follows: snow pears, rock sugar, red dates, and a white fungus known as yín ěr (silver ear). Of these, I was most intrigued by the yín ěr. As I was somewhat unfamiliar with this fungus, I did a little bit of research and learned that it is a parasitic yeast that oozes around in a slimy film until it finds a host. At that point, it blooms into what looks like a wavy, white blossom—this is the part we eat. Yín ěr is a popular ingredient in traditional Chinese medicine and in certain Chinese dishes, especially sweet dishes. It doesn't have much taste on its own, but it does add a jelly-like texture to whatever it's added to. All that being said, it's hard to tell how this fungus affects this particular drink. Bīng táng lí is not especially thick or gelatinous, nor does it have any noticeable white fungus chunks floating around, so it must affect the drink in other ways. In any case, the drink is sweet and fruity and an excellent way to keep hydrated in Xi'an.

Key words: pear, sweet, red dates, white fungus, fruity

ALSO TRY:

粉汤羊血 (Fěn
Tāng Yáng Xuè),
金线油塔 (Jīn Xiàn
Yóu Tǎ),
甑糕 (Zèng Gāo),
凉皮 (Liáng Pí)

Shandong

Jinan

糖酥火烧

Táng Sū Huǒ Shāo

COST: 3 RMB

This charming little pastry lives up to its name, which literally means "sweet flaky flame-baked." Layers of tasty dough are baked together, resulting in a dense, flaky treat. Táng sū huǒ shāo comes in the standard variety of Chinese flavors, including sesame, peanut, mung bean, and more. They are perfect for a late afternoon snack to satisfy your sweet tooth and stave off hunger until dinner.

Key words: sweet, flaky, chewy, dense

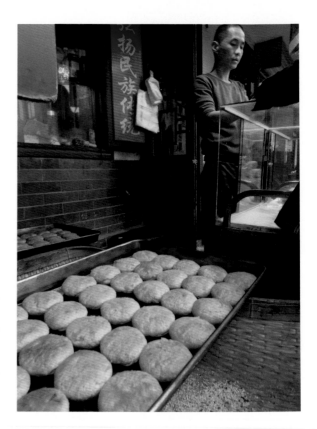

油旋

COST: 1 RMB

For my money, this snack, first sold back in the middle of the 19th century, is the best street food in Jinan. The dough—made mostly of wheat flour, lard, and some spring onions—is rolled out into a long tube then coiled into a tight spiral. The chef flattens it out on an iron griddle coated with oil, fries it on both sides, and then warms it close to an open flame. The final product is a slightly salty coiled pancake, crispy and golden on the outside, warm and doughy on the inside. Because the dough was coiled rather than balled, the crisp edges are not limited to the sides, but follow the outline of the spiral right to the center—a perfect ratio. If you are the type that gets cravings for salty snacks like potato chips, the traditional yóu xuán will be sure to hit the spot. Highly recommended for all who pass through Jinan.

Key words: salty, oily, crispy

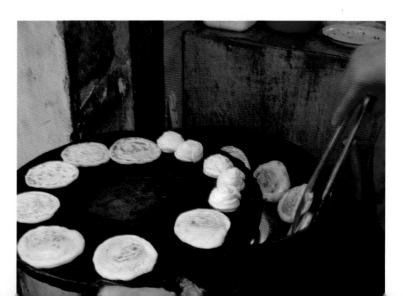

黄焖鸡米饭

COST: 15 – 20 RMB

This classic Jinan dish may stretch the definition of "street food," as it is commonly available in restaurants, but you can also find it served from outdoor stalls in night markets. Essentially a savory, slow-cooked chicken stew served with rice, huáng mèn ji mǐ fàn is more than a snack—it is a tasty and filling meal. The succulent chicken meat is juicy and soft; it slides right off the bone. Different chefs have different recipes, but chances are you'll find a few peppers or other vegetables mixed into the thin brown gravy the meat is soaking in. Best eaten for dinner or a late lunch.

Key words: juicy, chicken, stew, hearty

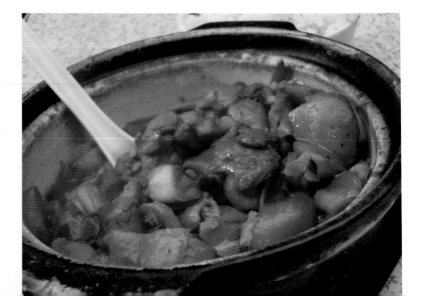

把子肉

Bǎ Zi Ròu

COST: 3 – 5 RMB

What's not to love about bǎ zi ròu? Pocket comb-sized slabs of pork belly with a layer of fat on one edge are boiled with onion, ginger, and star anise, and then stewed with sugar, soy sauce, and more onion, ginger, and anise. The meat is fatty without being overly greasy, a bit sweet, and well-seasoned. The anise leaves the tiniest hint of licorice flavor—enough to entice licorice lovers, but not enough to put off people who can't stand the stuff. Eaten with rice as the locals do, bǎ zi ròu would make a terrific appetizer to an evening meal.

Key words: pork belly, fatty, flavorful

煎饼卷大葱

Jiān Bǐng Juǎn Dà Cōng

COST: 5 RMB

This snack, popular in Shandong Province as well as much of the Northeast of China, is very simple. In fact, it only has two components: a paper-thin, crepe-like pancake and a long, green scallion.Like crepes, these pancakes are made by ladling a thin skin of wheat flour batter onto a wide, circular griddle and frying it just long enough to be slightly crispy on the edges (without losing the pliability necessary to roll it up). Unlike a crepe (at least any crepe I've ever eaten), the next step is to put a whole green onion on the pancake and roll it up like a cigar. Voila! There you have your jiān bǐng juǎn dà cōng. It tastes just like you would expect—like an onion in a pancake. Admittedly, the sharp scallion flavor can be somewhat overwhelming when eaten whole. Most vendors will serve it with a dipping sauce in order to mitigate that immediate pungency. Jiān bǐng juǎn dà cōng also comes with a complicated origin story involving a wicked stepmother locking her stepdaughter's beloved in a room without food in order to study and prove himself. The young woman kept him alive by sneaking him food (jiān bǐng juǎn dà cōng of course) disguised as a pen wrapped in paper. Thanks to the young woman's creative thinking, the young man survived long enough to win over the stepmother and the two were married to live happily ever after.

Key words: pancake, onion

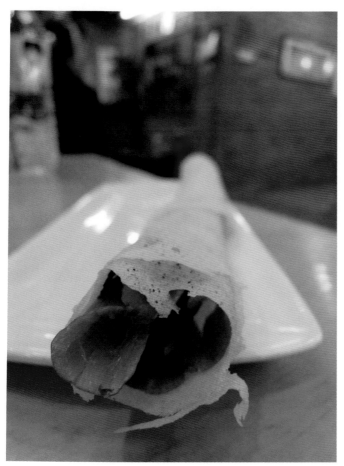

347

Qingdao

海星

Hǎi Xīng

COST: 10 RMB

Given its location, it's no surprise that seafood dominates the culinary scene in Qingdao. The seafood there is fresh and delicious, just as one would expect from a coastal city. One local highlight is a creature found all over the world's oceans, but not typically considered food: the humble starfish. These little guys are dried out, leaving the top side rigid and sharp, like armor. The underside is covered in unappetizing protrusions known as "tube feet." So how does one eat a starfish? With sharp armor on one side and tube feet on the other, you don't want to eat the outsides. All the good stuff is safely tucked away inside the legs. The easiest way to eat the starfish is first to break off one leg (with apologies to the starfish). Then, use your fingers to pry open the leg via the fissure in the middle of the tube feet. See that olive green mush inside the leg? There's

your food. It's not particularly dignified, but the thing to do now is hold that leg open and use your tongue to dig out the succulent starfish meat. If you've ever eaten river crabs in China, you'll find that the starfish tastes just like the brain area of the crab. It also tastes very similar to the sea urchins that you can find all over Qingdao. If you've never had the pleasure of eating river crab or sea urchin, I guess the closest way I can approximate the taste is that starfish tastes the way a beach smells at low tide. The texture is soft, moist, and mushy. I'm probably not making it sound very appetizing, but that's the way it goes. I'm going to guess that this is not going to be a favorite for everybody. For the seafood lovers out there, though, it's worth a try. It's a bit more expensive than a lot of street food (you will probably pay between 10 and 20 RMB for a single starfish, depending on how touristy of an area you're in). One other note: it's not clear how much the locals eat starfish on a day-to-day basis. Though it is traditionally eaten in the Qingdao area, these days it seems to be mostly for tourists. For travelers looking to have the "local experience," this might be off-putting, which is too bad, because the starfish is a unique local treat. This might be one of those times where it's okay to jump on the touristy bandwagon and give it a go.

Key words: starfish, mushy, strong flavor

青岛锅贴

COST: 8 RMB

Guō tiē, or pan-fried dumplings, are another on the list of foods that are found throughout China with minor regional variations. Qingdao's take on the pot sticker is a delight. For the most part, it follows the standard guō tiē pattern: crescent-shaped, wheat-based dumplings stuffed with a variety of fillings and then fried in a shallow pan generously coated in oil. Where it alters the tradition a bit is in the stuffing. Like many foods in Qingdao, the secret to its success is seafood. Fresh shrimp, fish, and crab have found their way into Qingdao's pot stickers. Like all guō tiē, they taste excellent and are worth spending a few RMB. I recommend getting three or four of three or four flavors to really give yourself the full experience.

Key words: dumplings, pan-fried, seafood

牡蛎 and 扇贝

Mǔ Lì and Shan Bei

COST: 4 RMB EACH

Seafood lovers take heed: once again, Qingdao proves that it's the place for you. Here the city offers two classic seafoods, oysters and scallops. They are roasted on the half-shell and then topped with oil, minced garlic, and chopped peppers. Seafood doesn't get much fresher than this, so be prepared for a real treat. The oyster and scallop meat is springy and chewy, with a wonderfully oceanic flavor. The topping, which mostly tastes like oily garlic, enhances the flavor without overpowering it. Seafood is the name of the game in Qingdao's local food, and these are great examples of why.

Key words: oyster, scallop, garlic, oily

劈柴院海胆蒸蛋

COST: 8 RMB

If the all of the world's animals were to get together and have a contest to see which one appears most inedible to humans, there's a good chance that the sea urchin would be among the top contenders. Nothing about its appearance screams "eat me!" And yet we managed to make it work. Somewhere in history a human being looked at a living underwater pricklebush, thought to him or herself, "I'm going to find a way to eat that thing," and then did it. It's almost a testament to the human spirit—we are determined, inventive, curious, and hungry. Here in Qingdao, you have the opportunity to reap the benefits of the human ingenuity that came before you by eating a sea urchin. You can get sea urchin at many sushi restaurants around the world, but it's prepared differently in Qingdao. For reasons that likely have to do with tourists, sea urchin in Qingdao is generally served inside half of the sea urchin's dried spiny husk. Sitting out in neat rows, they almost look like bird nests. Inside, you will find a mix of mushy urchin meat and creamy egg custard. The flavor of sea urchin is notorious for being one of the world's most difficult-to-acquire acquired tastes. Like the starfish also available in Qingdao, sea urchin tastes the way

352

an ocean smells at low tide—sort of briny and rotten. Its reputation is based in truth—sea urchin is, indeed, a powerful flavor. Fortunately (or unfortunately, depending on your tastes), the knockout punch of straight sea urchin is mitigated to some extent by the steamed egg that is mixed in. The custard portion of this street food is glossy and creamy, with a rich, eggy flavor. It's an unusual combination that works better than you might expect. For people who are hesitant to try pure sea urchin due to its reputation, this may be a safe way to ease into the waters.

Key words: sea urchin, egg, creamy, mushy

排骨米饭

Pái Gǔ Mǐ Fàn

COST: 10 RMB

Are you a fan of meat so tender and juicy that it virtually melts off of the bone? Sure you are—you're human. So, from one human to another, I encourage you to seek out Qingdao's pái gǔ mǐ fàn. There are two main parts to this dish: a bowl of rice and a bowl of pork ribs in broth. The ribs are really the focal point. They have been cooked in a casserole dish or pressure cooker with a mixture of water, ginger, soy sauce, aniseed, and salt in such a way that the juice and flavor of the broth really gets into the fiber of the rib meat. The ribs have a lovely brown hue, and they glisten with fat and broth. The meat is unbelievably moist and tender; you barely need to chew it. Eaten with the rice, these pork ribs can make a very fine and very filling meal. It is one of the few non-seafood street foods available in Qingdao, so it's a great way to add some variety to your meals in the city.

Key words: pork ribs, tender, juicy, rice

西镇臭豆腐

Xīzhèn Chòu Dòu Fu

COST: 5 RMB

Although not nearly as famous as the stinky tofu available in Changsha or Shaoxing, the Qingdao version of the malodorous dish is both distinctive and satisfying. The tofu itself shares some similarities with Shaoxing's stinky tofu. It has been fermented with a complex brine and has a noticeably fetid aroma. Like the Shaoxing version, the cubes of tofu have been lightly fried to give them a crisp, golden exterior and a soft yet firm interior. The similarities end, however, with the presentation method. In Qingdao, the blocks of smelly tofu are served in a bowl or cup soaking in a tasty mixture of vinegar and chili oil. The tofu soaks up the juices like a sponge, giving each morsel a complex array of sour, spicy, and musty tastes. The servings are not huge, so this stinky tofu is perfect for a light, mouth-watering snack between meals. It may not have the same reputation as some of China's other stinky tofu, but Qingdao's xī zhèn chòu dòu fu is a winner in my book.

Key words: stinky tofu, spicy, sour

青岛啤酒

COST: 3 RMB

Ask anybody outside of China to name as many Chinese beers as they can, and I suspect very few would get past Tsingtao. It is well-known throughout much of the world as well as in China, where it is the country's second largest brewery. So why would a beer available in its recognizable green bottles all over the world be included in a book meant to highlight hyperlocal street foods? Because here in its home city of Qingdao (Tsingtao is an earlier transliteration of the city's name), you can purchase it by weight on the street. The Tsingtao brewery was founded in the early twentieth century when Qingdao was under German rule as part of the Kiautschou Bay concession (1898 – 1914). Of course establishing a brewery was a priority for the Germans living in Qingdao, so they built it in 1903 and it has been operating ever since. Think about that—it has stayed open while the city was controlled by Germany, Japan (twice), the Republic of China, and the People's Republic of China. It was nationalized for many years (at which time the Chinese government changed some of the strict German beer rules to allow rice in the recipe) until the early 1990s when it was privatized once again. The Tsingtao brewery has been through a lot during its long history in the area, and it is a source of pride for many citizens. So in a way, it's no surprise that the brewery's flagship product is available all over the city. Poke your head into many of the city's hole-in-the-wall restaurants and you will

find a keg of beer waiting for you. Ask the vendor for a bag (yes, a bag), fill it up as much as you want, weigh it, pay for it based on the weight, and you're on your way. You can either drink it right out of the bag or relocate it to a mug when you reach your destination. Qingdao is the only city I've ever visited where you can buy beer in a bag by the kilogram and then drink it as you wander the streets. It's a unique opportunity that has resulted from the city's unique history. Don't miss it.

Key words: beer, bag

Shanxi

Datong

刀削面

Dāo Xiāo Miàn

COST: 10 RMB

Datong's signature dish is right on the edge of what can be reasonably called a "street food," as it is found just as frequently in fancy restaurants as it is on street corners. The focal point of this dish happens to be its most famous ingredient: sliced noodles. Popular legend says that certain rulers during the Yuan Dynasty (1279–1368) outlawed most knives and sharp metal in order to suppress any potential rebellions. Within their realms, every ten households would need to share a single knife for all of their cooking needs. One man, frustrated by having to wait for the knife, suggested that his wife slice the noodles with a piece of sheet iron he had found. It was too blunt to chop the block of dough, but they were able to shave slices off directly into the boiling water. Thus was born a culinary tradition. These days, dāo xiāo miàn is made in the same basic fashion, albeit with more sophisticated tools. A large block of dough that must weigh at least 15 kg is swiftly shaved with a knife; long, rough-hewn noodles cascade into the boiling water. After cooking, the noodles are thick and inconsistent in shape, soft and chewy in texture. The rest of the dish may include a whole variety of ingredients. My bowl included tofu, beef, chili oil, and cilantro. All of those secondary ingredients were tasty, but they weren't the point—the noodles are the common link between each vendor's take on this. Find yourself a bowl of dāo xiāo miàn and enjoy a yummy Datong tradition.

Key words: sliced noodles

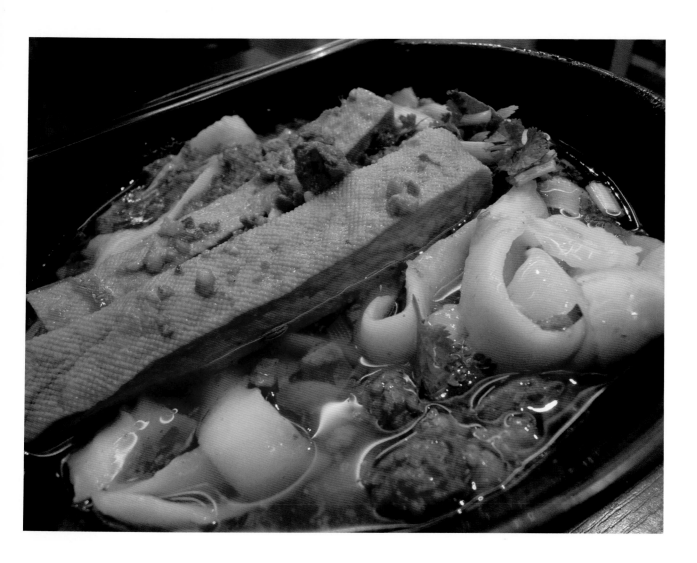

凉粉

COST: 6 RMB

Liáng fěn, the cold pseudo-noodles made of jellified mung bean starch, is one of those street foods available in different Chinese cities with minor regional variations. The jelly blocks in Datong are not significantly different than those in other cities. They are translucent with a white-blue tint, and cut into rectangular prisms roughly 1 cm x 1 cm x 10 cm. They are solid enough to maintain their shape in water, but not so solid that they won't yield to a slight pinch from your chopsticks. Indeed, they can be somewhat challenging to pick up, as they are mighty slippery. These square fingers of jelly are dropped into a thin, salty broth and mixed with tofu slices, dried soybeans, cilantro, vinegar, and chili oil. Like all liáng fěn, the jelly is served chilled, which makes for an interesting contrast with the spicy heat of the chili oil. If the thought of eating cold, spicy, vinegary mung bean jelly is appealing to you (as it is to millions of Chinese people), then make sure to try this dish when you're in Datong.

Key words: mung bean, jelly, spicy, slippery

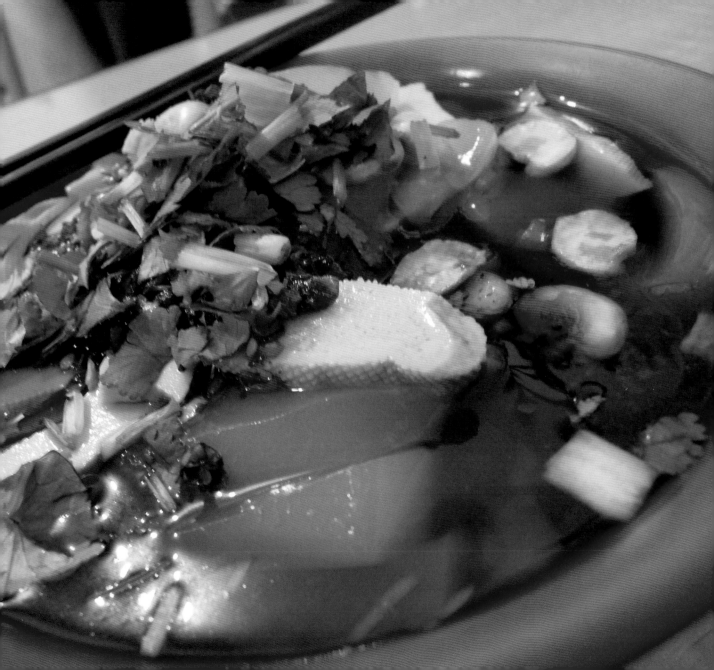

稠粥

COST: 5 RMB

Looking for a hearty, warm breakfast in Datong? Look no further than the local chóu zhōu, or "dense porridge." The two components of this street food are served separately so that you can mix them together as you see fit. The first component is the porridge itself, made of boiled golden millet, cooked much the same way as oatmeal, grits, or any other grain-based porridge. It is thick, lumpy, and pliable—press into it with a spoon and the dent will hold its shape. The second component here is a bowl of shredded vinegary vegetables. These will change seasonally, but you are likely to find some combination of radishes, cucumbers, carrots, seaweed, cabbage, and bean sprouts. The two components are mixed together either all at once or bite by bite, as you prefer. Their different flavors complement one another nicely; the grainy, buttery taste of the porridge blends smoothly with the sour bite of the vinegar in the vegetables. It is a healthy, hot, and filling breakfast—a great taste to start your day in Datong.

Key words: millet, porridge, vinegar, vegetables, dense

抿豆面

COST: 7 RMB

Mǐn dòu miàn is primarily made up of small slugs of pasta similar in taste and design to German spätzle. When making this pasta, the dough is strained through a colander and dropped into the water to boil, making each piece unevenly shaped and about the size of a caterpillar. The pasta is soaking in a mildly spicy red soup with chunks of juicy pork. Due to their small size, the noodles are numerous in the bowl, ensuring a dense bite of chewy pasta in each spoonful. It isn't overly spicy, but it does have enough chili oil to tingle your tongue a little bit. I would perhaps rate it a 3 or 4 out of 10 on the spiciness scale. This simple dish is tasty and warm—a very fine meal.

Key words: spätzle, pork, mildly spicy, soup

羊杂

COST: 10 RMB

I suspect most readers cannot count sheep organs among the foods that they have eaten in their lives. And that's too bad, because they truly are a tasty treat. Yáng zá, or miscellaneous sheep organs, is a street food across much of Northern and Central China. Datong's variety of the dish is different from other cities' mainly because of the addition of some long, round noodles to the soup. The noodles are chewy and slippery, the kind that flick soup into your face if you slurp them too quickly. Each bowl of yáng zá has a generous portion of noodles sitting in an oily, red chili-oil broth. Recipes for the broth vary among individual vendors, but you can assume that most will have spicy chili oil, a dash of vinegar, garlic, cinnamon, onion, and maybe some anise. Of course the highlights of the dish are the organs themselves. Kidneys, lungs, intestines, hearts (if you're lucky), and liver all have their moments to shine in this steaming bowl of offal. Each organ has a distinctivetaste and texture, so you end up with a lot of variety in one bowl. Add in the various sour, spicy, and herbal flavors in the broth and you have a surprisingly complex (and delicious) bowl of offal soup.

Key words: sheep organs, noodles, spicy, oily

荞麦灌肠

Qiáo Mài Guàn Cháng

COST: 8 RMB

These gray-brown noodles, thick as sausages, are made of buckwheat and served in a thick soup flavored with Shanxi vinegar, chili sauce, and soy sauce. The noodles are soft and slippery, like buckwheat jelly. By themselves they don't have much flavor other than a subtle wheatiness, so the complex flavors of the soup are a nice complement. The soup is thick and gloopy with sour, spicy, and salty flavors all mixing together in every mouthful. Although the noodles aren't porous enough to absorb the soup, they do receive a nice soup coating that makes them even slipperier. This is a very fine representative of Taiyuan and Shanxi cuisine.

Key words: buckwheat noodles, slippery, sour, spicy, salty

黑凉粉

COST: 6 RMB

You may be familiar with liáng fěn, or cool jellied mung bean starch, from other parts of China. Here in Taiyuan, the liáng fěn is made of different materials (a type of grass) and is the color of black coffee. Each thick slice is soft, glassy, and squishy, like a black jellyfish. Several of these large slices are served in a bowl of soup flavored with sesame sauce, chili oil, and vinegar. In the bowl, these disparate liquid flavor-enhancers swirl without mixing—a pleasing visual effect. Once in your mouth, however, all bets are off. The nuttiness of the sesame, the spicy punch of the chili oil, and the puckering sourness of the vinegar all mix together perfectly on your tongue. Add to that the slippery blocks of black jelly and you've got yourself one tasty street food.

Key words: slippery, spicy, nutty, sour

手擀面

Shǒu Gǎn Miàn

COST: 8 RMB

This is a dish in which the ingredients take a back seat to the production method and change from vendor to vendor (or buyer to buyer). What makes shǒu gǎn miàn unique is the way the noodles are made. To make shǒu gǎn miàn, you make a mound of dough out of wheat flour and water, then roll it flat with your hands like pizza dough or a pie crust. Once you've got a reasonably flat disc of dough, you slice off a pile of noodles, throw them in boiling water, and voilà: shǒu gǎn miàn! The creation process for these noodles makes them more irregularly shaped, chewier, and springier than most other noodles in China. There are many ways to serve shǒu gǎn miàn. When I ate them, they were served in soup alongside tofu, wood ear mushrooms, unbelievably juicy pork, and bamboo shoots. It was hot, savory, and very filling. You, of course, can choose whatever variation you like. So long as there are hand rolled noodles in the bowl, you are eating an authentic dish of shǒu gǎn miàn.

Key words: chewy, springy, noodles

ALSO TRY:

头脑 (Tóu Nǎo)

One taste that you will come across often in Taiyuan is one of Northern China's most famous products: Shanxi vinegar. The methods used to brew this vinegar are protected carefully, but its primary ingredients are sorghum, peas, and barley. It boasts a really nice flavor—a little bit sweeter and mellower than some of the more sour vinegars you'll come across. Spend a day or two eating in Taiyuan and you'll almost certainly try some Shanxi vinegar. If you find yourself a big fan, you might even consider visiting the Shanxi Vinegar Culture Museum located just outside the city.

Shanghai

Shanghai

葱油拌面

Cōng Yóu Bàn Miàn

COST: 5 RMB

In a small bowl sits a dense thicket of long, skinny noodles with an oily sheen—here you have Shanghai's cōng yóu bàn miàn. Both the ingredients and cooking methods are fairly straightforward. The preparation begins with chopped green onions fried in oil with a splash of soy sauce. While the oil is soaking up the sharp scallion flavor, the vendor quickly boils a handful of hand-pulled noodles. The two are then combined: into the bowl goes the pile of noodles, a bit of the scallion oil, and a few fried scallions. Mix it all together and you've got yourself a completed bowl of cōng yóu bàn miàn. The oily sauce lubricates every noodle beautifully, giving each bite a sweet and salty flavor with just a hint of scallion piquancy. Like I said, its simplicity is one of its greatest selling points, proving once again that sometimes the simplest recipes can result in the tastiest dishes.

Key words: noodles, scallions, oily, sweet, salty

小笼包

Xiǎo Lóng Bāo

COST: 8 RMB

In many people's estimation (mine included), xiǎo lóng bāo are the crown jewels in Shanghai's culinary scene, street food or otherwise. Also known as "soup dumplings," this marvelously delicious snack should be at the top of your list of foods to try in the city. Vendors selling xiǎo lóng bāo are readily identifiable by their piles of round bamboo steamers stacked in tall columns and belching steam into the air. One basket contains about eight individual dumplings, each one flat on the bottom and twisted to a crinkly point at the top. Within the thin skin you will find a small packet of stuffing (usually pork, although modern vendors are happy to twist the recipe with seafood, vegetables, or more unusual ingredients) and some hot broth. The broth makes eating xiǎo lóng bāo a delicate venture, for one poorly aimed bite will spill broth all over the place. There are two main schools of thought on how to eat them without spilling any precious broth: 1) bite off the pointed peak and then drink the soup within; or 2) eat the whole dumpling in one bite, allowing any explosive juices to spill only into your mouth. Either way, you're in for a real treat. Xiǎo lóng bāo are bursting—both figuratively and literally—with flavor, and they make for a singularly addicting snack. No trip to Shanghai is complete without having at least one basket of xiǎo lóng bāo, so be on the lookout for steaming baskets—you won't want to miss them.

Key words: dumplings, soup, pork

葱油饼

COST: 2 RMB

Cōng yóu bǐng is a quintessential street food—greasy, cheap, quick, and portable. It's sold from carts, small stalls, and hole-in-the-wall shops all over the city (much of the appeal of cōng yóu bǐng for me was the character of the particular shop where I sampled it). (Much of the appeal of cōng yóu bǐng for me was the character of the particular shop where I sampled it.) Cōng yóu bǐng are thick pancakes made of larded, unleavened dough stuffed with scallions and a little bit of pork. The dough patties are fried on a griddle, flattened with an iron, crisped by a fire, and then served. Most vendors are sole proprietors, so by necessity they have a complex one-man-assembly line going; at any given moment, there are probably a few cōng yóu bǐng in each stage of the process. The final product is delicious. It's greasy, flaky, layered, and savory. One bite tells you that it's great for your taste buds but not so much for your heart (a hallmark of some of the world's best street food). Despite the artery-clogging properties of cōng yóu bǐng, they are so good that I am told many locals eat them every day. Try one of them out some morning in Shanghai and I think you'll understand why.

Key words: scallions, pancake, greasy, savory

油条 and 豆浆

COST: 4 RMB

Chinese crullers, or yóu tiáo, are reasonably common in a number of Chinese cities, so it's a little difficult to pin down where they originated. They may or may not come from Shanghai. Regardless of their provenance, the fact is that yóu tiáo are now associated with Shanghai culture, particularly when paired with flavored dòu jiāng (soy milk). A stick of yóu tiáo is composed of two attached-at-the-hip tubes of dough, each about a foot long. The dough is light and flaky, sort of like a croissant, but much greasier. The process for making yóu tiáo starts with rolling out the dough into a long ribbon, about the width and length of a sash. After it's rolled out, the vendor folds the dough in half (top to bottom) and then slices it width-wise into strips about the size of a harmonica. The only thing left for the vendor to do is to throw it into the oil and let it soak up those fatty juices for a while—there you have your yóu tiáo! As I mentioned above, in Shanghainese culture, yóu tiáo is often eaten with a bowl of dòu jiāng mixed with ingredients such as pickled vegetables (for a savory version), sugar (for a sweeter version), or small bits of yóu tiáo. You can eat them separately or dunk the yóu tiáo into the dòu jiāng to soak up the flavor—consider this a Chinese version of coffee and donuts. Yóu tiáo and dòu jiāng is almost always eaten for breakfast in Shanghai, so if you want to try it out, make sure you get out onto the streets before 9:00 or so.

Key words: fried, cruller, greasy, soy milk

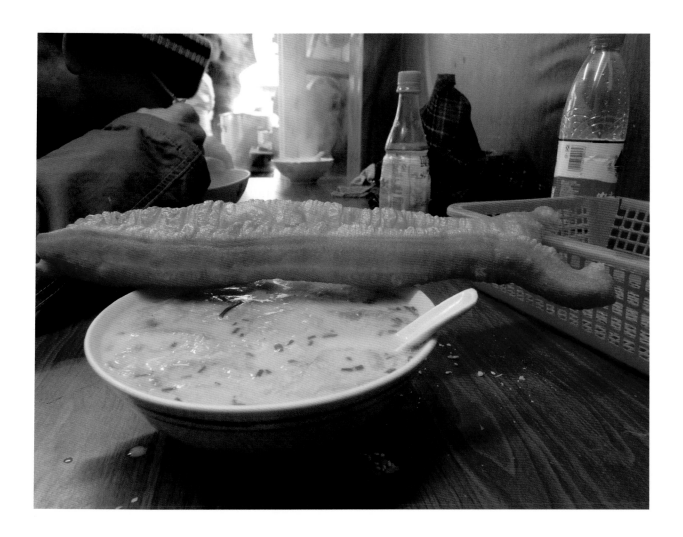

上海菜饭

Shànghǎi Cài Fàn

COST: 5 RMB

At first blush, vegetable fried rice may not sound like the most glamorous or unusual street food in Shanghai. Why travel all the way to China to get vegetable fried rice when it is literally on every single Chinese menu in the world? I don't have a compelling answer to that question other than the fact that Shànghǎi cài fàn is a basic folk recipe that holds a special place in Shanghai's culture. In most ways it doesn't deviate significantly from the fried rice that you might be familiar with. The ingredients are extremely simple, oftentimes consisting solely of rice, bok choy, and oil (although some people throw in some sausage or egg). These ingredients are stir-fried together for a few minutes, allowing everything to mix up and get nice and greasy. Here's where the recipe does diverge in a key way: traditional Shànghǎi cài fàn includes a certain amount of crunchy rice. To make that, the vendor needs to let the rice sit unstirred in the wok for a few minutes, or as long as it takes to get a layer of crisp, golden crust on the underside of the rice. This delectable crust is highly treasured by many locals, and is indeed what makes Shànghǎi cài fàn worth trying.

Key words: fried rice, oily, bok choy, crunchy

ALSO TRY:

南翔小笼包 (Nánxiáng Xiǎo Lóng Bāo), 蟹壳黄 (Xiè Ké Huáng), 排骨年糕 (Pái Gǔ Nián Gāo), 擂沙圆 (Léi Shā Yuán), 油豆腐线粉汤 (Yóu Dòu Fu Xiàn Fěn Tāng),生煎馒头 (Shēng Jiān Mán Tóu)

Sichuan

Chengdu

甜水面

Tián Shuǐ Miàn

COST: 5 RMB

One of the most common questions people ask me is, "what was the best thing you ate in China?" Of course this is an impossible question to answer—how could a person choose just one? China is a huge country with a wide variety of local cuisines, all of which have something marvelous to offer a curious and adventurous eater. It is a fool's errand to try to compare hundreds of street foods and select a single favorite. So perhaps I am a fool, because I have landed on a single stock answer to this question: Chengdu's tián shuǐ miàn. It is, in my opinion, a perfect street food: inexpensive, fast, full of simple ingredients with complex flavors, and representative of a city's unique culture. Oh, and it tastes amazing. At the heart of the dish are some rough-hewn wheat noodles. These noodles are cut in long rectangles about one square centimeter in width. They are thicker and firmer than some noodles; flexible without being rubbery. On top of a small nest of noodles, the vendor will ladle some red sauce made of vinegar, chili oil, sesame seeds, and ground Sichuanese peppercorns. You may recognize the interplay between the chili oil and the Sichuanese peppercorns as the source of Sichuan's famous málà flavor, a combination of spicy and numbing sensations. On top of all of that, the vendor will add an unexpected sprinkling of large sugar crystals. That's all there is to it. It's hard to explain the complexity of the flavors in this dish. You've got the sour acidity of the vinegar, the tongue-melting heat of the chili oil, the mouth-tingling prickliness of the peppercorns, and the pure sweetness of the sugar. Behind all of this, you

have the noodles acting as a scrumptious stage to showcase the varied flavors of the sauce. The result is a small dish of noodles that packs a mighty punch. It might not seem that such disparate flavors would combine well; after eating this dish, you might wonder why you would ever separate them again. Tián shuǐ miàn is without a doubt one of my favorite—if not my absolute favorite—street foods in China. Any trip to Chengdu that doesn't include a bowl of these heavenly noodles is woefully incomplete. Get out there and try them—your taste buds will be forever grateful.

Key words: noodles, spicy, numbing, sweet

三合泥

COST: 3 RMB

Act quickly if you want to try out this traditional Chengdu street food. Although it was popular in days of yore, it is increasingly difficult to find on the streets of the city. Perhaps it has to do with its name (it means "triple mud"). Or perhaps it might be its appearance (there's a reason that it is called "mud"). It's also possible that it is viewed by the younger generation as passé, an unwanted remnant of days gone by (much like Beijing's dòu zhī). Whatever the reason, though, if you want to experience this traditional street food you may have to do some searching. As the first, more appetizing part of the food's name suggests, there are three primary ingredients to sān hé ní: sticky rice, sesame seeds, and either black soybeans or walnuts (different sources disagree on the third ingredient). These ingredients are blended together, boiled, and then simmered in lard. This process results in a brown, lumpy paste that looks—believe it or not—like mud. At this stage vendors might add some peanuts or some walnuts, and then it's ready to serve. It is mildly sweet, nutty, and mushy, as one might expect given the ingredients and cooking process. Some modern vendors, in an effort to appeal to younger clientele, don't use all of the traditional methods and end up with a jelly-like consistency and a sweeter taste than sān hé ní ought to have. Look for the real stuff: it resembles a sludgy casserole with peanuts in it. Admittedly, the visual appeal is somewhat low, but it doesn't taste half bad. If nothing else, you are tasting a piece of Chengdu's history—a taste you might not be able to experience for too much longer.

Key words: ugly, mushy, rice, sesame, beans, walnuts, peanuts

三大炮

Sān Dà Pào

COST: 3 RMB

Pow! Pow! Pow! That's the unmistakable sound of sān dà pào (literally "three big gunshots") being prepared. It is the only street food I know that involves sound as part of its identity, and for this reason it holds a special place in my heart. It is more than just a snack—it is an experience with an essential theatricality. At its core, sān dà pào is not much more than a ball of glutinous rice coated in soybean flour and topped with a sugary red-brown sauce. Ah, but how does the rice ball get coated in the soybean flour, I hear you asking? Good question—here's where it gets interesting. A sān dà pào stall will usually consist of a container of pounded glutinous rice, a large red drum with dish-sized brass cymbals attached (sort of like a giant tambourine), and a wide, shallow basket of soy flour. When you order sān dà pào, the vendor will tear off a chunk of sticky rice, form it into a ball, and hurl it at the face of the drum. As it bounces off of the drum skin and into the basket of soy flour, the drum booms and the cymbals rattle in a satisfying racket. An order of sān dà pào comes with three rice balls, which the vendor will throw in rapid succession to create the namesake three gunshots. Once the rice balls have rolled down the slanted basket, they are sufficiently coated in soy flour to be transferred into a bowl where they are covered with a sweet sauce and served. The rice balls are soft, dense, and squishy, with a mild sweetness. The soy flour coating keeps them from sticking together and gives them a powdery dryness and

nearly unnoticeable nutty flavor. Inexplicably, the sticky red syrup on top reminded me of a combination of Dr. Pepper and barbecue sauce. On their own, sān dà pào are a reasonably pleasant snack; with the addition of their clamorous preparation, though, they enter into the realm of particularly memorable street foods. If you like your dinner with some din, your snack with some crack, or your chow with some pow, you won't want to miss Chengdu's sān dà pào.

Key words: theatrical, sticky rice, squishy, sweet

担担面

COST: 6 RMB

Dān dān miàn is, with good reason, one of the first street foods people think of when they think about Chengdu's street cuisine. It is one of the city's most famous dishes, in part because it has been exported with varying degrees of authenticity to Sichuanese restaurants worldwide. Legend has it that dān dān miàn was created in the mid-19th century by vendors who would carry a stick across their shoulders with a basket of noodles hanging off of one end and a basket of sauce on the other. This carrying stick was called a dān, which is where the noodles got their name. These days you would be hard pressed to find a roving vendor selling dān dān miàn from stick across his shoulders; fortunately, they are still widely available throughout the city. The central feature of dān dān miàn is the pile of thin, flattened yellow noodles. Along with the noodles, you will find some minced pork, a few scattered pieces of pickled vegetables, and a mouth-numbing málà sauce made of chili oil and Sichuanese peppercorns. This is one of those dishes that mostly lives up to its hype: it is just as yummy as its reputation suggests. The noodles are soft and filling, while the sauce packs a spicy and tingling wallop for your unsuspecting taste buds. The other ingredients are of course indispensable to the integrity of the dish and certainly make themselves known, but the noodles and sauce are the true stars here. Dān dān miàn is one of Chengdu's quintessential dishes, and it is well worth seeking out while you are in the city.

Key words: noodles, spicy, numbing, pork, pickled vegetables

五香油茶

COST: 4 RMB

This strange snack may not be for everybody, for it is somewhat peculiar both in taste and texture. Wǔ xiǎng yóu chá means "five fragrance oil tea," a name which doesn't do a great job of explaining what you're about to eat. The base of the dish is a starchy paste, almost like gravy, that is made from boiled rice flour and flavored with onion powder and five-spice (which consists of star anise, cloves, Sichuanese peppercorns, Chinese cinnamon, and fennel). This gravy has an unusual spicy-bitter flavor and a gloppy consistency (not to mention the subtle numbing sensation provided by the peppercorns). To give the dish some texture, vendors usually throw some crispy fried noodle strips, a few scattered pieces of green onion, and a handful of crunchy soybeans or peanuts on top. My understanding is that there is no tea involved at all—it got its name because of its golden color, reminiscent of certain types of tea. I have an affinity for strange flavors and textures, so wǔ xiǎng yóu chá was a winner for me. Nonetheless, it was clear that this was not going to be the case for all comers. Should you want to try this dish, note that it is generally considered a breakfast, so seek it out early in the day.

Key words: starchy, gravy, bitter, spicy, crunchy noodles, soybeans

叶儿粑

Yè Ér Bā

COST: 2 RMB

One of China's many variations on steamed and stuffed glutinous rice balls, yè ér bā work well as a simple snack. Vendors offer two different types: savory and sweet. The savory dumplings are stuffed with pork and seasonings (sometimes including the infamous Sichuanese peppercorn), while the sweet ones typically have a sweet red bean paste and ground nuts hidden inside. Each stuffed rice ball is wrapped individually in a leaf—sometimes lotus, sometimes orange, sometimes banana—to be steamed. A freshly steamed ball of yè ér bā is soft, chewy, and moist, with a waxy skin. Of course the flavor on the inside depends on your personal tastes— my predilections veer towards the sweet varieties, but both kinds are good. I am told that yè ér bā originated in the western part of Sichuan Province and are often eaten at festivals such as the Tomb Sweeping Festival in the spring. They are not limited to festival times like some foods, though, and are happily available all year to satisfy your cravings for a quick snack.

Key words: glutinous rice, savory or sweet, steamed, banana leaf

肥肠粉

Féi Cháng Fěn

COST: 6 RMB

Here's another winner for Chengdu: yam noodles and pig intestines in a fiery red broth. It is every bit as mouth-watering as it sounds. The glassy yam noodles are soaked and then boiled directly in the previously prepared intestine broth, allowing the rich intestine flavor to soak directly into the noodles. (Note: Some vendors use wheat noodles; the yam noodles are more traditional.) When the noodles are nice and tender, the vendor scoops a slippery tangle of noodles and intestines into a bowl, mixes in some chili oil and vinegar, sprinkles the surface with green onions and peanuts, and voila: féi cháng fěn! The noodles are slippery and soft, practically requiring you to slurp them while unceremoniously whipping drops of broth onto your face, and the intestine pieces are chewy, with a clear animal flavor. Behind all of this, of course, is the broth, which is five-alarm spicy. In a city full of remarkable cuisine, féi cháng fěn holds its own as an excellent bowl of noodles (so long as you have a taste for intestines and chili heat, that is).

Key words: yam noodles, pig intestines, very spicy

红油抄手

COST: 6 RMB

Hóng yóu chāo shǒu, along with their less-spicy cousins lóng chāo shǒu (龙抄手), are Sichuan's take on wontons. In most ways, they stick to the general blueprint for wontons in China: thin dumpling wrappers, juicy pork meat, maybe a green vegetable or two, and a bowl of steaming broth. It is the broth that really distinguishes hóng yóu chāo shǒu from wontons in other parts of China. Like many foods in Chengdu, the key is in the spice. Hóng yóu chāo shǒu's broth is not a simple pork or chicken stock—the flavor is heavily dialed up by the addition of chili oil, soy sauce, and sesame oil. What you end up with is a deep red soup speckled with sesame seeds that promises to please all devotees of spicy food. While they remain in the broth, the wontons look stately and vibrant, their fringes drifting aimlessly like decorative fish tails. As soon as they are removed for consumption, however, they collapse into a wrinkled blob in your spoon. They taste soft and moist, savory and spicy. Thanks in no small part to its distinctive spicy base, hóng yóu chāo shǒu is a worthy and unique representative of the Chinese wonton family.

Key words: wontons, pork, spicy

兔头

COST: 6 RMB

Some street foods in China are excellent starting points for people reluctant to try the more outlandish foods you sometimes come across. This is not one of those foods. In fact, this is basically the other extreme; a food that only the more adventurous travelers will seek out: rabbit heads. Vendors selling rabbit heads are unmistakable, as the heads are typically arrayed on a tray all together, staring at you like an undead rabbit army. Some vendors have spiced them with a málà sauce, while others have simply roasted them with very little additional flavoring. When you place an order, you receive one rabbit head and some plastic gloves. The outside of a rabbit's head does not have a lot of meat. To access anything worth eating, you are required to take this head apart, piece by piece. You probably want to begin by grabbing the rabbit's lower jaw in one hand and its upper jaw in your other hand before pulling them apart like a wish-jaw. This stage in the process, before you've even eaten anything, may be enough to convince some folks to pass on this one. If you are able to persuade yourself to press on, though, there are some really nice flavors to be had. I had the sense ahead of time that this would fall into the category of foods such as chicken wings that are too much work and too much mess for too little reward. In this case, I am glad to say that my supposition was proven false. Don't get me wrong—this is a food that requires a lot of work on behalf of the diner, and in return you get messy fingers and not very much meat. What sets the rabbit's head apart from other messy, high-energy, low-yield dishes is the variety of flavors it offers. You are expected to eat anything here that isn't bone: the jaw muscles, the tongue, the upper palate, the eyes, the brains, and any other miscellaneous flesh that you can find. Each part has a different taste and texture, which makes the reward much greater than a mere chicken wing. I was particularly fond of the jaw meat (brown, gamy,

succulent) and the tongue (chewy, mild, a bit tough). I want to emphasize one more time that this is not an easy food to eat. After the first bit where you break open the jaws, as if opening up a stapler for reloading, you have to pull all sorts of sections of bone away. The hardest part to access is the brain—I was instructed to bite the top of the skull to crack it open like an egg. Be careful during the whole process, because it turns out that rabbit skulls have very, very sharp bones. My verdict? Definitely worth a try. If you are able to convince yourself to tear open a rabbit's skull with your bare hands, an interesting mix of flavors and textures awaits.

Key words: rabbit head, taste and texture variety

猪油发糕

COST: 2 RMB

Most cakes, Chinese and otherwise, are predictably safe choices for vegetarians with a sweet tooth. This one is an exception, for among the limited ingredients in zhū yóu fā gāo you will find pork lard (zhū yóu). Flour, sugar, and yeast round out the ingredient list, making this a pretty simple treat with winning results. The white cake you get from baking these ingredients together is spongy and as porous as an English muffin, although it is not particularly light. It has an oily sheen, but doesn't taste greasy. Its pleasant sweetness is not overpowering, but quietly waits to be discovered in the many nooks and crannies. Zhū yóu fā gāo is a yummy dessert that is a welcome refreshment after feasting on Chengdu's many spicy dishes.

Key words: cake, lard, spongy, subtly sweet

糖油果子

COST: 3 RMB

One of the sweetest items you can find on a skewer in China, táng yóu guǒ zi is a tantalizing treat for any incorrigible sugar addicts out there. In some ways, this snack is quite similar to Chengdu's sān dà pào. Like its percussive cousin, táng yóu guǒ zi begins with sticky orbs of glutinous rice about the size of golf balls. Instead of bouncing off of drums and getting coated with soy flour, though, táng yóu guǒ zi are glazed in brown sugar and fried in a pan to give them a crispy, golden-brown exterior. After being fried, they are sprinkled with sesame seeds and pierced on a skewer. As you might expect from the sugar, the rice, and the frying, they taste excellent. The surface is crispy and warm (with a subtle nutty flavor from the sesame seeds), while the inside is chewy and partly hollow. Of course they are also marvelously sweet. They are cheap, sugary, and easy to carry around—in other words, they are simply a delight.

Key words: sticky rice balls, sugary, fried

川北凉粉

Chuānběi Liáng Fěn

COST: 5 RMB

Liáng fěn, or cold mung bean noodles, are popular in a number of cities in Western and Northern China. They didn't originate in Sichuan, but that didn't stop the region from putting their own spin on the dish. The liáng fěn itself is pretty standard: flexible, milky white or clear rectangular noodles made from the powder of ground mung beans. The noodles are sleek, slippery, and rubbery (without being chewy). Where this version diverges from other cities' liáng fěn is in the sauce. You can probably guess at this point how Sichuan has made this dish their own: they spiced it up. The sauce for the liáng fěn you can buy in Chengdu is made from chili oil and Sichuanese peppercorns, endowing it with the province's famous málà flavor. The "liáng" in liáng fěn means "cool," which refers to the temperature of the noodles when they are served. The refreshing coolness of the liáng fěn conflicts nicely with the fire of the sauce, making this an exciting mixture of sensations in your mouth. It may not be the most traditional Sichuanese dish you can eat in Chengdu, but it is a lovely local twist on a dish available elsewhere in the country.

Key words: mung bean noodles, cold, spicy, numbing, oily

鸡丝荞麦面

COST: 6 RMB

Simple ingredients prepared simply equals great taste—that's the basic formula for chicken noodle soup throughout the known world. It is time-tested and reliable through a number of variations, including this Sichuanese specialty. Jī sī qiáo mài miàn makes very few alterations to the basic framework of chicken noodle soup. Hearty buckwheat noodles provide the base, thin brown broth spotted with blips of oil offers the backdrop, and silky shreds of chicken give it the texture and flavor people look for in a good chicken noodle soup. Vendors might throw in a handful of chives or other garnishment, but the basic structure of the soup is unmistakable. It is salty, slurpy, and pleasantly reminiscent of cold days past.

Key words: chicken, buckwheat noodles, oily, salty

Tianjin

Tianjin

煎饼果子

Jiān Bǐng Guǒ Zi

COST: 4 RMB

Beijing might (emphasis on *might*) be able to claim jiān bǐng, that ubiquitous Chinese breakfast crepe, as its own, but Tianjin—just down the road from Beijing—seems to have the definitive claim on this variation. Jiān bǐng guǒ zi begins in basically the same way as regular jiān bǐng: a gloppy batter of wheat flour, egg, and water is spread onto a round griddle to be fried like a thin pancake. While it cooks, the vendor cracks an egg or two atop the crepe, scatters a handful of green onions, and smears some chili sauce (spicy) and fermented bean sauce (sour) across the whole shebang. Now finished cooking, the vendor rolls it up, folds it in half, and you eat it like a breakfast burrito. The variation in Tianjin (which has also spread to other locales that now serve jiān bǐng guǒ zi) comes just before the rolling. On top of the eggs and sauce and everything, the vendor will add a long piece of yóu tiáo (a greasy Chinese cruller—see the Shanghai section for more info). This addition gives the jiān bǐng guǒ zi a pleasing texture that the regular jiān bǐng lacks. It also makes it a little bit greasier, but who's counting. Jiān bǐng guǒ zi is usually eaten for breakfast, so get out there early—there's no better way to start a day in Tianjin than with a greasy, eggy, spicy, sour mouthful of jiān bǐng guǒ zi.

Key words: egg, spicy, sour, cruller, crispy

糖炒栗子

Táng Chǎo Lì Zi

COST: 5 RMB

Roasted chestnuts are a classic cold weather street food all over China. Normally I wouldn't include a food that is available all over the country, as this book is really about the culture of hyperlocal foods, but I've been led to believe that Tianjin has a reputation as being the best place in the country to get them, a fact that I thought merited their inclusion. Preparation is relatively straightforward: fresh chestnuts are cooked with water, salt, and sugar in a shallow pan filled with hot charcoal. If you buy them directly after they have been cooked, their shells are extremely hot, so be careful. The shell often cracks open during the roasting; if it hasn't, you'll need to crack it open with your fingernail or teeth.Unpracticed eaters may need to de-shell half a bag before they get the hang of the technique. Once you're inside, the chestnut flesh is warm, sweet, and nutty, albeit somewhat insubstantial. True to their reputation, these chestnuts are excellent in Tianjin. As certain holiday songs have suggested, they make a lovely snack on a cold day.

Key words: chestnuts, hot, sweet, nutty

糕干

COST: 2 RMB

Gāo gān, or "dry cake," is a perfectly apt description of this street food. It's a brick-shaped cake made of rice flour, stuffed with sweet red bean paste, and topped with a raisin. As the name suggests, this cake is quite dry—almost powdery. We're talking about the type of dryness that wicks all of the moisture from your mouth and makes it difficult to swallow. Fortunately, the red bean paste heart counteracts the dryness to some extent, making this a bit more palatable. The red bean paste is smooth and sweet, maybe even tangy. Together, the dry rice powder and the moist red bean paste make a simple and visually appealing snack.

Key words: rice powder, dry, red bean paste, sweet

麻花

Má Huā

COST: 2 RMB

What's not to like about a crispy fried twist of dough? If the question weren't rhetorical, the answer would be "nothing," because there's nothing not to like. Tianjin's famous má huā is made of long spaghetti-strips of dough that are twisted up like a rope and fried to a golden crisp. Some recipes also include a stuffing of some sort in the middle of the rope. Má huā comes in a variety of flavors including sesame (both white and black), peanut, osmanthus, red bean, and more. Though the fried dough here might make you think this was a sweet treat like a donut, most má huā actually tend to be salty or savory. Má huā have a nice fried-food aroma and a crunchiness that is awfully satisfying to bite into. Because it is made from many individual strips of dough instead of one large hunk of dough, the finished má huā is pleasingly dense—each strip retains much of its structural integrity through the frying process. Prepackaged má huā are available in stores all over the city; I would recommend taking the time to seek out a vendor that sells them fresh—they just taste better that way. For an alternate take on Tianjin's má huā, head up to Changchun in Jilin Province, where they make a softer, sweeter version.

Key words: braided, crunchy, fried

耳朵眼炸糕

Ěr Duo Yǎn Zhá Gāo

COST: 3 RMB

One of Tianjin's most beloved street foods, ěr duo yǎn zhá gāo was invented around the turn of the 20th century by a man named Liu Wanchun. The hutong where he lived and sold his wares was, for some reason, named Ěr duo Yǎn ("earhole"). Over time, as his sweet fried rice cakes became more and more well-loved in the city, they were identified with Mr. Liu and his earhole alley, which is how they became known as ěr duo yǎn zhá gāo: earhole fried rice cakes. The non-orifice part of the name gives you a pretty good idea of what you're getting into here. A blob of yellow rice and glutinous rice dough about the size of a persimmon is stuffed with a mixture of red bean paste and brown sugar and then fried. What you end up with is a ball with a thin, crispy, blistered skin and a gooey, squishy, sweet interior. It is a delightful treat for the senses, particularly if you are a normal person who likes sweet and fried foods. A food that I have used the words "earhole" and "blistered" to describe might not sound very appetizing, but you'll have to trust me—this one is a winner.

Key words: crispy, sweet, rice, red bean paste, sugar

天津粉肠

COST: 5 RMB

This sausage, native to Tianjin, is plump and juicy—a recipe for great taste in a cured meat. The taut intestinal casing offers a pleasant resistance against your teeth and contains a good amount of fatty pork meat (moderately greasy) spiced with ginger, green onions, salt, and nutmeg. It is a well-spiced but not particularly spicy sausage, so people with low tolerances for spicy foods should feel welcome to partake. You pay for it by weight, so order as much as you like. Although you might be tempted to eat it all on the spot, you might want to note that it travels and stores well, so consider carrying it around to nibble on while you wander the streets of Tianjin. At the end of the day, you can finish off the last few bites before laying down to a night of happy, sausage-filled dreams.

Key words: sausage, ginger, plump, juicy

驴打滚

Lǘ Dǎ Gǔn

COST: 2 RMB

Most of the glutinous rice and red bean treats you find in China have one basic form: a sphere of sticky rice with a core of sweet red bean paste. Tianjin and Beijing (it's not exactly clear which city is the true birthplace) offer a novel variation on that theme. Rather than ball up the rice, the vendor will flatten it out, spread the red bean paste on it, and then roll it up like a Swiss roll. He or she will slice it into pieces about the size of a fat thumb and then dust them with soy bean flour. This final dusting is what gives lǘ dǎ gǔn its name, which means something like "donkey rolling"—it refers to a donkey rolling around on the ground and getting dirt all over its back. Lǘ dǎ gǔn is soft and sweet, layers of rice alternating with layers of red bean paste. The soy bean flour keeps the outside from getting too sticky, which is nice. All in all, it's a simple, tasty little diversion.

Key words: sticky rice, roll, red bean paste, sweet

上岗子面茶

COST: 6 RMB

The base of this goopy street food is a thick porridge made of boiled millet, flour, and sesame seeds. It has a caramel color and a gummy, starchy consistency. When it is served, the vendor will top it with sugar, raisins, nuts, sesame seeds, dried fruit, peanuts, cinnamon, or other similar ingredients. Before you dig in, you'll want to stir it all up into a complicated mélange of flavors and textures. It's sweet and mild in flavor, floral in aroma, and pasty in texture. Eat a bowl for breakfast and you'll be filled up and fueled for several hours of touring the city.

Key words: millet paste, porridge, sweet, fragrant

锅巴菜

COST: 4 RMB

Though it might look like another bowl of noodles, Tianjin's famous guō bā cài is actually a series of thin pancake slices. The pancakes are made from a batter of millet and mung bean powder (which is where they get their brownish green color). They are lightly fried, sliced into strips, and then dried, leaving them crisp and delicate. After all that is done, the vendor will prepare a gravy with sesame oil, garlic, fermented tofu (known as xiāng gān), sugar, soy sauce, and chili oil. This gravy is thrown into a pot with some additional spices, and the pancake strips follow soon after. In this pot of gravy, they soak up flavor and get nice and soft, so that when you finally take them out of the pot and serve them up (with a little bit of the gravy for flavoring), they are like tender, delicate noodles. They have a complicated mixture of flavors including savory, salty, sour, and spicy, all of which are fairly mild and unassuming. You can almost think of it like eating crepe slices mixed with a thick, spiced sauce. It's a lovely breakfast that's definitely worth seeking out in Tianjin.

Key words: pancake strips, gravy

糖果子

Táng Guǒ Zi

COST: 2 RMB

Not so much a breakfast itself as a supplement to a good breakfast, táng guǒ zi is something like a Chinese breakfast pastry. It is basically a sweet tablet of fried dough. Unlike some fried pastries, this is crispy on the outside and slightly softer on the inside, especially if you eat it warm. A popular variation on the standard táng guǒ zi includes a fried egg stuffed inside. I haven't tried this variation myself, but it sounds good. The whole thing is about the size of a paperback novella, albeit a novella covered in bumps and bubbles from the frying. For a sweet and crispy accompaniment to your breakfast, you can't go wrong with táng guǒ zi.

Key words: sweet, crispy, fried

狗不理包子

Gǒu Bù Lǐ Bāo Zi

COST: 10 RMB

Last but not least for Tianjin is gǒu bù lǐ bāo zi—a strong contender for the city's most beloved street food. This is the kind of food that you are virtually required to eat if you are on a culinary tour of the city. Like some of the other foods available in the city, there is a colorful story behind gǒu bù lǐ bāo zi's name. It literally means "dog ignores buns." The story goes that the man who invented these buns about a century-and-a-half ago had the nickname "little dog" as a child. When his steamed buns became popular, he was so busy preparing them that he couldn't pay any attention to any of his friends or customers. Consequently, people started to say that the little dog was ignoring them, and the name soon stuck to the buns themselves. In the most basic terms, there's not much that distinguishes these buns from other steamed buns available in China. They are stuffed with a tantalizing mixture of pork, pork belly, onions, ginger, and soy sauce and steamed until they are soft and moist throughout. Each bun is pinched closed with fifteen wrinkles, giving it an intricate floral appearance. Most of that is pretty standard procedure for bāo zi in China. So why are these buns so revered in Tianjin? Apparently it has to do with the care put into each bun. The recipe calls for very precise ratios of ingredients, and very specific methods of rolling, rubbing, and steaming all of the ingredients. Locals consider them to be a national treasure, so be sure not to miss them while you are passing through Tianjin.

Key words: steamed bun, juicy, pork

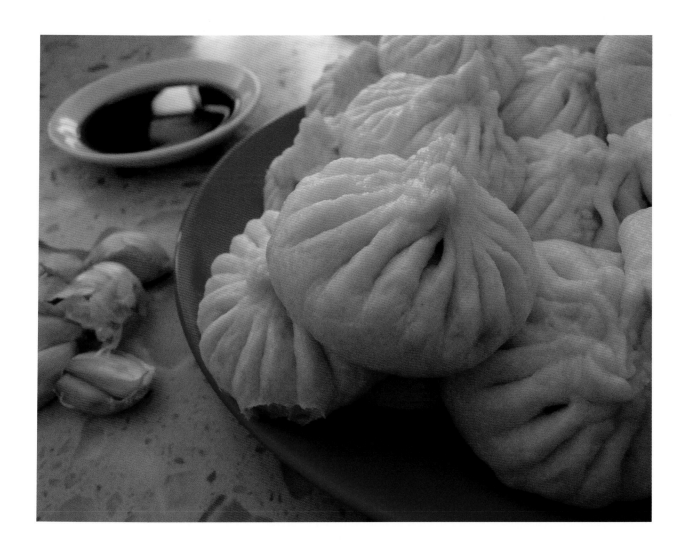

411

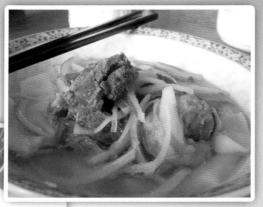

Xinjiang

Urumqi

苜蓿饺子

Mù Su Jiǎo Zi / Kök Chöchüre

COST: 10 RMB

Urumqi is rightly infamous for its long, bitterly cold winters. It should come as no surprise, then, that the coming of spring is a time of gladness in the city. One herald of the advent of spring is the arrival of fresh, green clover in the grasslands around Urumqi. This annual growth has developed into a yearly tradition in Urumqi: clover dumplings. These boiled wheat flour dumplings are stuffed with a delicious mixture of egg, clover (or alfalfa), and occasionally some beef or tofu. The dumpling shells are soft and slippery, giving way to gentle pressure from your teeth to allow the fresh-tasting insides to spill out. Vendors typically serve up a huge portion of dumplings they say is intended for two people but in reality could feed four or five. These wonderful little treats are only available for a couple of months in the springtime, so you may be out of luck if you are visiting Urumqi any other time of the year. If you happen to be there in the spring, check these out. They are a lovely tradition.

Key words: dumplings, clover, egg, fresh

烤羊肉串

COST: 4 RMB

Go to virtually any city in China, from Shanghai to Beijing, from Xi'an to Chengdu, from Dalian to Kunming, and you will find grilled, seasoned, and skewered mutton. It is one of the most ubiquitous street foods in all of China, mainly thanks to the Hui people who can be found throughout the country. The Muslim faith of the Hui people accounts for the choice of mutton over pork. So where does this omnipresent food originate? In the cuisine of Muslim-dominated Central Asia, a geographic region that includes Urumqi (it is, after all, the most landlocked city in the entire world—what is more "central" than that?). You might be asking yourself whether the kǎo yáng ròu chuàn made by the Uyghurs in Xinjiang tastes any different than the Hui-made skewers in, say, Beijing. I'm happy to share that the answer is yes—they taste different (and better!). Instead of the puny shrivels of wrinkled meat you can buy in the Eastern cities, the vendors in Urumqi offer big, substantial hunks of meat on their skewers. They are fatty, marvelously juicy, and full of grease that runs down the sides of your mouth when you tear a piece off with your teeth. In my experience, vendors out here use less seasoning than the Hui vendors in other Chinese cities, allowing the flavor of the sheep to stand proudly on its own. That being said, there is still a nice dose of cumin and chili pepper to give some character to the meat. These mutton kabobs are perhaps the most representative street food of Urumqi (and Xinjiang in general) and should be right at the top of the must-try list for any non-vegetarians passing through the area.

Key words: mutton, grilled, greasy, juicy

烤包子

Kǎo Bāo Zi / Samsa

COST: 3 RMB

These baked stuffed buns are a fine counterpart to the steamed bāozi available in other parts of China. Like many culinary items in Urumqi, kǎo bāo zi are a creation of the Uyghur people and are, therefore, suitable for a halal diet. An unleavened dough is shaped into a rectangular pocket into which the vendor will insert a mixture of mutton, onions, ginger, sesame oil, and cumin. After sealing the pocket shut with egg yolk, the bun is baked in a tandoor oven until it is golden brown on the outside. This outside layer is crispy and very thin. As you can see in my picture, it doesn't take much to accidentally pierce this outer layer. The filling inside is juicy and savory, with a nice spiced flavor emanating from the cumin and a bit of pungency from the onions. Urumqi's baked stuffed buns are a taste-bud-pleasing snack that is both cheap and easy to find—just what street food lovers are looking for.

Key words: mutton, juicy, bun, thin shell

馲奶

Tuó Nǎi / Shubat

COST: 8 RMB

Less of a street food and more of a street drink, tuó nǎi is fermented camel milk. This unusual beverage—also called chal or shubat—was popularized in Central Asia and brought to Urumqi by the Kazakh people. Fermented camel milk is made by mixing fresh milk with a smaller sample of already fermented milk. More and more fresh milk is mixed in over three to four days and allowed to sour, at which point it is ready to serve. The drink is served cold—very nice on a hot day. At a glance, you can see that this milk is frothy, thick, and brilliantly white. The first sip is a bit startling, as the fermentation has created a sparkling bubbliness that bites at your tongue like carbonated water. It is sour and acidic, which only adds to the bite. There is a minor alcoholic taste to the milk, as well as very mild hints of citrus. You wouldn't know it from the sound of it, but fermented camel milk is actually quite tasty and refreshing. Also, local lore claims that it has virus-fighting abilities, so you've got that going for you as well. The bottom line? For a delicious sample of Central Asian culture in China, you can't go wrong with tuó nǎi.

Key words: fermented, camel milk, frothy, sour, sparkling

马肠子纳仁

Mǎ Cháng Zi Nà Rén / Qeza Narin

COST: 8 RMB

As the popular saying goes, "when life gives you horses, make horse sausage." If there is anything you can find in abundance in Central Asia, it's horses, so it's no surprise to find horse sausage here. In this dish, another Kazakh specialty, large slices of horse meat sausage are mixed in a soup with red onions and wheat noodles. The meat looks a bit like beef, but it is tougher and somewhat sweeter. The sausage casing and contents are fatty and chewy and just as delicious as it sounds. Of course the sausages are the central feature of the dish, but the whole thing wouldn't be as tasty without the noodles adding hearty substance, the onions adding pungency and crunch, and the soup offering itself as a base of operations. This Kazakh dish is another winner for Urumqi.

Key words: horse sausage, fatty, onions, noodles, soup

奶疙瘩

Năi Gē Da / Kort

COST: SOLD BY WEIGHT

Variations on this hard cheese are popular throughout much of Central Asia, from Iran all the way up to Mongolia. Production methods are different from the cheeses that are common in Europe and the United States. Milk from a mare or a sheep is fermented, thickened, boiled, formed into small blocks, and then air-dried. This air-drying process makes the cheese chunks rock solid, to the point where you worry about your teeth when you bite into them. "Rock solid" is to be understood as a nearly literal description. The benefit of such a cheese is that it travels well and doesn't go bad, which is perfect for nomadic cultures. The cheese can be eaten plain or rehydrated in water to create a yogurt-like substance. Eaten plain, it has a salty, sour taste, slightly reminiscent of yogurt. Since it is so hard, you can only really nibble at it—one little chunk can last for quite a while. In fact, some people prefer to pop a piece into their mouth and let it slowly melt away like hard candy. However you choose to eat it, this is another treat that will send your taste buds straight to Central Asia.

Key words: cheese, dried, hard, sour

抓饭

Zhuā Fàn / Polu

COST: 10 RMB

Zhuā fàn, known as "polu" (pilaf) in the Uyghur language, is the local variety of a family of rice dishes popular throughout Central Asia. The ingredients of this dish are simple: rice, lamb, orange and yellow carrots, caramelized onions, oil, mutton fat, garlic, and cumin. Everything is mixed together and cooked in a large pot—a nice change from the stir-frying you get with many of the oily rice dishes in China—until the grease from the mutton fat has been infused into each and every grain of rice. As you might expect, that makes for a truly delicious flavor throughout. The large chunks of lamb are tender and succulent like slow-cooked meat. The richly flavored rice is buttery, glistening, and greasy, encouraging you to eat it by the spoonful. The spices and vegetables serve honorably as color and flavor accents to the dominating presence of the meat and rice. Due to all of the rice and grease, zhuā fàn is a filling dish—one bowl will fill you up for hours. Locals can't get enough of this mouth-watering Uyghur dish, and it's not hard to see why. Try it out and see for yourself.

Key words: mutton, rice, greasy, savory

馕

COST: 4 RMB

Náng is perhaps the most quintessentially Uyghur food in Xinjiang. You've heard "give us this day our daily bread?" Well, this flatbread is a basic daily staple for many (maybe most) Urumqi residents. It is related by tongue and taste to the better-known (in the West) naan. There are more types of bread in Urumqi than you might expect, but it is generally safe to call them all náng. Round heaps of dough are beaten, flattened, decorated with intricate patterns, and stuck to the inside walls of an iron oven to bake. When they emerge they are crispy and brown on the outside, with dense, warm insides. The final step is to sprinkle them liberally with black sesame seeds, onion flakes, or garlic. Náng is not a fluffy white bread you would use to make a peanut butter and grape jelly sandwich then cut off the crusts and slice into triangles before eating. It is heavy and hearty and a good side dish to a dripping hunk of mutton, which is precisely what makes it such a popular snack in Xinjiang. The bottom line is that if you are looking to eat like the locals while traveling, this is an unmissable dish in Urumqi.

Key words: dense, flatbread, baked, hearty

Yunnan

Kunming

过桥米线

Guò Qiáo Mǐ Xiàn

COST: 9 RMB

Admittedly, this Yunnan specialty is in a bit of a gray area between "street food" and "restaurant food." I've chosen to include it because it is often available in small street-side shops and it doesn't hurt to err on the side of inclusion. Guò qiáo mǐ xiàn, or "crossing the bridge noodles," are probably the best known Yunnan food. Apparently the origin of the unusual name is something of a mystery. The story I like best goes as follows. A man was studying for his imperial exam on a small island (presumably the isolated setting made for more focused studying), and his wife was struggling to find a way to bring him his lunch without the soup getting cold and the noodles getting mushy. Her solution was to keep the broth hot in one jar and carry the ingredients separately in their own containers. After she crossed the bridge to the island, her husband could combine the ingredients and eat it hot and fresh. Wherever the name came from, the story does do a fair job of describing the dish—it ought to come with a small sign reading "some assembly required." When you order crossing the bridge noodles, you should expect a large bowl of very hot, oily broth and several smaller plates of uncooked food. Common ingredients include sliced pork or chicken, raw quail eggs, chicken skin, tofu, pickled vegetables, chives, and glassy rice noodles. As soon as the plates and bowls arrive at your table, you should transfer the raw meat or eggs to the soup for cooking (my waitress scolded me for pausing to take photos). The other ingredients can be transferred over to the soup bowl at a more leisurely pace, as they

require less cooking time. All you need to do now is wait a few minutes and then dive in. There are no surprises in the taste here: the meat is succulent, the vegetables are fresh, and the glass noodles don't have much flavor but offer some nice texture and substance. It is a satisfying and very filling meal, whether or not there are any imperial exams on your horizon.

Key words: self-assembled, rice noodles, soup, filling

烧豆腐

COST: 4 RMB

Tofu doesn't usually surprise me. Sure, there are seemingly thousands of ways to prepare it, including China's infamous stinky varieties, but how often does a bite of tofu really catch you off guard? For me, Kunming's shāo dòu fu is one of the few that has done that. It looks fairly unassuming, like a pile of tiny, grayish-brown chargrilled pillows served with a small bowl of dipping sauce made from chili powder, soy sauce, chili oil, parsley, and mint. Before my first bite, I anticipated a fairly standard mild tofu that would mostly serve as a textural foundation for the sauce. My assumption was wrong: this tofu has a remarkably strong taste. It is bitter and acidic, with a charred, biting aftertaste. Some of that is due to the fermentation process and some is due to the charcoal grilling process, but you're not thinking about that when your taste buds are electrified with those sensations. Contrary to what I expected, the tofu is not merely a vehicle for the flavors of the sauce—the sauce actually *cuts* the flavor of the tofu, making it less immediate and more complex. Lest I focus too much on the taste, I should note that the texture is also interesting: each tofu pillow has a thin casing and an unusually dense, springy core. All in all, this is a dish that is full of surprises, most of which are (thankfully) positive.

Key words: tofu, acidic, bitter, charred, sauce

豌豆粉

COST: 5 RMB

Wān dòu fěn is Kunming's tasty answer to the liáng fěn found elsewhere in China. The production process is nearly identical: pea starch (instead of liáng fěn's mung bean starch) is boiled in water, cooled into a gelatin-like block, and sliced into jiggly rectangular prisms. These jelly pillars are served chilled and topped with chili oil, ginger, garlic, and parsley. By itself, the wān dòu fěn has a smooth texture—firm but soft; an opaque, light yellow color; and a pleasing pea flavor. This is all complemented by the sauce, which adds a bit of spiciness, a dash of garlic, and a kick of ginger. It's a delightful, slippery combination that slithers right down your throat.

Key words: green pea, slippery, spicy, garlicky

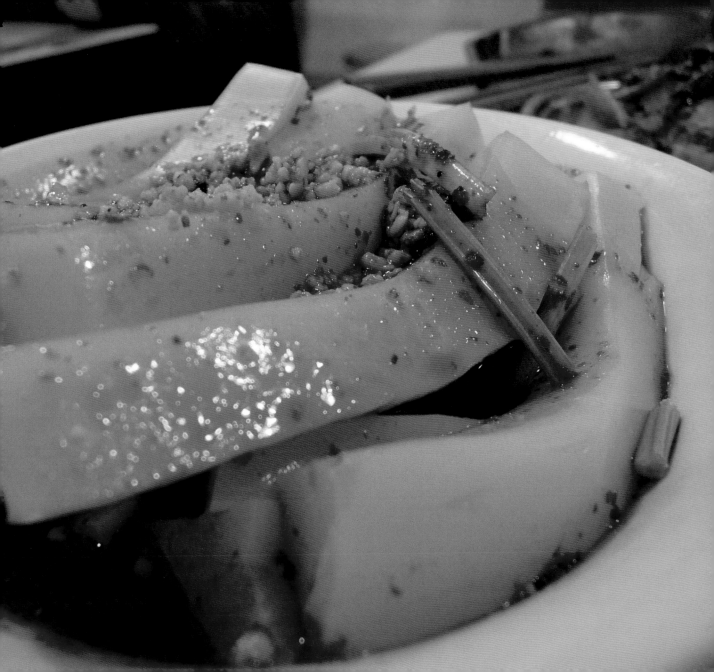

调糕藕粉

Tiáo Gāo Ǒu Fěn

COST: 5 RMB

To look at this peculiar Yunnan specialty, you wouldn't have any idea how it was made, or even what ingredients went into it. A bulging mound of viscous brown sludge serves as a squishy pedestal to a crown of crumbly white crystals topped with sugar. Allow me to clear up the mystery: it's mostly lotus root and rice. The base of this concoction is lotus root that has been ground into a fine powder and soaked in water. While it is soaking, a syrup is created by boiling water and brown sugar. The soaked lotus root powder is mixed into the hot syrup, giving you the gelatinous blob you see in the picture. For the white crown on top, all that needs to be done is to put some glutinous rice powder into a mold and steam it. When the vendor is ready to serve, he or she will empty the mold on top of the hot blob, pour some rose water or osmanthus syrup on top, and sprinkle it with brown sugar, pine nuts, or raisins. Voila! There you have one of Kunming's traditional street foods. Although it seems a shame to disrupt the integrity of the dish before you, you'll probably want to mix the lotus and rice together before you dig in. The gritty crumbliness of the rice and gluey thickness of the lotus offer a nice contrast of textures, and the whole thing tastes sweet without being cloying. Despite the cooking process, you can still taste the lotus and rice flavors, as well as the delicate floral taste from the rose water and the pure sweetness of the brown sugar. It's an interesting dish that seems to be hard to find these days, so grab it when you have the chance.

Key words: lotus root, glutinous rice, thick, lightly sweet

木瓜水

Mù Guā Shuǐ

COST: 4 RMB

When you've had your fill of Kunming's local specialties on a hot day and you're looking for a refreshing dessert to cap it off, you might consider investigating mù guā shuǐ, or "papaya water." The preparation process is somewhat mystifying to me, but I've been led to believe that it involves making a jelly out of the slimy coating on papaya seeds. This jelly is scooped into a bowl of brown, sugary syrup and served. The jelly is extremely delicate, practically flirting with the border between liquid and solid; although you can pick it up with a spoon, you basically have to slurp it up like a soup. It has a very mild flavor, partly sweet (both from the syrup and from the jelly) and partly sour. It's hard to identify the papaya, although there is a faint ghost of fruitiness to the jelly. As it is served chilled, it really is a pleasant way to end a meal. If you are able to conclude your culinary explorations for the day on this note, I think you'll be pleased.

Key words: sweet, sour, delicate, jelly

越南小卷粉

COST: 6 RMB

One example of the simple fact that culture is not always confined by political boundaries is Kunming's yuè nán xiǎo juǎn fěn. The first part of the name, yuè nán, means "Vietnam," a country that shares a border with Yunnan province. Yuè nán xiǎo juǎn fěn is basically a bunch of pickled vegetables, pork, wood ear mushrooms, and egg loosely wrapped in rubbery sheets made of glutinous rice. For less than 10 RMB, you can get a decent pile of these rolls and a bowl of chili oil for dipping. Expect them to be savory, salty, and a bit sour on their own, and a little bit spicy when they've been dipped in the chili oil. They are a good reminder that culture criss-crosses boundaries much easier than people do.

Key words: Vietnamese, rolls, salty, pickled vegetables, pork

饵块

Ěr Kuài

COST: 2 RMB

Ěr kuài is one of the most traditional and local foods Kunming has to offer. It is such a part of the city's history that it has been officially designated part of Kunming's "intangible heritage" (much like the boy eggs in Dongyang). It is cooked in a variety of ways and is eaten frequently both on the street and in the home. The simple heart of ěr kuài is steamed sticky rice that is pounded into a dough-like consistency. Traditional pounding methods involve a massive hand-operated structure that looks like a combination of seesaw and hammer. You can still find some vendors using it, but others have switched to more mechanized production processes. After being steamed and pounded, the rice is kneaded into various shapes and sold.Out on the street, you are most likely to find ěr kuài that has been rolled into pancake shapes and grilled. When you order one of these pancakes, you are given the choice of several sauces to slather on top before the pancake is rolled or folded for easy consumption. Sweet sauces are generally made with peanuts or sesame seeds; spicy sauces are made mostly with chili oil; sour sauces usually include fermented bean curd. As you would expect from something made solely of steamed rice, ěr kuài doesn't offer much flavor on its own, so the sauce is really key to the taste of the dish. The texture, on the other hand, is entirely provided by the rice—it is floppy and moderately chewy. It has also retained some of that starchy stickiness that is characteristic of sticky rice. All in all, ěr kuài is a simple but scrumptious treat with a lot of local history. Definitely worth a try if you happen to come across it on the streets of Kunming.

Key words: sticky rice, spicy/sweet/sour sauce

猪蹄

COST: 5 RMB

Now we come to the humble, unsung pigs' feet. Believe it or not, I consider these grilled hooves to be one of life's great guilty pleasures. That may be surprising to those of you who are only familiar with pigs' feet as they are sold in the West. Those briny, pallid chunks of flesh crammed into dusty jars on long-untouched grocery store shelves always seemed a bit unappetizing to me, and I suspect most people share that assessment. So for those, like me, who have looked ungenerously upon the humble pig foot, let me tell you this: there is another way. Kunming's roasted pigs' feet are a revelation. Watch as these vibrantly colored hunks of meat and bone are cut down the middle, grilled, and seasoned before your very eyes and served hot, fresh, and oozing with grease. It's that last part—the grease—that turns this from a quotidian pleasure to a guilty pleasure. When you receive a pig's foot, you might notice a generous layer of fat between the skin and the bone, as well as how thick the skin is. As you survey those features, your arteries involuntarily clench in anticipatory revulsion, while your brain frantically replays the relevant lectures from high school health class, hoping to overrule the momentum your taste buds are trying to build. There are no two ways about it: this is not a healthy food. If you're lucky, your taste buds win the internal debate and you tear into this porcine delight with vigor. It is heavenly. The skin is rubbery and chewy, while the meat (or fat) is soft and greasy. The seasoning is mildly spicy and the meat has a nice sweetness to it (not sugary sweet—meaty sweet; think of the sweetness of ham for a comparison). As you eat, your mouth is coated with a thin layer of grease, giving your tongue, teeth, and cheeks a sticky, waxy sensation. Before you know it, you are left with bones on your plate, contentment in your stomach, and half-regret in your brain. Unless you are looking to drastically shorten your lifespan, pigs' feet

are not to be eaten every day. Once in a long while, though, you can take the plunge and be richly rewarded. Like all guilty pleasures, the bashful guilt you feel coupled with the rarity of the experience are all part of the magnificent joy of pigs' feet. Savor those moments. Everyday foods like spinach sustain life; guilty pleasures—like pigs' feet—are what make it worth sustaining.

Key words: pigs' feet, greasy, fatty, rich, guilty pleasure

油燃面

COST: 5 RMB

Any noodle-lovers out there who are tired of soup and vegetables getting between them and their noodles will be glad to see yóu rán miàn on the streets of Kunming. This delicious dish ruthlessly eliminates anything non-essential and limits itself to noodles and sauce—a bold move which pays off handily. Really all you have is a densely packed bowl of yellow, spaghetti-like noodles that have been tossed with a fried, gritty sauce. The secret of yóu rán miàn's success is that sauce. It is made from ground sesame and black mustard seeds, lard, soy sauce, chili oil, and salt, all fried together in a greasy red and black mess. This sauce is surprisingly gritty, which I assume is due to the sesame and mustard seeds.Because the noodles are so long and thin, they get tangled into a big, dense knot in your bowl, resulting in a large surface area to grab hold of the sauce. Every bite is full of the sauce's greasy, gritty, mildly spicy (almost like cumin) sensations. If that sounds as good to you as it does to me, then you won't want to miss Kunming's yóu rán miàn.

Key words: thin noodles, gritty, chili oil, sesame, mustard

烤蚕豆

Kǎo Cán Dòu

COST: 2 RMB

Of all the foods you can find roasted on skewers in China, this might be the smallest and cutest. Thin bamboo spears are stuck through five to ten fava beans, grilled, and sprinkled with chili powder and other spices. Obviously they aren't substantive enough for a meal, but they work well as an appetizer or snack. They are firm but not crunchy, and have a pleasing salty/spicy bean flavor.

Key words: fava beans, chili powder, roasted

It's a basic truth that foods (among all other elements of culture) regularly move in and out of style. This happens all over the world, and it's useful for keeping things lively. For culinary travelers, though, it makes finding the most traditional foods a bit of a challenge. That being said, we can be grateful that individual restaurants have stepped up here and there to offer a wide variety of classic foods all in one convenient place. One stellar example is 民生街老牌涮菜馆 at 12 Minsheng Street in Kunming. It may not be as much fun as finding the food on the street, but it's possible to eat a ton of hard-to-find street foods there, so it may be worth a visit.

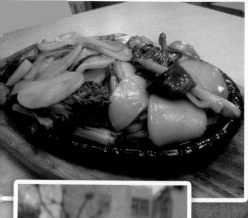

Zhejiang

Dongyang

童子尿煮鸡蛋

Tóng Zǐ Niào Zhǔ Jī Dàn

COST: 1 RMB

When people hear that I've written a book about Chinese street food, one of the most common questions I get is "what was the weirdest thing you ate?" I don't really like calling foods "weird" or "bizarre," as I find that a little too culture-centric. Then I go on to say that despite all that, it's still easy to name the weirdest thing I ate in China. It's tóng zǐ niào zhǔ jī dàn. It may look like an ordinary hard-boiled egg, and in many ways it is. There is just one key difference: this egg is cooked in the urine of young boys, preferably under the age of ten (because urine from an eleven-year-old would just be gross).

The name tóng zǐ niào zhǔ jī dàn literally means "boy urine cooked egg," but that's often abbreviated to just tóng zǐ dàn, or "boy egg." Boy eggs are not easy to find in China. They are really only available in Dongyang during springtime. I heard rumors from some train seatmates that boy eggs are also available in other southern Chinese cities, but I haven't found anything to substantiate this. Frankly, in my experience they weren't even easy to find in Dongyang, even though they've been officially listed as part of the city's "intangible cultural heritage." It took a good bit of asking around before I found a woman selling them from a wide, rusty pot.

On the outside, a boy egg looks exactly like a normal egg, albeit with a faint smell of urine. Once shelled, however, it's a different story. It has a marbleized look, which is a result of the cooking method—after boiling

in the urine long enough to become solid, the eggshells are cracked a bit to allow the urine to soak into the egg itself during the remainder of the boiling. The patterns on the egg are where the cracks were in the shell. Actually, this shelled egg doesn't look terribly different from the tea eggs you can find all over China. The key difference there, of course, is that tea eggs are cooked in tea instead of the urine of young boys. I can't emphasize that point enough—that this is an egg cooked in urine. Now, while the look of the boy egg is fairly similar to the tea egg, there are several important sensory differences, the most notable being the way they smell and feel. Have you ever changed the bed sheets for a child who wet the bed at night? If so, you may recall how the air was heavy with the odor of stale urine, and how your fingers felt a bit slimy after touching the soiled linens. Throw in the smell of egg for good measure, and that's exactly what it is like to hold a boy egg, which, I remind you, is intended for human consumption.

So how does it taste? Surprisingly, not that bad. In fact, it doesn't taste much different from other hard-boiled eggs. That strong odor of urine doesn't translate into a strong taste, oddly enough. That's not to say that it isn't there—it is just very mild. Like most hard-boiled eggs in China, the white (if you could call it that) is salty (though perhaps the saltiness comes from a different source...) and rubbery, while the yolk tastes rather ordinary. Two or three bites and it's gone.

The foremost question in your mind, I suspect, is "why would anybody eat this?" The short answer is that it's tradition. Tradition is a powerful force in China, and in Dongyang these boy eggs are traditional. The longer answer is that traditional Chinese medicine values the urine from virgin boys as a good preventative measure against joint pain and other ailments. Why it has to be boys and why they have to be virgins, I don't know. Many people in Dongyang eat these by the dozen in the springtime. That's not to say that everybody likes them, of course. Some Dongyangers find the whole idea repulsive. Also, it's worth noting that anytime I mentioned the boy eggs to a native Chinese person in any other part of China, they were pretty grossed out by the whole idea. So I caution you against thinking this is something everybody in China does. Just like eating

dog or cat, it's true that some people do it, but it's considered distasteful by much of the population.

Another question you might be asking is "where do they get the urine?" Easy answer: local schools. Amazingly, vendors provide buckets to schools and encourage the boys to use those rather than the toilets. I also suspect some readers may be questioning how sanitary this endeavor is. Not very, to be honest. However, most doctors in Dongyang agree that these eggs won't hurt you (even if they don't believe in the supposed therapeutic benefits). Depending how much faith you put in Chinese doctors, you can probably feel reasonably comfortable on the safety front.

I wouldn't label boy eggs a must-try street food in China. They are difficult to find and aren't particularly tasty. They are, however, unique (remember: these are eggs cooked in urine), so if you're the type that likes to track down the most unusual foods you can, it might be time to plan a pilgrimage to Dongyang. For the rest of you, I suspect reading about it here was more than enough.

Key words: eggs, urine

447

Hangzhou

猫耳朵

COST: 8 RMB

Māo ěr duo, or "cat's ears," is an evocatively named jelly bean-sized noodle-like pasta in Shanxi Province, as well as in Italy (see orecchiete). In fact, local legend says that Marco Polo learned to make this while in Hangzhou and brought the recipe back to Italy, sparking a tradition of Italian pastas. A second legend claims that in the 18th century the Qianlong Emperor, traveling incognito, took a sightseeing boat ride in Hangzhou and got caught in the rain at lunchtime. He asked the boat's owner to prepare his favorite northern noodles, but the boat didn't have the right equipment. The boat owner's granddaughter instead prepared these cat's ear noodles, which, like northern noodles, are wheat-based instead of rice-based. The dish pleased the emperor so much that he revealed his true identity to the young woman and invited her to cook for him in the Forbidden City. Years later, the girl opened a small restaurant in Hangzhou to share these imperially approved noodles with the world, which is good news for us. A complete bowl of māo ěr duo is composed of cat's ear noodles,

green peas, bamboo, and a light broth; either pork, chicken, or shrimps are also added. The ingredients are all dense and sink right to the bottom of the soup. It is a tasty dish just as likely to be found in a small Italian kitchen, making it virtually a comfort food to the average Westerner. This means that it is a good entryway for people curious about Chinese street food but wary of unfamiliar dishes.

Key words: wheat pasta, soup, pork

叫化鸡

Jiào Huà Jī

COST: 30 RMB

Hangzhou's most famous dish—beggar's chicken—resides right on the border between restaurant food and street food. Beggar's chicken has only one ingredient: a whole chicken. The magic comes in the three-step preparation: 1) wrap the chicken tightly in lotus leaves; 2) pack clay around the lotus leaves; and 3) bake the chicken in a special oven or over an open fire. It sounds simple—and it is—but the result is fantastic. After cutting open the top of the package with scissors or a knife, you can dive right in with your fingers (some vendors will provide plastic gloves for this part). The chicken is so tightly packed that none of the juices have escaped during cooking, which results in soft, succulent flesh that pulls right away from the bone. A bit of flavor from the lotus leaves seeps in as well, giving the chicken a slightly different taste than traditionally cooked chicken. Beggar's chicken is a bit more expensive than your standard street food (20-30 RMB), but it's definitely worth it. You do, after all, get a whole chicken for that price.

Key words: chicken, succulent, lotus leaves

450

葱包烩

COST: 4 RMB

Cōng bāo huì is a popular breakfast food in Hangzhou, and it's not hard to see why: it tastes great! To prepare this dish, the vendor grabs a big hunk of watery dough and rubs it onto a hot griddle. A thin layer of the dough sticks to the griddle to make a crepe-like pancake. This process is often repeated many times to create a stack of these crepes—if you have the chance to watch, it's a fun process to see. Once the crepe is done cooking (it doesn't take very long due to its thinness), the vendor will wrap it around some long scallions, a couple sticks of yóutiáo (see the Shanghai section for more on yóutiáo), some pickled vegetables, and either sweet or spicy sauce (or both, if you feel like it). The rolled pancake is flattened and heated up in a griddle press. Like a Chinese burrito, it's a tasty, handheld snack that mixes savory, sweet, spicy, and fried flavors. Trust the locals: it's a great way to start your day in Hangzhou.

Key words: yóutiáo, scallions, burrito

452

桃浆

Táo Jiāng

COST: 5 RMB

Táo jiāng, roughly translated, means "peach tree jelly." Although you might be able to find it all year round in Hangzhou, it is typically eaten in the summer. Although the name seems to suggest something like a peach jam or jelly that you could use as a condiment, the truth is actually much more interesting. The base of táo jiāng is sap that comes from the peach tree. It is collected in rock-hard, irregularly shaped, crystalized clumps, about the size of a walnut. To make a batch of the jelly, you let the crystals soak in cool water for at least half a day (usually more), and then throw them into some boiling water. At this point, you can add some extra flavoring, such as goji berries, medlar, or osmanthus blossoms. After you let it cool, it's time to scoop it out into a bowl or cup and eat. The final product is sort of like Jell-O sitting in a thin syrup with some berries and flowers floating on top. The sap crystals retain their basic shape, but have a texture like grainy gelatin. Because of the cooking, their orange color has oozed out of the crystals and into the water, so the jelly itself is colorless. It's a fine snack—slightly sweet and very refreshing in the summertime. Depending on the season, you can probably expect to pay 3–5 RMB for this refreshing beverage.

Key words: peach sap, syrup, goji berries

Ningbo

缙云烧饼

Jìnyún Shāo Bǐng

COST: 3 RMB

You know that relative or friend you have that you're a teensy bit jealous of? Maybe they're more attractive or they're smarter or they have a cooler job or whatever. You know the one. Well, in the world of street food, jìnyún shāo bǐng is the cousin that all of China's other shāo bǐng are jealous of. Jìnyún shāo bǐng is a magnificent patty of freshly baked bread stuffed with meat and vegetables. During preparation, the vendor rolls out the dough, packs it with pork and vegetables, and then slaps it onto the interior wall of a large metal drum. The drum functions as an oven, with either burning coals or a small fire inside. The dough for the bread is sticky, so each individual patty clings to the side of the drum for as long as it takes to bake. When it is finished, the vendor removes it from the drum and keeps it warm until you come along to order it. The finished jìnyún shāo bǐng is heavy and floppy, golden and fire-baked-dusty on the outside while warm and moist on the inside. The bread is rich and doughy and the stuffing is savory and greasy. For the size of it, this is a surprisingly hearty snack—it might even make a whole lunch for those with a small appetite. It's worth noting that jìnyún shāo bǐng technically comes from Jinyun, a city southwest of Ningbo, but you can find it all over Ningbo. Whether you find it in Ningbo or Jinyun, though, you won't want to miss this—the king of shāo bǐng.

Key words: bread, meat, savory, warm

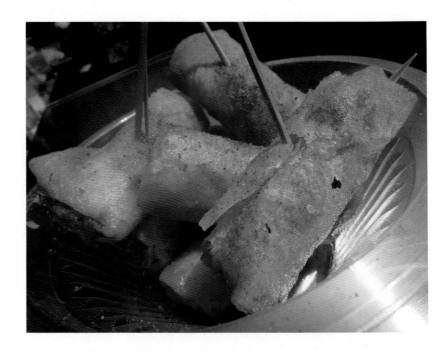

春卷

Chūn Juǎn

COST: 5 RMB

If you've ever eaten a spring roll in a Chinese restaurant in the West, then you have a good idea of how Ningbo's spring rolls taste: a greasy greasy exterior, fried to a golden crisp and sprinkled with spices, with shredded vegetables and meat on the inside. Although they are tasty, I'm not totally sure what distinguishes Ningbo's spring rolls from the spring rolls in other parts of China. I have been assured that they are special to the city, but it's difficult to figure out how. Perhaps that doesn't matter, though. They are hot, oily, and full of savory treasures. Maybe asking them to be unique on top of all that would just be greedy.

Key words: greasy, golden, crispy, vegetables

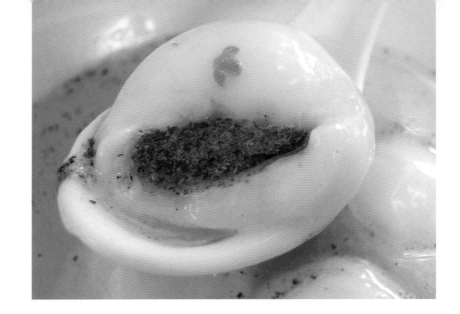

汤圆

Tāng Yuán

COST: 5 RMB

China offers several different types of tāng yuán, those stuffed balls of glutinous rice in sweet soup. One of the most famous tāng yuán varieties originates in Ningbo. The heart and soul of a bowl of tāng yuán are the glutinous rice dumplings. Ningbo's tāng yuán dumplings are each about the size of a ping pong ball. They are soft and chewy but not sticky. Inside each dumpling is a sweet, grainy mixture of black sesame seed paste, sugar, and lard. These balls don't have a lot of structural support, so they look best when they are suspended in their syrupy soup. As soon as you lift one out, it collapses under its own weight into a shapeless blob. They can barely contain the black sesame inside—as soon as you bite in, the mixture oozes out into your mouth. Some vendors throw a few osmanthus blossoms into the bowl as well for some color and fragrance. The whole thing is sweet, gooey, syrupy, and delicious. You can try Ningbo tāng yuán in much of Southeastern China, but it's best in Ningbo.

Key words: sweet, glutinous rice, black sesame, syrupy

粽子

Zòng Zi

COST: 3 RMB

With a history of more than 2,000 years, zòng zi is one of the most ancient street foods you can eat in China. Legend has it that they were invented when the poet Qu Yuan drowned himself in a river following the capture of his state's capital by an opposing general. His neighbors and admirers so respected him that they threw silk packets of rice into the river so that the fish would not eat his body. Later, these packets of rice (now wrapped in bamboo leaves instead of silk) were eaten to commemorate the poet's life. Different types of zòng zi exist in different parts of China, but in Ningbo you are most likely to find the Jiaxing version, since it is a nearby city in Zhejiang Province. Moving from the outside in, here's what you'll find in a freshly steamed Jiaxing zòng zi: 1) wrapping twine; 2) bamboo leaf; 3) brown sticky rice; 4) pork. Once you've unwrapped the packet, you'll find that the rice is subtly sweet, gummy, and lip-smackingly greasy, while the pork is rich and savory. Overall, Jiaxing zòng zi is a very fine snack and a great way to commemorate a long-dead Chinese poet.

Key words: rice, steamed, gummy, pork

年糕

Nián Gāo

COST: 8 RMB

Nián gāo, or New Year cake, shows up in different forms all around China. Most take the form of a sweet and honeyed sticky dessert, but here in Ningbo it shows up in a wonderfully umami fried dish. Like all nián gāo, Ningbo's version begins with a glutinous rice flour dough. It is then sliced into thin slivers. Instead of being coated with sunny flavors like honey, mint or osmanthus, the nián gāo in Ningbo is stir-fried with oil and vegetables such as carrots, Chinese broccoli, and mustard greens—the ingredients will vary from vendor to vendor. The vegetables taste fresh and offer an interesting textural contrast to the chewy glutinous rice discs. The texture of this nián gāo is denser and stiffer than most other types of nián gāo. As a whole, it has a pleasing greasiness and savory flavor. If you've missed out on nián gāo elsewhere in China because you aren't into sweet foods, this could be your big chance—don't miss it.

Key words: glutinous rice, savory, greasy, vegetables

Shaoxing

臭豆腐

Chòu Dòu Fu

COST: 4 RMB

Of the several distinct local varieties of stinky tofu available in Chinese cities, Shaoxing's is probably the most well-known. It isn't quite as pungent as some, though it does have a very recognizable aroma. Like twice-used gym socks inadvertently left under a pile of musty laundry for a month. Just like in the cartoons, you can virtually see the scent trails wafting through the city and lifting passersby up by their nostrils to float back to the source. If you follow your nose to a stinky tofu vendor, you will find that the powerful smell is emanating from an unassuming cube of tan tofu. The process of creating Shaoxing's chòu dòu fu starts with regular tofu that is fermented in a brine of amaranth, mushrooms, bamboo shoots, and sundry other vegetables and herbs. Once fermented, the tofu gains a gray appearance as well as a fetid smell. It is chopped into cubes, fried until golden and crispy, and skewered for serving. Like all stinky tofu, it never tastes as strong as it looks. It actually has a nice savory taste to it, sort of a complex, earthy flavor, like some cheeses. Of course because it has been fried, it also has a certain oiliness, particularly on the crispy exterior. All in all, chòu dòu fu is a solid snack that justifies its position as Shaoxing's most famous street food.

Key words: tofu, fermented, stinky

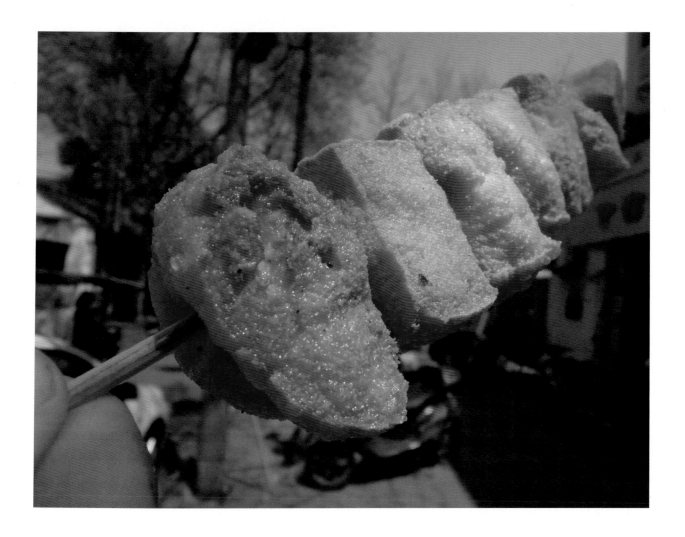

461

茴香豆

Huí Xiāng Dòu

COST: 3 RMB

Huí xiāng dòu, or fragrant fennel beans, might not be for everybody. Fennel, black licorice, and aniseed, all of which share similar flavors, are notoriously hit-or-miss with human taste buds. If you're in the camp that can appreciate the flavor (the correct camp, as far as I'm concerned), then you might want to give these beans a try. They are fava beans (often translated as "broad beans" in China) that have been boiled with fennel, cinnamon, and salt until crisp and fragrant. The beans are waxy on the outside with a dense, starchy interior. They look a bit like golden raisins, but they taste more like spiced beans. In all honesty, the fennel flavor is fairly mild, so don't be turned off if you aren't a fennel fan. These beans store and travel well, so consider buying a bagful and keeping them as a snack for long train rides. Share them with your seat mates and you'll have made some friends for life.

Key words: fava beans, fennel

Acknowledgments

Without any hyperbole, I can truthfully say that you would not be reading this book right now if it weren't for the generous support of a wide variety of people. From friends and family to couch surfing hosts to eagle-eyed proofreaders, this was not a solo effort.

Although most of these supporters will remain anonymous, I'd like to offer my particular thanks to the following people: my mother, my father, Fairy Xu and David He, Gangsheng Pan, Ginni Lam (林靖怡), Guldana, Jeff Jacobstein and family, Mike Szymanski, Jinglun Ding, Kevin Chen, Lauren Campbell, Lindsay Butt, Martin H, Ming and Rosie Zhao, Steven Lv, Bruno Stauffacher, Steven Ye, Beppie and Gert, Mike Adler, Brad and Katie Pollack, Richard Lee Pu, Eden Chalumeau, Tiger Tsuei in Ningbo, Wencan Shi, 罗大川, Xiao Chen, Jonathan and Monika, Baxi, Willie, Sun Zhenni, Teacher Tian and family, Terrence Chen, Tiantian, Timothy Ingalls, Huiyuan Liu, Yu Jialiu, Zhuang Jingyue and Sun Xiaorui, Zoe and family, 陈碧兰, Lilly Chow, Bruce Humes, and everybody at Blacksmith Books.

Above all, the biggest debt of gratitude is owed to my wife, Leslie, who has been gracious, encouraging, and patient from the very first day I said I wanted to quit my stable job to eat my way around China for three months. My great thanks to everybody, named or unnamed here, who helped me along the way.

EXPLORE ASIA WITH BLACKSMITH BOOKS
In all good bookshops or at *www.blacksmithbooks.com*